LIGHTHOUSES
of Lake Superior's North Shore

*The Historic Beacons
of Minnesota, Isle Royale
and Ontario*

BY ELLE ANDRA-WARNER

Design by Katie Viren and Amber Pratt
Maps by Katie Viren

North Shore Press

A division of Northern Wilds Media, Inc.
1708 W. Highway 61, P.O. Box 26
Grand Marais, MN 55604
www.northernwilds.com

ISBN 978-1-7332652-0-1

Printed in Canada by Friesens.

10 9 8 7 6 5 4 3 2

Dedication

Dedicated to the people—the keepers of the light—who looked after the lighthouses of Lake Superior, and to the people and organizations now dedicated to the preservation of those lighthouses, its history, and the keeper tales.

Acknowledgements

Lighthouses are fascinating places and over the years I've visited a number of them in travels through the United States, Canada and Europe. Some lighthouses are in remote water locations facing weather extremes and isolation for the keepers, while others are accessible on land. Particularly interesting are the history and stories about the lighthouses of Lake Superior and the keepers who kept the beacons of lights flashing to guide ships on their journey. At the same time, those Superior keepers were always prepared to assist ships in distress, rescue mariners and provide shelter.

Thank you to Northern Wilds Media publishers Shawn Perich and Amber Pratt for providing me with the opportunity to write about Lake Superior lighthouses in Minnesota, Isle Royale and Ontario. And special thanks to editors Breana Roy and Candice Letkeman for their excellent editing skills, and to the production team at Northern Wilds for bringing the book to print and market.

Many thanks also to those who have provided water transportation for me to visit some of the Ontario lighthouses, particularly Captain Greg Heroux of Sail Superior and his Frodo sailboat. Words of appreciation also to Explore Minnesota Tourism, Tourism Ontario and Tourism Thunder Bay.

To historians and researchers, thank you for laying the foundations for preserving the history and stories about Lake Superior lighthouses, and thanks to the photographers (past and present) who have provided valuable visual records of Lake Superior lighthouses, including Ron Walker, Oceans & Fisheries Canada; Paul Morralee, Canadian Lighthouses of Lake Superior; Great Lakes Lighthouse Keepers Association; and others.

And special kudos to my family—my husband Glenn (I sure appreciate the fresh coffee you bring to my office) and my daughters Tania, Tami and Cindi—for their ongoing support and encouragement.

Contributors

We are indebted to the following photographers and lighthouse historians who contributed to this book. We especially want to acknowledge the assistance of Larry Wright and the Great Lakes Lighthouse Keepers Association, which allowed us access to their extensive photo files. Charles W. Bash was also generous in providing access to his photographic collection. Ron Walker of Canada's Department of Fisheries and Oceans provided many historical photos.

Christine Johnston

David Johnson

John Caughlan

Lois Nuttall

National Park Service

Paul Morralee

Paul Sundberg

Radiant Spirit Gallery

Richard Main

Front cover photos left to right: Split Rock Lighthouse by Paul Sundberg, Grand Marais Lighthouse by David Johnson, Duluth Harbor South Breakwater Outer Lighthouse by Larry Wright.

Back cover photo: Split Rock Lighthouse by Paul Sundberg.

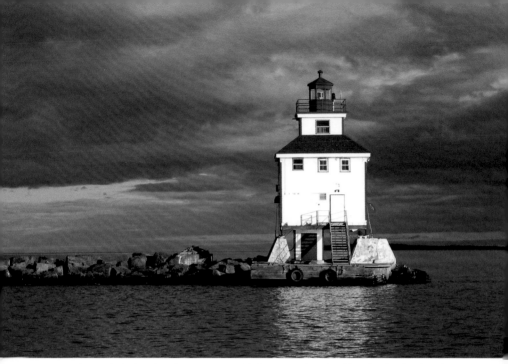

First lit in 1940, the Thunder Bay Main Lighthouse is a familiar Thunder Bay landmark.
Elle Andra-Warner

Table of Contents

Dedication **iii**

Acknowledgements **iv**

Photo Credits **v**

Introduction **1**

MINNESOTA

SECTION MAP **2**

Minnesota Point Lighthouse **5**

Duluth Harbor South Breakwater Inner Lighthouse **9**

Duluth Harbor South Breakwater Outer Lighthouse **15**

Duluth Harbor North Pier Light **19**

Two Harbors Lighthouse **23**

Two Harbors East Breakwater Light **29**

Split Rock Lighthouse **33**

Grand Marais Lighthouse **39**

ISLE ROYALE

SECTION MAP 44

Rock of Ages Lighthouse 47

Isle Royale Lighthouse 53

Rock Harbor Lighthouse 59

Passage Island Lighthouse 63

ONTARIO WEST

SECTION MAP 68

Victoria Island Lighthouse 71

Pie Island Lighthouse 75

Angus Island Lighthouse 81

Mission Channel
Entrance Light 85

Port Arthur Breakwater Light 89

Kaministiquia River
Range Lights 91

Thunder Bay Main Lighthouse 95

Welcome Island Lighthouse 99

Thunder Cape Lighthouse 103

Trowbridge Island
Lighthouse 107

Point Porphyry Light 113

No. 10 Lighthouse 119

ONTARIO NORTH

SECTION MAP 122

Lamb Island Lighthouse 125

St. Ignace Lighthouse 129

Battle Island Lighthouse 133

Slate Islands Lighthouse 139

Hawkins Island Light 145

ONTARIO EAST

SECTION MAP 148

Otter Island Lighthouse 151

Quebec Harbour Range Front
& Rear Lights 155

Davieaux Island Light 159

Chimney Point Lighthouse 165

Agate Island Lighthouse 169

Michipicoten Island East End
Lighthouse 173

Michipicoten Harbour
Lighthouse 179

Gargantua Light 185

Caribou Island Lighthouse 191

Coppermine Point Lighthouse 197

Corbeil Point Lighthouse 201

Ile Parisienne Light 205

Bibliography 211

Introduction

It was a visit years ago to Battle Island Light on the North Shore of Lake Superior—the first lighthouse that I had ever visited—that got me hooked on lighthouses.

Though Battle Island Light had already been automated, greeting us at the site was Bert Saasto, the former lighthouse assistant keeper, now its resident summer caretaker. We had come to the island on a friend's converted tugboat and spent a couple of hours with Saasto touring the grounds, listening to his stories, and climbing to the top of Battle Island Light for a stunning panoramic view of the lake and islands.

In 1991, Battle Island Light was the last of the Great Lakes lighthouses with a keeper to be automated and closed, and it was Saasto that had the honor of being the last lighthouse keeper to be taken off the lakes.

Since then, I've visited other lighthouses on Lake Superior and continued to be awed by the quiet grandeur, history, and lighthouse keeper tales, particularly about the courage and tenacity of the old-time keepers. Lake Superior lighthouses and their keepers had a crucial role of keeping the light shining to guide the journey of ships to safe port, as well as being ready to rescue crews and people from ships in distress or shipwrecked.

After shipping season closed, keepers usually returned to the mainland, picked up by ships or helicopters. But if they had to find their own way back, making the crossing was dangerous and even deadly, like it was in 1917 for keeper William Sherlock from Michipicoten Island's East End Light (his widow Mary took over keeper duties from 1918-1925). Some liked the life of a lighthouse keeper so much they returned for decades. Many had their families with them during the season (Malones with their 11 children on Isle Royale's Menagerie Island Light). And a few lived year-round at their lighthouse stations (Andrew Dick family with 10 children on Porphyry Light).

There's a romanticism, a nostalgia, a curiosity about lighthouses. How were they constructed? How was the light lit and kept going in the early days? What was it like to be in a lighthouse during a brutal Lake Superior storm? What was it like to live for months on a remote island in Lake Superior? Any shipwrecks near the lighthouse?

On Lake Superior, the first light to be lit was the Whitefish Point Light in 1849 on the Upper Peninsula of Michigan on the lake's southeastern shore. The first for Ontario was St. Ignace Light on Talbot Island, lit on July 1, 1867 (the same day that Canada officially became a country) and abandoned five years later as the "Lighthouse of Doom" after the first three keepers all died in different circumstances.

Thankfully, many of the Lake Superior lighthouses are being restored and preserved by organizations and individuals, and their history and keeper tales recognized and celebrated. Whether you sail on Lake Superior or are an armchair traveler, this lighthouse book provides a glimpse of the Lake Superior lighthouses of Ontario, Minnesota and Isle Royale, and the people who looked after them.

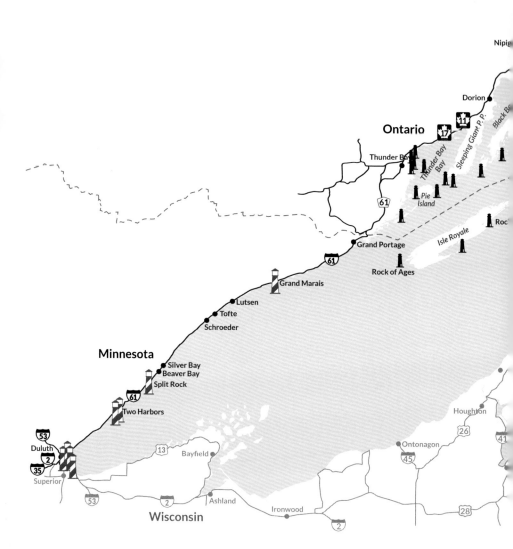

Minnesota

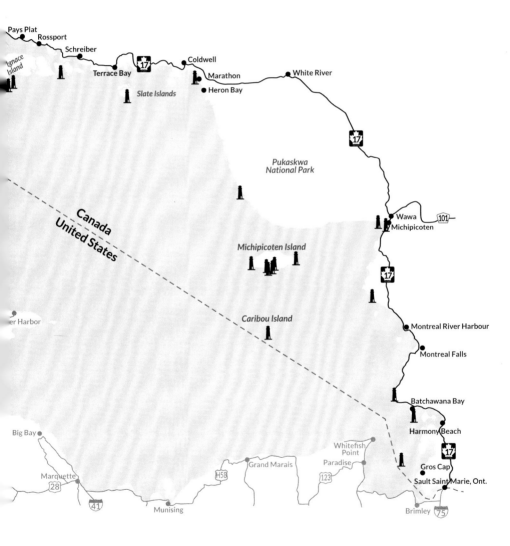

Pays Plat
Rossport
Schreiber
Ignace
Island
Terrace Bay
Coldwell
Marathon
White River
Slate Islands
Heron Bay

Pukaskwa
National Park

Canada
United States

Wawa
Michipicoten

Michipicoten Island

er Harbor
Caribou Island
Montreal River Harbour

Montreal Falls

Batchawana Bay

Big Bay
Harmony Beach

Whitefish
Point
Grand Marais
Paradise
Gros Cap

Marquette
H58
123
Sault Saint Marie, Ont.

28

41
Munising
Brimley
75

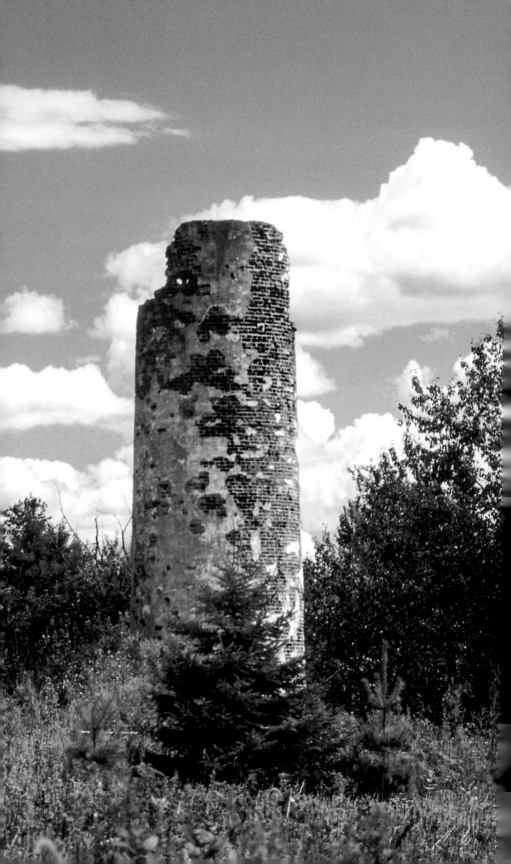

Minnesota Point Lighthouse
(also referred to as Old Standby or Zero Point Lighthouse)

LOCATION: Near the eastern end of Minnesota Point
(Park Point)

BUILT: 1856–1858

LIT: 1858 Discontinued: 1878

RELIT: 1880

EXTINGUISHED: August 6, 1885

STATUS: Decommissioned and abandoned. Listed in National
Register of Historic Places on December 27, 1974

COORDINATES: N 46.71, W 92.0259

OWNED BY: U.S. Army Corps of Engineers

OPEN TO PUBLIC: Yes, grounds only

GETTING THERE: Take the 1.5-mile (2.4 km) hiking trail from
the parking lot of the Sky Harbor Airport at the
eastern end of Minnesota Point, or walk along
the lakeshore

CONSTRUCTION

Minnesota Point Lighthouse, sometimes called Zero Point Lighthouse, was
built on the "barrens" stretch of land on Minnesota Point at "zero point," a site
first chosen in 1823 by Lieutenant Henry Woolsley of the British Royal Navy as
the point to start all geographic surveys of Lake Superior. According to some
tales, the lighthouse is built right on top of the actual mile marker zero.

First lit in 1858 (the same year that the State of Minnesota was created), the
Minnesota Point Lighthouse was a 50-foot (15 m) tall, 12-foot (3.7 m) diameter

First lit in 1858, the Minnesota Point Lighthouse has been dark since 1885. You can hike to
the tower that remains of this historic Duluth landmark. *Larry Wright*

cylindrical tower connected by a covered passageway to the adjacent slate-roofed one-and-a-half-story keeper's house. All of the structures were constructed using red bricks shipped from Cleveland.

The tower's foundation was built using blue rubble stone, and both its interior and exterior were plaster-coated with a lime and cement mortar mixture. Topping the tower was a wooden cupola and a 10-sided lantern that housed a fifth-order Fresnel lens displaying a fixed red signal from 50-foot (15.3 m) focal plane. The light was visible for 10 miles (16.2 m).

Within 10 years of being built, the Minnesota Point Lighthouse had some problems. According to the 1868 annual report of the United States Lighthouse Board, the tower remained in good condition, but the other structures needed repair: "The dwelling leaks badly around the chimneys. The rain and soot have discoloured the walls. The plastering has fallen in many places, and is loose in nearly all the rooms. It is proposed to replaster the house throughout, and to reflash the chimneys." The recommendations were actioned and the work was done the following year.

The Minnesota Point Light was in operation for 20 years until 1878, when it was deactivated after being replaced by a light on the north pier of the Superior Entry. However, five years later, in 1880, the Minnesota Point Light was relit when the North Pier Light was temporarily discontinued while the U.S. Army Corps of Engineers undertook dredging and enlarging the Superior Entry.

When the North Pier Light was re-established in 1885, the Minnesota Point Light was permanently extinguished. The keeper's house continued to be occupied by the keepers of the North Pier Light until the last keepers left in 1894, and the dwelling was refurbished and transferred to the Wisconsin side of the Superior Entry entrance.

BACKGROUND

On Minnesota Point, there were at least three North American burial sites. According to the Duluth Archaeology Center Report No. 11-22 (2011), there was an Ojibwe village and burial site just west of the lighthouse site. A winter storm in 1876 eroded the sand, exposing bones, beads, and artifacts. The archaeological report also states, "Early documents of the Duluth-Superior area record wigwams on this end of the point as well as [evidence of] other Native American use including a portage trail where the Duluth Ship Canal is now located (Mulholland and Mulholland, 2008b)."

It was on Minnesota Point that the famous French explorer Daniel de Greysolon, Sieur duLhut, for whom the city of Duluth is named, landed on

June 27, 1679, with some voyageurs and Native guides.

Before the privately-funded 150-foot (46 m) wide and 16-foot (4.8 m) deep Duluth Ship Canal was completed in 1871, the only channel into the harbors of Duluth and Superior from Lake Superior was through Superior Entry, a natural 2,000-foot (610 m) opening through a long sandbar that stretched from Duluth to Superior. Minnesota Point was the seven-mile (11.3 km) western (northern) part of the sand bar, and Wisconsin Point, the three-mile (4.8 km) eastern (southern) part; together, they formed one of the world's largest freshwater sandbars. Between the Minnesota and Wisconsin Points was the Superior Entry opening.

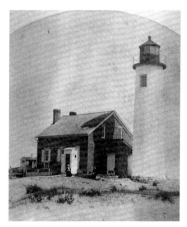

The Minnesota Point Light marked the Superior Entry, the natural outlet of the St. Louis River estuary. *Great Lakes Lighthouse Keepers Association*

Keeper Tales

The first keeper was Reuben H. Barrett, who lived in the keeper's house with his wife Stella and their four children. For a foghorn, he used a hand-blown tin logging dinner horn that he and/or his wife would blow—sometimes for hours—to warn incoming ships of thick fog. Locals reported that the horn's call sounded more like a cow-call, earning the signal the nickname, "Barrett's Cow." (Barrett had previously lived on Minnesota Point while clerking for Duluth pioneer George Stuntz at his trading house, located on the bayside of the point, near where the Minnesota Point Lighthouse was later constructed.)

INTO THE TWENTY-FIRST CENTURY

Today, the lighthouse's truncated tower still stands, but is crumbling and has lost most of its whitewashed-mortar exterior finish. The historic tower is now surrounded by a chain-link fence to keep out vandals.

Minnesota Point Lighthouse was Minnesota's first lighthouse and the first high-powered light on Lake Superior. On December 27, 1974, it was listed in the National Register of Historic Places.

Duluth Harbor South Breakwater Inner Lighthouse

LOCATION: Western Lake Superior, on the south breakwater of the Duluth Ship Canal in Duluth, Minnesota

BUILT: 1889; 1901

LIT: September 1, 1889; September 1, 1901

AUTOMATED: 1976

COORDINATES: N 46 46 43.580, W 092 05 30.53

STATUS: Active federal aid to navigation. Added to the National Register of Historic Places on August 4, 1983, as Duluth South Breakwater Inner (Duluth Range Rear) Lighthouse.

CHARACTERISTICS OF LIGHT: Flashing white every five seconds

OWNED BY: Lighthouse tower privately-owned. Light owned by U.S. Coast Guard.

OPEN TO PUBLIC: No

CONSTRUCTION AND DESIGN

Construction began in the spring of 1889 to install a light at the inner (rear/western) end of the Duluth South Breakwater. United States Congress had appropriated $2,000 on March 2, 1889, to build the light to serve as a range light in tandem with the Outer Light at the entry of the Duluth South Breakwater.

The tower was a wooden pyramidal structure topped with an enclosed watch room housing the octagonal cast-iron lantern with a fourth-order Fresnel lens. The light exhibited a flashing red every six seconds at a focal plane higher than the Duluth South Breakwater Outer Light. Lining up the two lights—inner and outer—formed range lights to guide ships into the canal from Lake Superior.

The Inner Lighthouse was intended to make it easier for ships to take a line on the relatively narrow Duluth Canal and enter the harbor from Lake Superior. *Larry Wright*

Just 16 days after the light was lit on September 1, 1889, the popular 210-foot (64 m) passenger steamer *India* (built in Buffalo in 1871) had difficulty navigating her way between the piers and collided with the pier at the base of the new lighthouse. Her owners paid for the repair expenses. At the time, *India* was one of Anchor Line's famous "iron triplets" passenger steamers—*India*, *China*, and *Japan*—operating as part of a pool of vessels under the Lake Superior Transit Company. Each of the three ships carried atop her "birdcage" pilothouse a life-size wooden likeness of a person of the country for which the ship named. In 1906, she was renamed *City of Ottawa* when sold to Canadian owners before returning to the United States and her original *India* name; she was later abandoned in Louisiana and scrapped in about 1945.

As part of the harbor upgrade and reconstruction of the Duluth Ship Canal between 1899 and 1902, the canal's original wooden parallel south and north piers were removed and replaced with stone-filled timber crib substructure with a concrete superstructure. Once the piers were completed, the Inner and Outer lighthouses were removed, and in 1901 temporary lights were erected on the new south pier while the permanent lights were built. The temporary inner (rear) light was on a 37-foot (11.3 m) mast set up at the pier's inner end, and displayed a fixed red lens lantern from a height of 52 feet (16 m) above water.

Construction on the new permanent inner lighthouse, which continues today as the current structure, began in June 1900 and was completed in August 1901. Built at the aerial bridge edge of the south pier, it consists of a pyramidal steel skeletal frame supporting a 9-foot (2.7 m) round watch room and an octagonal cast-iron lantern. The skeletal tower at the base is 19 feet 5 inches (5.9 m) square, narrowing to 9 feet (2.7 m) square at the top where it supports the watch tower. From ground level, the watch tower is reached through a central cylindrical iron column that houses a spiral staircase. The stair cylinder supports the stairs, but not the watch room and lantern.

The lantern houses the old tower's fourth-order Fresnel lens with six flash panels, each having a bull's-eye in the central drum. The focal plane of the lens is 68 feet (20.8 m) above the water. When the light was lit on September 1, 1901, from the new tower, the temporary beacon was removed.

Originally, the cylindrical tower was painted white with a black lantern, but the colors were later reversed to a white lantern and black tower.

The light was automated in 1976, at the same time as the Outer Light was automated.

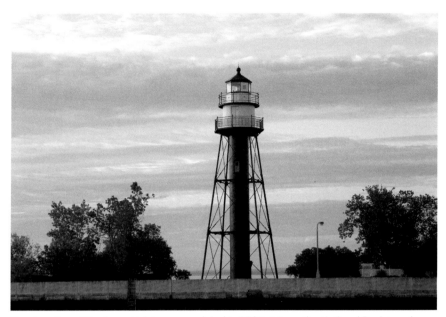

Construction of the Inner Light was completed in 1901. It is on the National Register of Historic Places. *Charles W. Bash*

In 1995, the fourth-order Fresnel lens was removed by the U.S. Coast Guard after some damage was found during inspection. It was replaced with a modern acrylic flasher. The lens was given on loan to the Lake Superior Maritime Visitor Center, where it was restored and put on display.

BACKGROUND

Upon completion in 1872 of the 300-foot (92 m) Duluth Ship Canal, the canal was framed by parallel wooden south and north piers. The piers were marked at the entry end of the south pier by the Duluth Harbor South Breakwater Outer (front) Lighthouse to help mariners find the canal.

However, vessels found it difficult to find the correct line of entry into the narrow canal. So, a taller, second light was built at the inner (rear) south pier to form a rear range light to the outer (front) light. Using the outer and inner lights provided an alignment that vessels could follow as a direct course to the opening between the two piers.

On August 4, 1983, the Inner Light was added to the National Register of Historic Places as the Duluth South Breakwater Inner (Duluth Range Rear) Lighthouse.

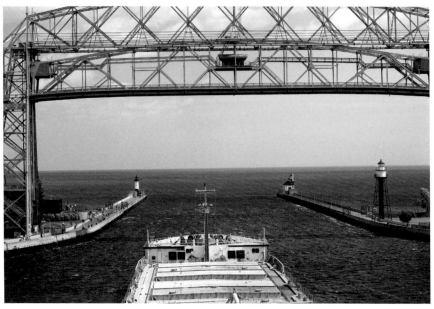

A view from the bridge of a freighter passing beneath the Aerial Bridge and through the Duluth Entry. *Larry Wright*

Keeper/Shipwreck Tales

The three lighthouse keepers of the Outer Light were also tasked with tending to the Inner Light. Lake Superior storms can be brutal, and recognizing that reaching the lights could be dangerous during inclement weather, a tunnel between the lights was added during the canal reconstruction.

When the concrete piers were being installed in 1898 to 1900, the tunnel was constructed, connecting the inner (rear) and outer (front) lighthouses as part of the new south pier breakwater. The tunnel provided a route for keepers to reach the Outer Light during stormy weather, as the lake's waters could wash over the pier, putting keepers at risk of being swept away into Lake Superior or being injured on icy walkways.

Inside the tunnel was a 1,150-foot (350.5 m) tramway with steel rails, and a cable-operated car that stretched the length of the tunnel. Using the car, the keepers would pull themselves by cable back and forth through the tunnel. The tramway was eventually abandoned as the tunnel leaked and flooded from seepage.

INTO THE TWENTY-FIRST CENTURY

In 2000, the United States passed the National Historic Lighthouse Preservation Act (NHLPA), recognizing "the cultural, recreational, and educational value associated with historic light station properties by allowing them to be transferred at no cost to Federal agencies, State and local governments, non-profit corporations, educational agencies, and community development organizations." The Act provided a mechanism for the disposal of federally-owned historic light stations that had been declared "excess to the needs of the responsible agency."

Each year, the U.S. government issues Notices of Availability (NOA) for historic light stations available for transfer at "no cost to eligible entities defined as federal agencies, state and local agencies, non-profit corporations, educational agencies, or community development organizations, for education, park, recreation, cultural, or historic preservation purposes." In 2007, the USCG made a NOA indicating that the Duluth Harbor South Breakwater Inner Lighthouse was now "in excess to the needs of the USCG" and available for transfer. As there were no takers for the free lighthouse, the following year (2008) it was sold at auction for $31,000 to a pair of Duluth residents.

The light remains in service as a federal aid to navigation at the site and remains the property of the United States Government.

Duluth Harbor South Breakwater Outer Lighthouse
(Duluth South Breakwater Light)

LOCATION: Western Lake Superior, offshore at entry to Duluth Ship Canal in Duluth, Minnesota

BUILT: 1873; Second Tower 1901

LIT: June 2, 1874; September 1, 1901

AUTOMATED: 1976

COORDINATES: N 46 46 48.46, W 092 05 15.02

STATUS: Active aid to navigation. Listed in the National Register of Historic Places in June 2016.

CHARACTERISTICS OF LIGHT: Fixed green light

OWNED/MANAGED: U.S. Coast Guard

OPEN TO PUBLIC: No

GETTING THERE: Accessible from shore on Duluth Harbor Ship Canal's south breakwater

CONSTRUCTION AND DESIGN

The first Duluth Harbor South Breakwater Outer (front) Light was a wooden pyramidal tower completed in 1874 by contractors hired by the Corps of Engineers. It was located offshore at the outer (front) edge of the wooden south breakwater of the Duluth Ship Canal.

The tower was capped with an octagonal cast-iron lantern, housing a fifth-order Fresnel lens. The light was lit on June 2, 1874, displaying a fixed

The sun rises over the south pier of the Duluth entry, beside the Outer Lighthouse.
Dawn LaPointe

red light from a 68-foot (20.8 m) focal height above water and was visible for 12.5 miles (20.1 km). In 1885, the characteristics of the light were changed to flashing red and white, and a year later, in 1886, the light was upgraded to a fourth-order Fresnel lens and changed to a fixed red light.

The head keeper's seven-room frame dwelling was built onshore, and an elevated catwalk was constructed between the keeper's house and the Outer Light.

In the late 1890s, the Duluth Ship Canal underwent reconstruction, including replacing the original wooden south breakwater with a concrete pier. In 1901, once the new concrete pier was completed, the original 1874 lighthouse tower and fog-signal house was replaced with a new single one-and-a-half-story rectangular fog-signal building, painted white with a red roof. The two-story light tower is built into the fog-signal building's southeastern corner, surmounted by a lantern using the fourth-order Fresnel lens from the old light. When the light in the new tower was lit on September 1, 1901, the characteristics of the light changed to fixed green.

On the National Register of Historic Places Registration Form for the Outer Light, the 1901 lighthouse is described as:

> Inside the tower's first story, a cast iron spiral stairway leads upward two stories to an overhead metal trapdoor in the base of the rectangular cast iron platform that caps the light tower. This iron platform supports the lantern, which is accessed by way of the trapdoor.

> The lighthouse's lantern is circular and sits centered atop its rectangular platform. It is approximately 9 feet [2.7 m] in diameter and 8 feet [2.4 m] tall. A metal pedestal centered in the lantern room floor supports the lighthouse's optic which signals a fixed green light with a focal plane 44 feet [13.4 m] above water level. It is visible for 17 miles [27.4 km] in clear weather.

> The outdoor gallery surrounding the lantern is rectangular and bounded by a railing made with cast iron bars supported by metal stanchions topped with round finials. The gallery's iron floor and railing are painted black.

Also moved over from the old building to the new was the 1885 steam-powered fog signal and boiler assembly, which were replaced in 1915 with a pair of locomotive whistles also powered with steam. In 1923, a dual-horn Type "F" diaphone fog signal replaced the locomotive whistle, resulting in the signal's horn being relocated to the roof and a parabolic reflector being installed. In 1958, an electric horn replaced the diaphone; in 1995, diaphones were put back

in service; and in 2006, the signal was dismantled and removed. It was said to be the last-known operating foghorn in North America.

In 2014, the fourth-order Fresnel lens was replaced with a modern automated light-emitting diode (LED) marine beacon that was visible for 15 miles (24.1 km).

BACKGROUND

The opening of the St. Mary's Falls Ship Canal locks in 1855 at Sault Ste. Marie, Michigan, provided a seaway link for larger vessels to enter Lake Superior from the lower Great Lakes. Maritime traffic soon increased on Lake Superior, and Duluth became one of the busiest ports on the Great Lakes. To mark the entry to the Duluth Harbor Ship Channel for incoming vessels, the first Duluth Harbor South Breakwater Outer Light was established in 1874.

Once the Duluth Harbor South Breakwater Inner (rear) Light was built and lit in 1889, the two lights formed a range alignment, and mariners knew that by lining up the taller white light of the Inner Light directly over the green light of the Outer (front), their vessels would be lined up for a safe entry into the canal.

Lighthouse Tales

A single keeper was assigned to the Outer Light Station from its establishment in 1873 and lived in the keeper's dwelling onshore. In 1885, an assistant keeper was added to help with the newly commissioned fog whistle, and in 1889, when the Inner (rear) Light was established, a second assistant was hired. The three keepers tended to both the Outer and Inner lights.

While housing was provided for the head keeper, the assistants had to find and pay for their accommodations in Duluth until 1913, when a two-story duplex was built for them across from the keeper's dwelling.

INTO THE TWENTY-FIRST CENTURY

The Duluth Harbor South Breakwater Outer Light, along with the Duluth Harbor North Pier Light, was added to the National Register of Historic Places (NRHP) in June 2016. The Duluth Harbor South Breakwater Inner Light had already been listed on NRHP in August 1983.

Duluth Harbor North Pier Light

(also known as Duluth North Pier Light, Duluth North Pierhead,
and Duluth North Breakwater Light)

LOCATION: Western Lake Superior in Duluth, Minnesota, at the offshore end of the Duluth Ship Canal's northern pier marking the canal's entry

BUILT: 1909–1910

LIT: April 7, 1910

COORDINATES: N 46 46 51.54, W 092 05 17.03

STATUS: Active; listed in the National Register of Historic Places in 2016

CHARACTERISTICS OF LIGHT: ISO red 6s automated LED beacon red light signal, three seconds on, three seconds off

OWNED BY: U.S. Coast Guard

OPEN TO PUBLIC: Deck surrounding the lighthouse is open to public, but not the light tower's interior

GETTING THERE: Accessible by walking along Ship Canal's north pier at Canal Park in Duluth

CONSTRUCTION AND DESIGN

Construction on the 37-foot-high (11.2 m) Duluth Harbor North Pier Light began in the fall of 1909 at the offshore end of the north pier approximately 1,000 feet (304.8 m) from land. The work included the crib and pier foundations and steel conical white tower with black base and black lantern. Finished the following spring, the light was lit on April 7, 1910.

Duluth's North Pier Light is a familiar landmark to the many visitors of the city's Canal Park district. *Dawn LaPointe*

The North Pier Light is an early example of a light tower built of steel, its interior wall consisting of riveted steel plates painted white.

Built upon a concrete foundation pier, the 28-foot (8.5 m) tower has a diameter of 10 feet 6 inches (3.2 m) at its base, and 8 feet (2.4 m) at the top. The foundation is approximately 50 feet (15.2 m) long, 30 feet (9.1 m) wide and 40 feet (12.2 m) tall, and includes a rock-filled 22-foot-tall (6.7 m) timber crib and 18-foot-tall (5.5 m) concrete pier. Extending from the lake bottom to approximately 4 feet (1.2 m) above the water are steel sheet piles on the north, east, and south sides that shield the foundation.

A central cast-iron spiral stairway with a pipe handrail leads to the tower's upper level and the watch room. White-painted beaded board lined the interior circular wall and ceiling, and a cast-iron ship's ladder to a trapdoor opening in the ceiling provided access to the lantern room.

Topping the light tower and surrounded by an open-air gallery is a black circular 10-foot-diameter (3 m) cast iron platform, which holds the lantern. The lantern, approximately 9 feet tall (2.7 m) and 7 feet 6 inches (2.3 m) wide, has eight cast-iron leaf doors painted white on the inside. The ceiling of the lantern room (the underside of the tower's roof) is covered with zinc sheeting painted white, while the cast-iron floor is painted gray.

The tower's entrance doorway, which faces the north pier, still has its original single-leaf metal door and doorknob, and is framed by decorative black cast-iron edging made in classical styling. It includes a pediment crowned in the middle with a raised semi-circle with a five-pointed star in the center, directly above the year "1909," the year construction began on the lighthouse.

The original optic installed in the lantern was a fifth-order Fresnel lens. It was removed in 2014 and replaced with the existing LED optic, a modern automated light-emitting diode (LED) marine beacon that illuminates red for three seconds, followed by three seconds off. The light's height above water is 43 feet (13.1 m), and in clear weather is visible for 16 miles (25.7 km). Electricity to power the light was always brought in by cable from shore, and the circuity has been upgraded.

BACKGROUND

North Pier Light is one of three lighthouses that mark the entry to the Duluth Ship Canal; the other two lights are the 47-foot (14.3 m) Duluth Harbor South Breakwater Outer Light, located approximately 300 feet (91.4 m) south of North Pier Light, and the 70-foot (21.3 m) Duluth Harbor South Breakwater Inner Light, located approximately 1,500 feet (457.2 m) west of the Outer Light.

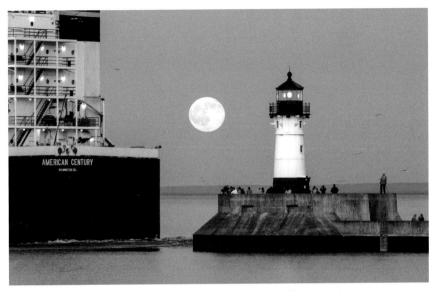

Duluth's North Pier, shown here beneath a full moon, is one of the best places to get a close-up view of the giant ships that ply the lake. *Gary Fiedler*

While the Duluth Ship Canal was completed in 1871, cutting through Minnesota Point to give vessels direct access to Duluth Harbor, the entry route had its problems. In their annual report in 1908, the U.S. Lighthouse Board wrote:

> *The approach to Duluth Harbor is one of the worst and most dangerous of the whole chain on Great Lakes. The entrance piers are only 300 feet [91.4 m] in width, and the north pier is so close to the shore that a vessel making a mistake in judging the width would be immediately on the rocks. The Lake Carriers' Association considers this a matter of such importance that it has made arrangements for the exhibition of private lights for the balance of the season of navigation in 1908.*

The following year (1909), U.S. Congress approved $4,000 to build the North Pier Light, with construction beginning that fall. When the North Pier Light was lit on April 7, 1910, it replaced the temporary light of the Lake Carriers Association and made entry into Duluth Ship Canal safer and easier.

LIGHTHOUSE KEEPERS

The same lighthouse keepers looked after all three of the Duluth Canal lighthouses. While the head keeper lived in a frame house constructed in 1874 with the South Pier Light, the assistant keepers had to find their own accommodations at their own expense until 1913 when a brick duplex was built for them.

Two Harbors Lighthouse

LOCATION: Western Lake Superior in Two Harbors, Minnesota, overlooking Agate Bay

BUILT: 1891–1892

LIT: April 14, 1892

AUTOMATED: 1981

COORDINATES: N 47 00 49, W 91 39 44

STATUS: Active; private aid to navigation; listed in the National Register of Historic Places on July 19, 1984

CHARACTERISTICS OF LIGHT: Flashing white every 20 seconds

OWNED BY: Lake County Historical Society

OPEN TO PUBLIC: Visitors have access to three of the original six structures at the light stations, including the light tower and the on-site former Frontenac Pilot House, now part of the museum

GETTING THERE: On U.S. Highway 61 at Two Harbors, about mid-point between Duluth and Split Rock Lighthouse

CONSTRUCTION AND DESIGN

Construction of the Two Harbors Lighthouse began in 1891 after the U.S. government purchased a one-acre parcel of land for the site for $1 from Thomas Feigh. The station was completed in 1892 and lit on April 14, 1892, by the first lighthouse keeper, Charles Lederle.

The Two Harbors Lighthouse dates to 1892. Portions of the facility are open to visitors.
David Johnson

The original lighthouse is described by the U.S. Department of Interior's Historic American Engineering Records (HAER) as:

The Keeper's House is a two-story red brick building 35 square feet [3.3 square m] with two gabled roofs, with an attached light tower 12 feet 9 inches [3.9 m] square, also of brick, 49 feet 6 inches [15.1 m] tall from the base to the top of the ventilator ball. Focal plane of the lens is 78 feet [24 m] above the mean low level of Lake Superior. The tower supports an octagon cast iron lantern which has an inscribed inside diameter of seven feet.

The original fog-signal house also survives, a dark red rectangular building of gabled roof, measuring 22 (6.7 m) by 40 feet (12.2 m), and housing duplicate 10-inch (25.4 cm) steam whistles, as well as the brick oil house, which measures 5 by 7 feet (1.5 by 2.1 m) with a gabled roof. None of the fog signal equipment has survived.

The site also contains a small assistant keeper's house, a framed L-shaped white building with gray trim and gabled cedar-shake roof, measuring 16 by 24 feet (4.9 by 7.3 m). Originally a barn, the structure was converted in 1895 to the assistant keeper's dwelling.

The square tower, which is triple-bricked, has an exterior gallery surrounded by a black iron railing and a white octagonal lantern topped by a red cone and ventilator ball. The tower's narrow, 40-step staircase winds up through four levels to the lantern, which has six of its sides glazed and two closed so the light shines in a 270-degree arc. The watch room on the fourth level has four porthole-style windows for the keeper to see the weather conditions and marine traffic, and to provide ventilation for the lantern.

An interesting note is that the keeper's dwelling was constructed two bricks thick, while the light tower topping the dwelling has walls that are three bricks thick. Where the tower and house meet are a full five bricks thick, as a safety measure to protect the keeper's family in event of a fire or explosion. The light tower was connected, yet are separate structures.

The original light was a fourth-order Fresnel lens, consisting of a series of mirrored prisms rotating around a fixed flame supplied by an oil and wick lamp, operated by a weighted chain that had to be reset every two hours. The light was lit by electricity in 1921, increasing the candlepower from 30,000 to 230,000. The Fresnel lens, which was removed by the U.S. Coast Guard in 1970 (some accounts say 1969) was replaced with a pair of rotating 24-inch (61 cm) airport-type 1,000-watt electric beacons visible for 20 miles (32.2 km) The fog signal was discontinued in 1973.

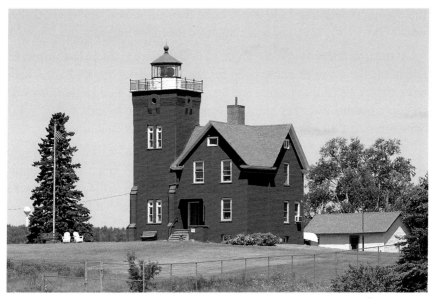

The Two Harbors Lighthouse is the last working lighthouse in Minnesota. *Charles W. Bash*

The lighthouse was fully automated by the U.S. Coast Guard in 1981, eliminating the need for keepers. The same year, the Lake County Historical Society was granted a lease of the property to provide tours. Seven years later, in 1988, the LCHS was granted a lease to provide tours of the light station, and through an act of Congress in 1999, ownership of the Two Harbors Light Station was transferred to LCHS. The same year, the society established the lighthouse bed-and-breakfast (B&B) to help generate funding.

Since 2001, LCHS has been responsible for the operation and maintenance of the light.

BACKGROUND

With the opening of iron ore mines in northeastern Minnesota, the ore docks of Agate Bay (present-day Two Harbors) became a busy shipping port. In 1884, the first shipment of ore from the Vermilion Range was loaded on the steamer *Hecla* and shipped to Philadelphia. Six years later, in 1892, ships loaded the first ore shipment from Mesabi Range (known to the Ojibwe people as *Misaabe-wajiw*, meaning "Great Mountain"), and in 1911, the first from Cuyuna Range.

By 1885, approximately 225,000 tons of ore had moved through Agate Bay, and both the Vessel Owners Association and the U.S. Lighthouse Service requested a light station be built to provide safe passage into Agate Bay harbor.

U.S. Congress authorized $10,000 to build the light station, and construction work began in July 1891, and was completed the following year.

At the time the station was completed in 1892, Two Harbors had surpassed Duluth as the major shipping point for the iron ores of Mesabi Range, with more than 1,300 ships entering and leaving Agate Bay. Two Harbors became the only beacon directing ships between the Apostle Islands and Duluth-Superior until 1910 when the Split Rock Lighthouse was established.

The three ranges—Vermilion, Mesabi and Cuyuna—formed the Mesabi Iron Range in Minnesota's Arrowhead County and became the largest producers of iron ore in the U.S. The ore was moved by train to the giant ore docks at Two Harbors and Duluth. In the 1930s, more than half of the world's iron ore was extracted from Minnesota's Mesabi Iron Range. Two Harbors played a key role in the development of the Mesabi Range iron industry.

The iron shipments from Two Harbors and Duluth continued for decades, with Two Harbors playing a key role in the development of the Mesabi Range iron industry. In the 1960s, the demand for iron began to decrease and the last ore ship from Vermilion left in 1967, from Cuyuna in 1980, and from Mesabi in 1984.

Shipwreck Tales

At the site of the Two Harbors Light Station, there is a pilot house that was once part of the 604-foot (184.1 m) steamer *Frontenac*. Why is it at Two Harbors? Back on November 22, 1979, during a wicked snowstorm with strong winds and raging seas with 12-foot (3.7 m) waves, the *Frontenac* grounded when her port side slammed into a reef extending out from Pellet Island at the end of Silver Bay's westerly breakwater. Stranded, she tried unsuccessfully to get off the reef, even as she was battered by the storm and her cabins were beginning to flood.

The U.S. Coast Guard *Mesquite* arrived the next morning to assist the *Frontenac*. But the storm had taken its toll—she had buckled in the hull and the deck now had cracks. After two-thirds of her bunker fuel had been removed, she came off the reef, was moved to Silver Bay for temporary repairs and then to Superior, Wisconsin shipyards for repairs. The repairs were never made and *Frontenac* was scrapped in 1985.

Fortunately, *Frontenac's* pilot house was saved and moved to the Two Harbors Lighthouse site, where she serves as a part of the museum.

In a strange twist of fate, 10 years later the USCGC 180-foot (54.9 m) *Mesquite*—which had been sent to assist *Frontenac* in 1979—would meet a similar fate. On December 4, 1989, the *Mesquite* grounded on a reef off of Keweenaw Peninsula in southern Lake Superior while collecting navigational buoys. Lodged on a rock ledge, the weather worsened and she was being battered by waves, damaging her hull and flooding her cabins. After unsuccessfully trying to free her, the crew abandoned ship and were rescued by a passing freighter. During the winter, she was so severely damaged by ice and fierce storms that she could not be salvaged. *Mesquite* was removed from the reef in July 1990, deliberately sunk in about 110 feet (33.5 m) of water, and is now a popular scuba dive site of the Keweenaw Underwater Preserve. *Mesquite*, which was built in Duluth in 1942 and saw action in the Second World War, was the first U.S. Coast Guard vessel to be declared a casualty.

INTO THE TWENTY-FIRST CENTURY

The Two Harbors Light is the oldest continuously operating lighthouse on western Lake Superior and the last working lighthouse in Minnesota. It is now a privately-owned aid to navigation, with the Lake County Historical Society responsible for the care and maintenance of the light.

The Two Harbor Light Station has a total of six original structures on site: the lighthouse tower with attached keeper's quarters; the assistant keeper's house; the foghorn-signal buildings; the oil house; the skiff house; and a garage. In addition, the historical society has added the Frontenac Pilot House as museum space.

Visitors have access to three of the station's original structures: the light tower, which has been restored and fitted with exhibits and houses the rotating light; the assistant keeper's building, which has been restored to late 1800s-era and has exhibits of Lake Superior shipwrecks and a kiosk with historical information on the area; and the keeper's quarters, which have been restored to early Twentieth Century and which the LCHS operate as a bed-and-breakfast inn.

While the lighthouse is still on the Light List as active, it is a private aid to navigation and is no longer maintained by the U.S. Coast Guard.

The station's Fresnel lens, which was removed by the U.S. Coast Guard in 1970 and had been exhibited at the Inland Sea Museum in Vermilion, Ohio, was returned in February 2015 to Two Harbors for display.

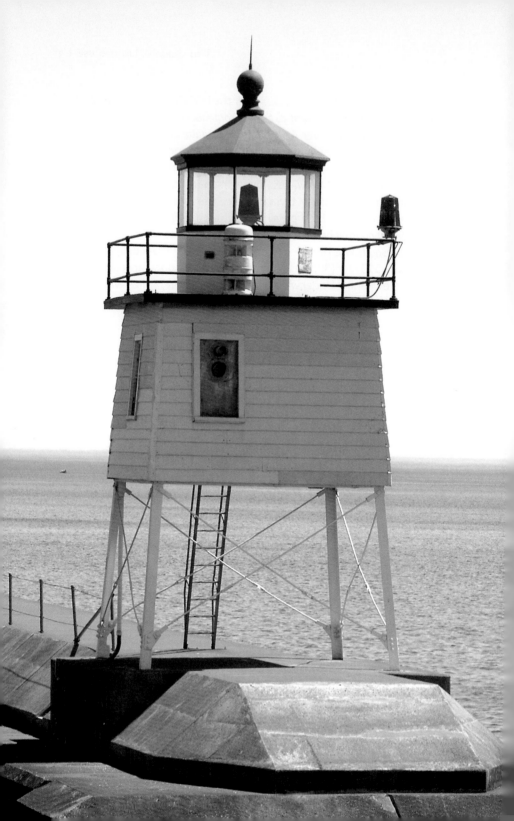

Two Harbors East Breakwater Lighthouse

LOCATION: Western Lake Superior, on the outer end of the eastern
breakwater in Two Harbors, Minnesota, near the
Two Harbors Lighthouse

BUILT: 1895

LIT: December 14, 1895; September 10, 1902; August 4, 1906

COORDINATES: N 47 00 36, W 91 40 12

STATUS: Active aid to navigation

CHARACTERISTICS OF LIGHT: Flashing red every six seconds

OWNED BY: U.S. Coast Guard

ACCESS: Site open; tower closed

GETTING THERE: Located on Highway 61 at Two Harbors between Duluth
and Split Rock Lighthouse

CONSTRUCTION AND DESIGN

In the late 1880s, Two Harbors—known then as Agate Bay—was one of
the world's busiest ports for iron ore shipping from the Vermilion Range and
Mesabi Range. In 1887, plans were made to improve and protect the harbor by
constructing breakwaters on both the east and west sides of the entrance to
Agate Bay Harbor. At the time, there were two elevated iron ore docks and two
merchandise docks.

While Two Harbors Lighthouse had started operations on the eastern
mainland side of Agate Bay in 1892, the Two Harbors East Breakwater Light
was established on December 14, 1895, when a white eight-day lantern light

You can walk to the East Breakwater Lighthouse to watch the lake freighters enter and
leave Two Harbors, a primary port for shipping taconite from Minnesota's Iron Range.
Charles W. Bash

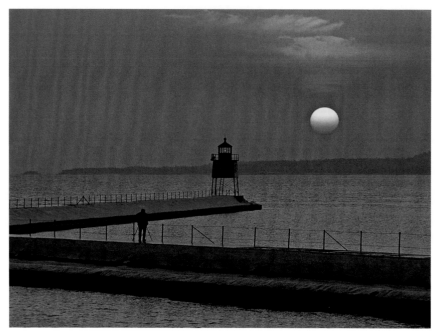

The East Breakwater Lighthouse has a working beacon that flashes red every six seconds. *Paul Sundberg*

marked by a fixed red lantern suspended from an iron post at the outer end of the east breakwater extended from the shore near the lighthouse.

In 1902, the iron post was moved 300 feet (91.4 m) to the outer end of the newly completed breakwater, and the light was changed from the lens-lantern to a Pintsch gas light exhibited on September 10, 1902.

In 1906—four years later—the post light was replaced by an enclosed light tower as described by the Annual Report of the Lighthouse Board:

The combined light and fog-bell tower and an electrically-operated fog bell, on the easterly breakwater, was completed on August 4, 1906, and on August 4 the light and fog signal went into operation. The new tower is 33 ½ feet [10.2 m] high to the focal plane, and is a square, pyramidal, skeleton iron structure, painted white, surmounted by a square watch room and black octagonal lantern. The fog bell is hung from the front of the tower and strikes a single blow every 10 seconds.

On July 22, 1915, the fog signal on the breakwater was changed from a bell to an electric siren, which was replaced 26 years later, in 1941, by an electric diaphragm horn. In September 1916, a light was established from a black mast on the west breakwater.

In 1947, while harbor improvements were being made, the east breakwater light was discontinued and removed for three years, until 1950, when work on the new L-shaped east breakwater was completed. The short skeletal pyramidal light and fog signal were put back in operation at the outer end of the new east breakwater. Its four steel legs were anchored to the concrete pier and it was topped with a square gallery and octagonal lantern.

INTO THE TWENTY-FIRST CENTURY

The lighthouse that was put into operation in 1906 continues to be in service, with a flashing red light every six seconds, to guide vessels into port.

SPLIT ROCK LIGHTHOUSE

LOCATION: Western Lake Superior, situated on top of a 130-foot
(39.6 m) rock cliff along the north shore of Lake Superior
in Split Rock Lighthouse State Park, Beaver Township,
Lake County, Minnesota

BUILT: 1909–1910

LIT: August 1, 1910

COORDINATES: N 47.20005, W 91.3669

STATUS: Station deactivated in 1969; Split Rock Lighthouse was
listed in the National Register of Historic Places in 1969,
and designated a National Historic Landmark in 2011

OWNED BY: Since 1976, the lighthouse and facilities have been operat-
ed as a historic site by the Minnesota Historical Society

OPEN TO PUBLIC: Open daily mid-May to mid-October

GETTING THERE: It is easy to get to Split Rock Lighthouse by car on U.S.
Highway MN61-N. From Duluth, the drive is northeast
48 miles (77.2 km); from Two Harbors, northeast 20 miles
(32.2 km); from Grand Marais, southwest 64 miles (103
km); and from the Canadian border, southwest 104 miles
(167.4 km).

ADDRESS: Split Rock Lighthouse
3713 Split Rock Lighthouse Road
Two Harbors, MN 55616 Tel. 218-226-6372

BACKGROUND

Split Rock Lighthouse, which sits on a sheer 130-foot (39.6 m) cliff, owes its
existence largely to a brutal 1905 storm that left shipwrecks along the north
shore, in particular the barge *Madeira*, less than a mile away.

Split Rock Lighthouse is the best-known icon of Minnesota's north shore. *Lois Nuttall*

In the early hours of November 28, 1905, a raging blizzard sunk 29 ships on Lake Superior. Pittsburgh Steamship Company's 436-foot (132.9 m) steel barge *Madeira* was being towed by the company's 478-foot (145.7 m) steel steamer *William Edenborn*. At about 3:00 a.m., the towline broke, leaving *Madeira* drifting and helpless. Three hours later, the *Madeira* was being smashed broadside against a cliff at Gold Rock Point (near the cliff of today's Split Rock Lighthouse). One crew member was lost (drowned after falling overboard), and *Madeira* broke in two and sank. The wreckage is now a popular dive site.

At the same time, a few miles away, the *Edenborn* slammed its bow at full speed onto the shore at the mouth of the Split Rock River. She also lost one crew member as the ship cracked mid-ship.

After the 1905 storm, a delegation of steamship owners led by the president of the Pittsburgh Steamship Company, which had a number of vessels lost or substantially damaged along the north shore because of the storm, successfully lobbied U.S. Congress for a lighthouse and fog signal to be built near Split Rock, then called Stoney Point.

CONSTRUCTION AND DESIGN

Construction on the lighthouse began in May 1909, and was completed in the summer of 1910 at a cost of $72,540. Ten buildings were constructed, including three yellow brick, two-story lighthouse keeper's houses, a fog building, and light tower.

The building of the lighthouse is a story in itself. Because there were no roads to the remote Minnesota site, all the workers, building materials (including tons of bricks), and supplies were shipped by boat to a dock built below the cliff and then loaded into a box crate called a "skip." They were then hoisted up to the cliff top by a 1,200-pound (544.3 kg) steam-powered derrick. The heavy steam hoist had been pulled up the steep slope by lines and tackle attached to trees before the derrick was erected and secured. In 1916, a tramway was completed to replace the derrick and it moved supplies up from the lakeshore until 1934 when the station truck began hauling in supplies.

Octagonal on the outside but circular inside, the light tower is made of yellow brick, reinforced concrete on a concrete foundation, and topped by a black dome. A black iron railing surrounds the gallery and lantern. Since the 38-foot (11.6 m) tower sits on a 130-foot (39.6 m) rock cliff, the beacon focal point is 168 feet (51.2 m) above Lake Superior and has a range of more than 22 miles (35.4 km). A black iron railing surrounds the gallery and lantern.

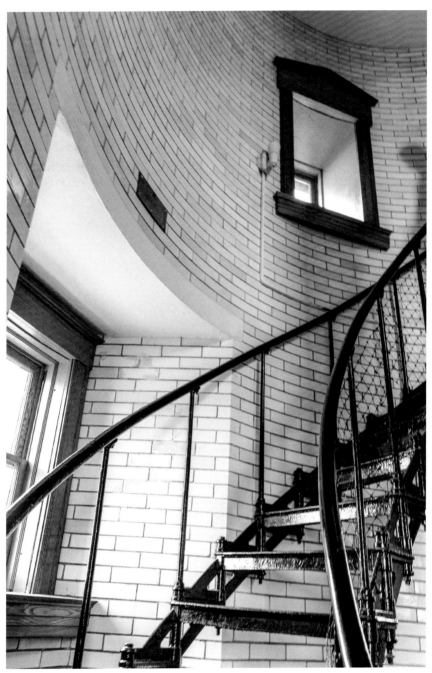

Impeccably maintained by the Minnesota Historical Society, Split Rock Lighthouse is open for tours. *Lois Nuttall*

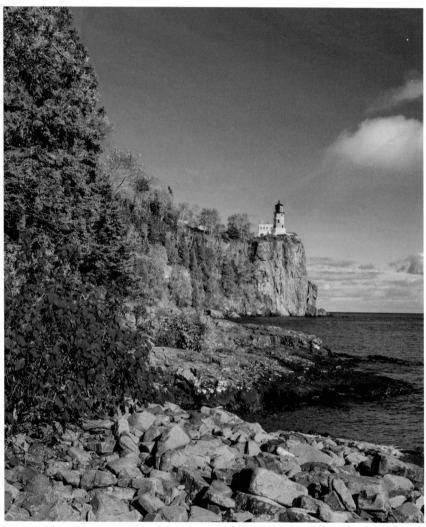

The rock-strewn waters near the lighthouse were treacherous for early mariners. There were no major shipwrecks after the lighthouse began operation. *Paul Sundberg*

Inside the tower there is a 32-step circular iron staircase, a hollow post or "weight-way" in the middle, and yellow brick interior walls with glazed enamel finish.

One of the main features of the Split Rock Lighthouse is its third-order bi-valve Fresnel lens, which floated in 250 pounds (115 kg) of mercury and operated on an elaborate clockwork mechanism of weights and pulleys that rotated the lens once every 20 seconds, producing a white flash of light every 10 seconds.

Lighthouse Tales

Regarding the Fresnel lens, one of the lighthouse tales is about the time more mercury was quickly needed as the light was slowing down. Keeper Franklin Covell (who served from 1928 to 1944) rushed to buy more from a druggist in Two Harbors, but no mercury was available. So, for the next two nights—until 8 pounds (3.6 kg) of mercury arrived—Covell and his assistant turned the lens by hand, using a marine stopwatch to time the intervals.

Another more tragic story dates back to 1910, just a few months after Split Rock Lighthouse opened. Two assistant keepers, Edward Sexton and Roy Gillis, left the station in a small rowboat at 12:30 p.m. on Sunday, October 2, to pick up the station's mail at Beaver Bay. Keeper Orren "Pete" Young (the first keeper, who served from 1910 to 1928) had warned the men, both inexperienced sailors, not to tie the sail down, but to hold it in place by hand so that it could be quickly released if sudden strong winds caught it, to minimize the risk of flipping. By nightfall, the men had not returned, and in the morning Young set out by boat to search for them. About two miles (3.2 km) west of the station, he located their empty boat, floating upside down, with the boat's boom slashed at the seat and the sail still securely tied to the gunwale. The bodies of the two men were never found.

INTO THE TWENTY-FIRST CENTURY

Lake Superior waters around the Split Rock Lighthouse area were once described as being among the world's most dangerous for ships; however, after the lighthouse was built, there were no further major disasters or shipwrecks.

Although the light was deactivated in 1969, since 1985 it has been relit every year on November 10 to commemorate the sinking of the *Edmund Fitzgerald* on November 10, 1975, and the loss of the 29 sailors who went down with the vessel. The *Fitzgerald* had sailed past the historic Split Rock Lighthouse after leaving Duluth Harbor on November 9, 1975.

Considered one of the most beautiful in the United States, and restored to its early 1920s appearance, Split Rock Lighthouse was listed in the National Register of Historic Places in 1969 and designated a National Historic Landmark in 2011.

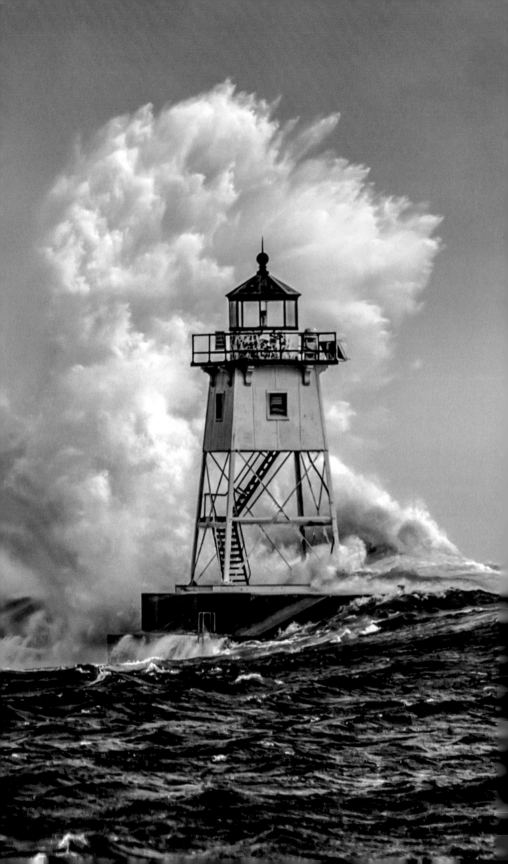

Grand Marais Lighthouse

LOCATION: Western Lake Superior, at south end of the breakwater at Grand Marais, Minnesota

BUILT: 1885; 1922

LIT: February 23, 1886

AUTOMATED: 1937

COORDINATES: N 48 40 48, W 85 58 12

STATUS: Active aid to navigation

CHARACTERISTICS OF LIGHT: Flashing green every four seconds

OWNER: United States Coast Guard

OPEN TO PUBLIC: Site open; tower closed

GETTING THERE: Walk along east breakwater toward lighthouse

CONSTRUCTION AND DESIGN

The project for improvements to the Grand Marais harbor, adopted in 1879, provided for a breakwater to narrow the entrance, thereby increasing the area of shelter for vessels. In 1883, the east breakwater, 350 feet (106.7 m) in length and jutting out from the westerly end of a distinctive spit of land extending into Lake Superior called Mayhew's Point—commonly known today as Artist's Point—was completed. Two years later, in July 1885, after materials arrived by lighthouse single-screw steamer *Warrington*, construction on the Grand Marais lighthouse was finished on August 21 and became operational on September 1.

The original lighthouse was a 32-foot (9.8 m) pyramidal wooden enclosed tower, anchored to the east pierhead. The square tower was surmounted by a surplus

The Grand Marais Lighthouse is exposed to Superior's fury. *David Johnson*

octagonal lantern from the Detroit depot. The beacon displayed a white light using a fifth-order Fresnel lens made by Saulter and Co., Paris, France, and had a focal height above water of 38 feet (11.7 m) and was visible for 13 miles (21 km).

The 1,500-pound (680 kg) fog bell, which had been used at Passage Island Lighthouse, was installed on the tower's west side, with its striking machinery housed below the lantern. The station's fog signal was changed in October 1923 to an electric siren with a 10-second blast every 20 seconds; three years later, the signal was altered to a five-second blast every 30 seconds.

The first lighthouse keeper, Joseph E. Mayhew, was appointed in February 1886. He had to find his own accommodations until the keeper's two-story dwelling was completed 10 years later, in 1896. The 2,200-square-foot (204.4 square m) residence was built by the Duluth firm of Wilson & Nauffs at a total cost of $2,800. It was the first building of its size in Grand Marais. The *Cook County News Herald* reported on August 8, 1896, "When completed, this will be the finest residence in Cook County and will be a credit to the village."

The lighthouse keeper's house was 42 feet (12.8 m) long and 28.5 feet (8.7 m) wide, built on a concrete, brick, and stone foundation. The lower level was finished with clapboard (horizontal siding) the upper level with cedar shake siding, and the roof was shingled in diagonal pattern some have called "modified mansard roof."

Storms took their toll on the lighthouse. In November 1886, high seas breached the base. A year later, in October 1887, when the tower was again damaged by a storm, plank protection was put in place on the east side of the tower. In November 1919, another storm damaged the south and north walls of the lighthouse.

The following year, in November 1920, the original lighthouse was replaced by a white square pyramidal steel tower with an enclosed upper part, and in 1922 it was moved to its current location at the end of the eastern breakwater.

BACKGROUND

It was during the early fur-trading era that the French gave Grand Marais its name, meaning "great marsh," for the marsh situated at the head of the bay and harbor. To the east is another bay, separated by a wide gravel bar with a rocky offshore point projecting into Lake Superior, which was once an island, but is now part of the mainland. To the Ojibwe people, the Grand Marais bay was known as *Kitchi-bitobig*, meaning "double body of water," recognizing the town's two separate bays.

By 1823, the American Fur Company had established a trading post in the area, but abandoned it in 1842. Twelve years later, Richard Godfrey, a Detroit independent fur trader, arrived in the area and stayed for a couple of years before returning to Detroit. During that time, a request by locals for a lighthouse

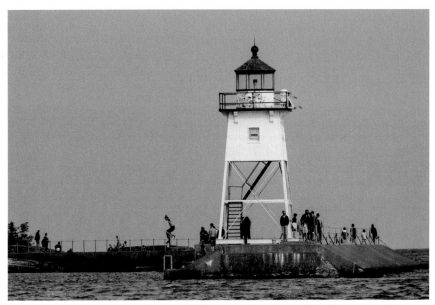

A walk along the east breakwall to the lighthouse is a favorite pastime for summer visitors to Grand Marais. *David Johnson*

at Grand Marais got a Congress appropriation for $6,000 on August 18, 1856, but after further study, it was decided there was insufficient need for one.

Settlers began to arrive along the north shore after the eastern Minnesota Territory became the state of Minnesota and was admitted on May 11, 1858, as the thirty-second state in the United States of America. In 1871, two mineral prospectors, Henry Mayhew and Samuel Howenstine, arrived in the area and are considered to be the founders of Grand Marais. Two years later, by the end of 1873, Mayhew, Howenstine, and Ed Wakelin owned most of village land along both the west and east bays.

In 1878, U.S. Congress denied Minnesota's request for a lighthouse, but seven years later, on March 3, 1885, after harbor improvements were made, Congress appropriated $9,952 for a light and fog signal to mark the harbor entrance. Construction began in July 1885, and was completed in August.

The lighthouse was automated and de-staffed in 1937.

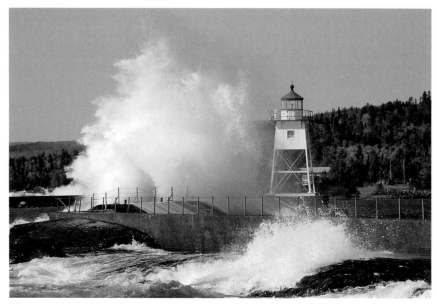

The Grand Marais Lighthouse was automated and de-staffed in 1937. *John Caughlan*

Shipwreck Tales

Grand Marais was not a harbor of refuge in December 1875 when the 60-foot (18.3 m) schooner *Stranger* was caught in a snowstorm on Lake Superior near the community. There was no breakwater, pier, or lighthouse at the time, though the loss of the *Stranger* and her four-man crew may have hastened the construction.

On Friday, December 9, 1875, the *Stranger* had delivered a load of fish from Grand Marais to Superior, Wisconsin, and the next day she headed back to Grand Marais after picking up a cargo of merchandise and provisions in Duluth. According to author-historian Julius Wolff in his book *Lake Superior Shipwrecks*, the schooner, in her haste to get underway, was not carrying an anchor.

On board were 24-year-old Captain Isaac "Ike" Clark, 18-year-old ship's cook Gordon Coburn, and crew members 33-year-old Joseph Cadotte and 22-year-old James LaFave.

The schooner arrived in Grand Marais on Sunday, December 12, but before she could unload her cargo, a fierce winter storm with gale force winds blew in from the northwest. Captain Clark tried to move the *Stranger* to a more sheltered section of the harbor, but she struck rocks and became unmanageable. Water gushed over her, the crew lost control, and winds were pushing her to the southeast. The *Stranger*

capsized. Young Coburn was swept overboard and drowned. The remaining three crewmen urgently swung axes to cut loose the masts and the rigging so the schooner would right itself. She did, but without any anchor and with the wind blowing off the land, the *Stranger* began drifting into the open waters of Lake Superior.

When people on shore realized that the *Stranger* was in trouble, a sailboat with six rescuers headed out. The men were Sam Howenstine (a co-founder of Grand Marais) and his son William, Paul LaPlante, Sam Zimmerman, Jack Scott, and John Morrison.

Local resident Thomas Mayhew describes what happened next in a letter to the editor of the Duluth *Minnesotan Herald*:

"The winds were howling and the weather freezing. The small boat maneuvered through high winds and heavy sea. Time and again, fighting against the forces of nature they came closer and closer. They finally came within eight feet [2.4 m] of the *Stranger* and tried to throw them a line and get the men off. They heard the words of Capt. Clark, 'Throw me a line.' A line was thrown not once but several times, but winds and waves took it. Then the heavy seas struck the sailboat and drove it away from the vessel, making further attempts futile. The small boat had to head back, fighting the cruel wind and waters, barely making it back to where they landed four miles from Grand Marais."

Around 5:00 p.m., the *Stranger* could still be seen about four miles out on Lake Superior. There was hope that perhaps the crew would ride out the storm—on board was a stove to keep them warm, plus blankets and food. However, hope was crushed when five days later, on December 30, 1875, fragments of the schooner came ashore.

INTO THE TWENTY-FIRST CENTURY

Today, the lighthouse keeper's house is one of the oldest structures in Grand Marais. It later became the U.S. Coast Guard Commander's residence, and since 1966 has been owned by the Cook County Historical Society, housing the Cook County Historical Museum. It was listed in the National Register of Historic Places in 1971. It continues to house the original 1885 fifth-order Fresnel lens.

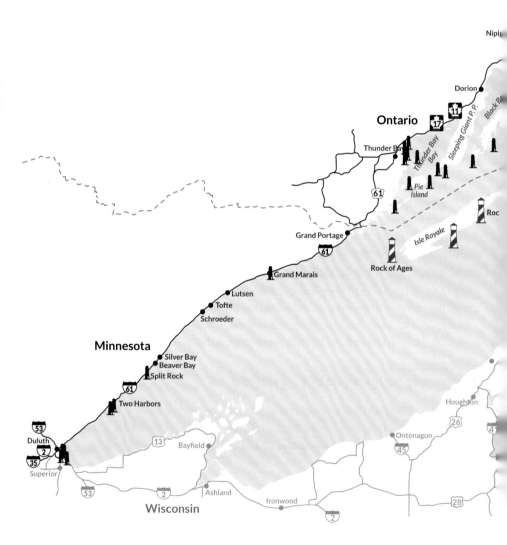

Isle Royale

Pays Plat
Rossport
Schreiber
Ignace Island
Terrace Bay
Coldwell
Marathon
Heron Bay
White River
Slate Islands
Pukaskwa National Park
Canada
United States
Michipicoten Island
Wawa
Michipicoten
Caribou Island
er Harbor
Montreal River Harbour
Montreal Falls
Big Bay
Batchawana Bay
Harmony Beach
Whitefish Point
Grand Marais
Paradise
Gros Cap
Sault Saint Marie, Ont.
Marquette
Munising
Brimley

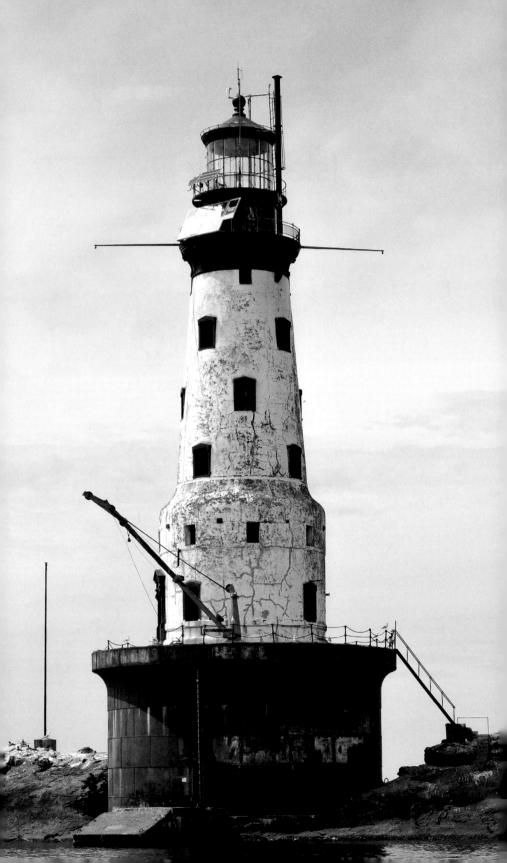

ROCK OF AGES LIGHTHOUSE

LOCATION: Northwest Lake Superior, Michigan, on the knife-edge of a small rock island five miles (8 km) off the southwest tip of Isle Royale, approximately four miles (6.4 km) outside of Washington Harbor in the open waters that are part of Isle Royale National Park

BUILT: 1908

LIT: 1908

AUTOMATED: 1978

COORDINATES: N 47 52 01, W 89 18 49

STATUS: Active aid to navigation; listed in National Register of Historic Places in 1983

CHARACTERISTICS OF LIGHT: Flashing white every 10 seconds

OWNED/MANAGED BY: National Park Service/Isle Royale National Park

OPEN TO PUBLIC: Structure currently closed. The Rock of Ages Lighthouse Preservation Society plans to open the light to the public once restoration work is complete.

GETTING THERE: Accessible only by boat. Can be viewed from ferries to Isle Royale from Grand Portage, Minnesota, or from Keweenaw Excursion boat tours.

CONSTRUCTION

Construction of the 10-story Rock of Ages Lighthouse began in May 1907. When it was completed in 1908, it was one of the tallest and most powerful beacons on the Great Lakes. Construction costs topped U.S. $125,000 (equivalent to U.S. $3.1 million in 2016).

Building the lighthouse on a jutting rock ridge about 50 feet (15.2 m) wide and 210 feet (64 m) long in Lake Superior waters was a challenge. First, a flat

An Isle Royale icon, Rock of Ages Lighthouse was built on a rocky islet in 1907-08. *National Park Service*

section was blasted at the west end of the rock. Anchored offshore, the lighthouse tender *Amaranth* had on her deck a large cement mixer that was used by the construction crew to mix the loads of concrete, then transfer them by scow to the Rock and use in construction, pouring them into the circular steel crib.

The U.S. Lighthouse Service described the Rock of Ages Lighthouse structure in 1912:

> *The lighthouse is of brick, with concrete trim and encloses a steel skeleton framework. It is cylindrical in shape at the base and conical for the upper part and rests upon a massive steel plate concrete-filled pier built upon the rock at about water level. The steel plates are riveted together, stiffened with angle rods, and tied back to the concrete by anchor rods. The pier is 50 feet [15.2 m] in diameter up to a point below the deck, where it is trumpet shaped, enlarging to 56 feet in diameter 30 feet [9.1 m] above the water. The lighthouse supports a cast-iron gallery, watch room and first-order straight-bar lantern.*

When the 130-foot (39.6 m) tower was completed in 1908, it was lit with a temporary third-order fixed red light and lens on October 11. Two years later, in 1910, a permanent second-order Fresnel was installed on a cast-iron pedestal and lit on September 15, 1910. The 8-foot (2.4 m) clamshell-shaped lens had four plate glass panels, each with seven refracting and 17 reflective prisms, floating on a bed of 1.5 tons of mercury turned by a brass clockwork mechanisms to give a double white flash every 10 seconds. The light had a height of 117 feet (35.7 m) above the water, was visible for 29 miles, and at the time was the largest of its kind on Lake Superior.

Four lighthouse keepers were on duty during navigation season, and lived within the 10-story lighthouse. Of the station's 10 levels, the two-story cylindrical crib were the sub-cellar and cellar which housed the water tank and boiler system that supplied steam heat throughout the levels. On the first floor was the fog-signal plant and hoisting engine for the pillar crane. On the second floor, the office; on the third, the mess room and kitchen; on the fourth, the keeper's and first assistant's rooms; on the fifth, the second and third assistant's rooms; on the sixth, the service room; on the seventh, the watch room; and on the top floor, the lantern.

Other additions over the years included a radio beacon (1929), diesel-powered electric generators (1930), and pair of Tyfon fog signals (1931).

The tower had a 120-foot (36.6 m) spiral cast-iron staircase connecting the floors. Tragically, in 1933, head keeper Emil Mueller had a heart attack, fell down the lower stairs, and landed dead on the assistant keeper C. A. McKay's bed.

In 1978, the station was automated and de-staffed. Seven years later, in 1985—a year after the station became solar-powered—the second-order Fresnel lens was removed over a five-day period and replaced with a new battery-powered solar beacon. The lens was relocated to the Windigo Visitor Center in Washington Harbor, where it continues to be on display.

BACKGROUND

The lighthouse gets its name from the Rock of Ages reef consisting of rock outcroppings in the open waters of Lake Superior. The reef presented a hazard for navigation and was the site of several shipwrecks of major vessels, like the *Cumberland* (1877), the *Henry Chisholm* (1898) and later, the *George S. Cox* (1933).

The Canadian 204-foot (62.2 m) wooden side-wheeler *Cumberland* was one of three vessels in 1872 that carried the first troops of the North West Mounted Police to Port Arthur (now part of Thunder Bay) where they began their trek out west. Five years later, the *Cumberland* was sailing from Port Arthur to Duluth on July 24, taking the route around the west end of Isle Royale, when the ship stranded on the Rock of Ages reef. A two-week effort to pull the *Cumberland* from the rocks failed; she was abandoned on August 6, 1877, and sank after a September storm broke her into pieces.

Sixteen years later, on October 18, 1898, the 257-foot (78.3 m) wooden steamer *Henry Chisholm* ran up on the Rock of Ages reef. She was so badly damaged that Captain Smith gave the order to abandon ship; everyone made it to safety in the lifeboats. The ship couldn't be saved, and during a two-day storm, the *Chisolm* broke up and sank in deep water on top of the *Cumberland* shipwreck.

Finally, after years of lobbying and more shipwrecks, the U.S. Congress appropriated funds to build the Rock of Ages Lighthouse to protect vessels from the reef. Construction began in 1907 and the light was lit in 1908.

However, even a lighthouse does not guarantee a vessel's safety. On May 27, 1933, in heavy fog near the Rock of Ages Lighthouse, the 259-foot (79 m) passenger steamer *George M. Cox* (previously named the *Puritan*) with 127 persons on board was on its way to Port Arthur when poor navigation put her off course and she crashed at high speed on the Rock of Ages reef. All the passengers and crew were rescued by the lighthouse keepers, who used the station's motorboat to tow the survivor-filled lifeboats to the station. The cold, wet survivors spent an uncomfortable night scattered up and down the winding stairway inside the tower before the U.S. Coast Guard arrived to take them to shore. It remains Lake Superior's largest successful marine rescue.

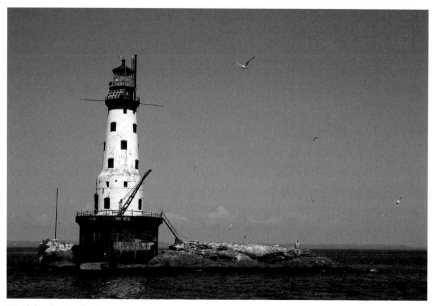

Work by the Rock of Ages Lighthouse Preservation Society is restoring the light to what it was in the 1930s. *Charles W. Bash*

The *Cox* eventually broke in two and sank not far from the *Cumberland* and *Chisholm* wrecks. All three wrecks are now popular diving sites and were listed in the National Register of Historic Places in 1984.

Lighthouse/Keeper Tales

In December 1926, the four keepers of the Rock of Ages Lighthouse made the news when they abandoned the lighthouse on Friday, December 17, because they were short of fuel and food, and had been out of tobacco for a week.

According to a Tuesday, December 21, newspaper report in the *Evening Star* (Washington, D.C.), one of the four men, Robert Morrill, braved ice-jammed Lake Superior in an open boat, hiked miles through waist-deep snow, and arrived in Duluth on the twentieth. He brought word that his three companions, whom he had left at Pigeon Post after they had made their way there in an open launch, were safe.

"We just decided to get out while the getting was good," Morrill said. "The tender was due December 12 when we were to stop our light and go home for winter. We ran the light and foghorn until noon of the 17th, when we left a note on the door and took to the launch. We landed at

Pigeon Point and stayed with William Hurst, a fisherman. I hiked 2 miles [3.2 km] to Jack Hurst's. He said he would lend me a skiff if I cared to take a chance. I started rowing the skiff Sunday from Pigeon Point to Washington Bay [Wauswaugoning Bay], four and half miles [7.2 km], and took from 8:30 a.m. to about noon. I spent the night on a little island there with a fisherman. Yesterday morning I started to cross the bay, three and half miles [5.6 km], and arrived at Hat Point at 9 o'clock. I walked from Hat Point to Mineral Center, about eight miles [12.9 km] altogether and then met four fellows in a car."

The other three men—Joseph Metiver, keeper of the Rock of Ages light, Ben Hudak of Sheboygan, Wisconsin, and Sterling Malone of Superior, Wisconsin—were still at Pigeon Point, Morrell said, but the fishing steamer *Winyah* was scheduled to call for them.

What is it like to be on the isolated Rock of Ages Lighthouse, especially in a storm?

During a 1931 interview, first assistant keeper C. A. McKay was asked that question by Detroit reporter Stella Champney. He replied, "You can't see anything but water. You can't hear anything but its roar. See that pier around the tower? It looks pretty high up and safe. Well, in a real storm, heavy green water sweeps over it. You can't even see it sometimes. You can't get away from the water even at the top of the tower. Spray sweeps over the tower windows and, when it's very cold, freezes on the glass. You can't hear anything but the boom! boom! of the seas as they sweep over the rocks, or the crack like gunfire as they hit the tower."

Is Rock of Ages station haunted? According to a 1972 newspaper article, it might be. Keeper Chuck Middleton reported that one of the doors in the tower would mysteriously open and close on its own. As the story goes, no keeper actually ever saw or had contact with any spirits, leading some to say it was a hoax, while others maintained something strange was happening in the tower.

INTO THE TWENTY-FIRST CENTURY

The volunteer non-profit Rock of Ages Lighthouse Preservation Society in partnership with Isle Royale National Park is carrying out restoration work at the lighthouse to preserve the history of the structure and bring it back to what it was in the 1930s.

Isle Royale Lighthouse

(also known as Menagerie Island Light)

LOCATION: Northwest Lake Superior, on Menagerie Island, the most easterly of the group of small islands at the opening of Siskiwit Bay, near the southern shore of Isle Royale; within Isle Royale National Park in Keweenaw County, Northern Michigan

BUILT: 1875

LIT: September 20, 1875

AUTOMATED: 1913

DE-STAFFED: May 29, 1914

COORDINATES: N 47 56 52.44, W 88 45 40.32

STATUS: Active aid to navigation in Isle Royale National Park; listed in the National Register of Historic Places in 1983

CHARACTERISTICS OF LIGHT: Flashing white every five seconds

OWNED BY: U.S. Coast Guard

MANAGED BY: National Park Service as part of Isle Royale National Park

OPEN TO PUBLIC: Grounds only

GETTING THERE: Private boat

CONSTRUCTION AND DESIGN

In 1875, the Isle Royale Lighthouse was constructed on Menagerie Island using red sandstone quarried from the Jacobsville Formation in the Keweenaw Peninsula. (The formation was named after the town of Jacobsville,

Menagerie Island's Isle Royale Lighthouse was built to serve copper miners in the 1870s. *National Park Service*

Michigan.) The lighthouse is on 3.5 acres, accessed by boat, and located about 37 miles (60.2 km) from Thunder Bay, Ontario, and 176 miles (283.2 km) from Duluth, Minnesota.

The keeper's separate dwelling was rectangular, had rubble walls, a wood-shingled hip roof (a new roof was installed in 1986), and was connected to the 61-foot-tall (18.6 m) rough stone tower by a covered passageway about 8.5 feet (2.6 m) long. The dwelling had eight rooms and housed the head keeper, his family, and the assistant keeper. To protect the window areas during severe storms, steel shutters were installed.

The whitewashed white tower, octagonal and pyramidal in shape, had a diameter of 16 feet (4.9 m) at its base, tapering to 10 feet 9 inches (3.27 m) at the top. At the base, the thickness of the outer wall was 40 inches (101.6 cm), with air space of 2 inches (5.1 cm) and an inner wall thickness of 8 inches (20.3 cm); at the parapet, the thickness of the outer wall was 10 inches (25.4 cm), air space of 2 inches (5.1 cm) and inner wall of 4 inches (10.2 cm).

The tower was topped by an octagonal iron lantern with 10 sides surrounded by a cast-iron gallery. Both gallery and lantern were painted black. A circular cast-iron staircase inside the tower went to the three levels and the cast-iron lantern room, which was accessed by a trapdoor. The illuminating apparatus was a fourth-order Fresnel lens made by the famous Fresnel lens maker Henry-Lepaute & Sons of Paris, which beamed a fixed white light at a focal point of 75 feet (22.9 m) above water and visible for 15.5 miles (25 km).

In 1906, a concrete-block oil storage building with a capacity of 500 gallons (1,892.7 l) was completed on the island.

In 1914, a major change took place at the lighthouse. On May 29, with the installation of an acetylene light with an automated sun valve producing a flashing white light every five seconds, the lighthouse was automated and the keepers removed from Menagerie Island.

Fourteen years later, in October 1928, duplicate lighting equipment was installed after the light went out and the keeper at Grand Marais Light traveled by commercial steamer to reactivate the light. The duplicate light was mounted outside on the lantern deck, while the main acetylene light was in the Fresnel lens; the two lights flashed in unison. They were fueled by six 180-cubic-foot compressed acetylene tanks located in the base of the tower, with two additional spare tanks placed outside the base that would automatically go into use if the main gas supply was depleted.

In 1941, the acetylene equipment was replaced by a 12-volt battery-powered lighting system, and 52 years later, in 1993, a solar-powered system was

installed at the lighthouse. The Fresnel lens had been removed. The current plastic optic lens (2018) is a 12-inch (30.5 cm) Tideland Signal (ML-300) Acrylic Optic.

BACKGROUND

When the second copper mining boom on Isle Royale began in 1873, ships once again came to the Isle Royale harbors, including Siskiwit Bay. It was this new mining boom that led to the construction of the second lighthouse on Isle Royale, this time on Menagerie Island, the most easterly of the group of islands at the entrance to Siskiwit Bay where the Island Mine was located.

In addition to guiding ships into harbor, the Isle Royale Lighthouse provided a warning to Lake Superior traffic of the existence of the island's south shore.

Keeper Tales

In September 1875, William Stevens was appointed the first acting keeper and his wife, Mary Ann, as the first acting assistant keeper on the remote, rocky island. Just over a month later, on October 26, 1875, they experienced their first brutal Lake Superior storm on Menagerie Island. Stevens wrote in his logbook:

"Damp and cloudy. The East northeast gale increased almost to hurricane. At 6 am the sea went clear over [the tower], rocks and broke the window sashes on south side of the house. Washed away everything loose, lumber, wood, rock off the island."

A year later, on November 18, 1876, Stevens and his wife were permanently appointed to their positions. Two years later, Stevens accepted a transfer on August 9, 1878; the couple had served at Isle Royale Lighthouse for three years.

John H. Malone took over as keeper in 1878 and stayed for 32 years; his brother James became the assistant keeper. In 1880, Malone, who was single at age 33, was told the lighthouse service preferred married keepers, so he went to Hancock, Michigan, met 19-year-old Julia Shea, and they were married on July 13. The couple had 12 children, one of whom died at birth. The family would spend summers at the lighthouse and return to the mainland after the close of the navigation season to spend the winter in Duluth.

Like many other lighthouse keepers, Malone's logbook entries throughout the years often commented on the weather. On October 16, 1880, he wrote: "Hail, snow and rain—a tempest; lost boat, boat house ways and dock. It was impossible to save anything."

Four years later, on November 10, 1884, he remarked, "It is almost impossible for us to stay here much longer for we have to cut ice from the way every day or we could not launch our boat, the only hope we have of getting off for winter quarters."

Arriving to open the lighthouse on a cold spring day, he remarked on May 11, 1885: "Arrived here at 12 o'clock and commenced lighting up. We had to keep three stoves going night and day steady to heat up in the house. It was just like an ice house. The lake is full of ice and the weather is very cold."

It was so cold on November 4, 1885, that Malone wrote: "This must be the North Pole."

During the summer, to supplement the supplies delivered by the lighthouse tender, the family kept a small garden of lettuce and radishes on Menagerie Island and a potato patch on nearby Wright Island. Along with the assistant keeper, Malone went fishing for lake and brook trout, and went hunting for ducks, rabbits, and prairie chickens. A main staple in their diet was the seagull eggs they gathered. In May 1886, Malone reported more than 1,000 eggs were collected during nesting season, and a year later by early June 1887, 1,478 eggs had been collected, some traded with crews of passing ships.

After 32 years as the keeper and at 65 years of age, John H. Malone accepted a transfer in 1910 to Pipe Island Lighthouse on St. Mary River. His eldest son, 29-year-old John A. Malone, took over as keeper for Isle Royale Lighthouse for two years, from 1910 to 1912, followed by Klass Hamringa, from 1912 to 1913, and the last keeper, Lee Benton, in 1914.

Shipwreck Tales

In his book *Lake Superior Shipwrecks*, author Julian Wolff called the November 7, 1885, shipwreck of the 262-foot (79.8 m) luxury passenger propeller *Algoma* at the northeast end of Isle Royale, the "most ghastly catastrophe in the history of the Lake Superior sailing."

Built in Scotland and launched in 1883, the *Algoma* was considered the "pride of the Canadian merchant marine" along with fleet mates *Alberta* and *Athabasca*.

On November 5, 1885, *Algoma* left Owen Sound on Georgian Bay, Ontario, and headed for Port Arthur (now Thunder Bay) in western Lake Superior, and the next day cleared the Soo Locks at about noon. About halfway across Lake Superior, she ran into a blinding snowstorm and gale force winds. When she began rolling hard, the sails were set to steady her. On the open lake under both sail and steam, *Algoma* was making about 15 miles per hour (24.1 kmh), but unbeknownst to Captain John Steed More and crew, she was drifting off course and moving dangerously close to Isle Royale.

The red sandstone used in construction was quarried on Michigan's Keweenaw Peninsula. *Charles W. Bash*

At about 4:00 a.m., the captain ordered the auxiliary sails taken down and a change of course. Then, about 40 minutes later, the *Algoma* struck the reef off Greenstone Island (now called Mott Island) on northeast Isle Royale. The heavy seas drove her further on the rocks, perching her stern on a ledge about 25 feet (7.6 m) from shore and 75 feet (22.9 m) above the water, while her bow was submerged. Stranded, the *Algoma* broke in two around 6:00 a.m.

While 14 survived the ordeal, including the injured captain, 46 were swept away and died in Superior's cold waters. It was the largest loss of life in the maritime history of Lake Superior.

On November 9, the survivors were rescued by the passenger steamer *Athabasca*.

Keeper Malone mentioned the shipwreck tragedy in his logbook before closing the lighthouse for the 1885 season. When he returned on May 12, 1886, to re-open Isle Royale Lighthouse, he wrote in the logbook about some "boats passing with loads of furniture from Algoma—chairs, lounges, bedsprings and feather pillows." And on June 25, 1886, he recorded finding on Menagerie Island "4 life-preservers on the beach abreast our station belonging to the ill-fated steamer *Algoma*. Also found a couple of small pieces of a piano."

INTO THE TWENTY-FIRST CENTURY

It is reported that the Isle Royale Light buildings are in fairly good condition.

Rock Harbor Lighthouse

LOCATION: Northwest Lake Superior, on the northeast corner of mainland Isle Royale at the south side of Middle Island Passage, on Indian Head Point, at the southwest entrance into Rock Harbor; located within boundaries of Isle Royale National Park, Michigan

BUILT: 1855

LIT: 1856

DISCONTINUED: 1859

RELIT: 1874

EXTINGUISHED: 1879

COORDINATES: N 48 5 21, W 88 34 45

STATUS: Inactive; listed in the National Register of Historic Places in March 1977

OWNER/MAINTAINED BY: United States National Park Service

OPEN TO PUBLIC: Tower open daily during summer

GETTING THERE: Accessible by paddling, hiking trail, boat and/or Isle Royale National Park ranger-led hiking tours

CONSTRUCTION AND DESIGN

Built in 1855 and lit in October 1856 by the first lighthouse keeper Mark Petty, Rock Harbor Lighthouse is a combined rubble stone building with a one-and-a-half-story keeper's dwelling attached to the 50-foot (15.3 m) tower by a short passageway from the house's first floor.

The 29-foot (8.9 m) square keeper's house stood 20 feet 9 inches (6.3 m) on a stone foundation, gabled-roof of cedar shake shingles and two brick chimneys.

First lit in 1856, Rock Harbor Lighthouse was abandoned in 1879. *National Park Service*

The conical tower was 16 feet 11 inches (5.2 m) in diameter that tapered to 14 feet 1 inch (4.3 m) at the base of the lantern. Within the conical tower was a spiral pine staircase ascending on a pine post to a trapdoor in the circular gallery floor to provide access to the lantern and lamp. The cast-iron lantern had eight vertically-set rectangular panels (six of glass and two of iron), and a domed copper roof. The original light was a fixed white light from a fourth-order Fresnel lens, visible for about 14 miles (22.5 km) from a height of 70 feet (21 m) above the water.

BACKGROUND

Copper exploration and mining began on Isle Royale after the signing of the Treaty of LaPointe in 1843 with the Chippewa Nation. By 1847, more than a dozen mining companies had established sites on the island and commercial fishermen were using the island as a base of operations. They pressured the government for a light on Isle Royale to guide and protect the ships arriving with supplies. With increased shipping traffic already expected as a result of the opening of the locks at Sault Ste. Marie, Michigan, in 1855 the U.S. Lighthouse Board decided to place the first light on Isle Royale, the Rock Harbor Lighthouse, at the entrance of Rock Harbor.

When shipping declined with the decrease in mining activity in the late 1850s, the U.S. Lighthouse Board de-commissioned Rock Harbor Lighthouse. On August 1, 1859, keeper Francis Bomassa extinguished the light and closed the station.

A second surge in mining interest in the 1870s brought shipping traffic back to the island and the Lighthouse Board made plans to put Rock Harbor Lighthouse back in operation. After work crews repaired, refurbished, and switched the fixed white light to fixed red, and upgraded the station, the light was relit on August 15, 1874 by keeper Anthony Kruger.

Just over five years later—when copper mining again decreased and the new Isle Royale Lighthouse was established on October 19, 1875, at Menagerie Island—the U.S. Lighthouse Board again de-commissioned Rock Harbor Lighthouse. On October 4, 1879, the light was permanently extinguished by the last keeper, Martin B. Benson, and the light station was abandoned.

AFTER THE LIGHT WAS EXTINGUISHED

Though the lighthouse was abandoned in 1879, it was used for a time as a sheltered campsite for vacationers and researchers. Louis O. Broadwell, author

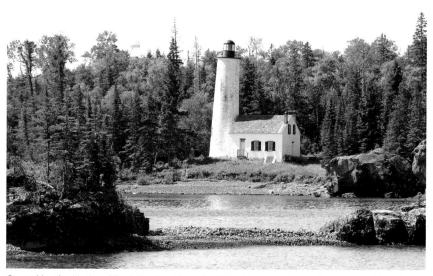

Owned by the National Park Service, the refurbished keeper's house is a popular historical exhibit. *Charles W. Bash*

of *The Guardian of the Isles* (Detroit, 1929), took up residence at the station for a number of summers until leaving in 1915.

Thirteen years later, in 1928, two commercial fishermen, brothers Arnold and Milford Johnson and their families, used the old abandoned lighthouse as a base of operations and shared living quarters. As the story goes, Arnold and his wife Olga lived on the first floor while Milford and wife Myrtle lived on the second floor. Fishing partners for 25 years, they used the lighthouse until 1939. The following year, Isle Royale National Park was established on April 3, 1940, and included Rock Harbor Lighthouse in its boundaries.

In the 1950s, the tower began to tilt. The National Park Service (NPS) stabilized the tower in 1962, leaving it with only a two-degree tilt. NPS also used cement products to "pressure grout" the tower's hollow interior walls, and replaced the original wood roof with asphalt. More restoration work was done in the following years, bringing the keeper's house back to its original appearance.

Today, the refurbished Rock Harbor Lighthouse is one of the most popular island stops for tourists. Besides being the first lighthouse built on Isle Royale, it is also one of the oldest surviving lighthouses on the Great Lakes. It is the only lighthouse on the mainland of Isle Royale, and the only one of Isle Royale's four lights to be extinguished.

In 1995, the refurbished lighthouse keeper's house became the Rock Island Lighthouse maritime exhibit featuring all four of the lighthouses and its 10 major shipwrecks.

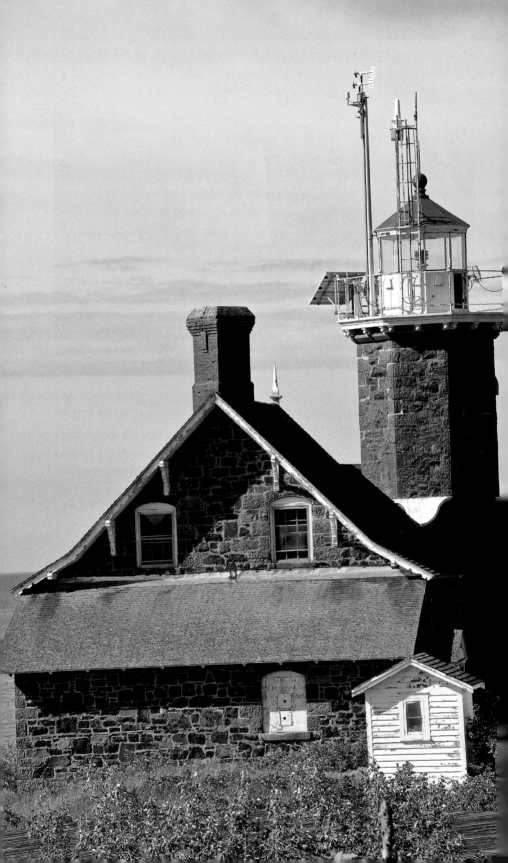

Passage Island Lighthouse

LOCATION: Northwest Lake Superior, on the southwest point of
Passage Island, Michigan, 3.25 miles (5.23 km) NE of Isle
Royale, 18 miles (29 km) from Ontario shore

BUILT: 1881–1882

LIT: July 1, 1882

AUTOMATED/DE-STAFFED: December 20, 1978

COORDINATES: N 48 13 27, W 88 21 57

STATUS: Active aid to navigation; listed in the National Register of
Historic Places in 2006

CHARACTERISTICS OF LIGHT: Flashing white light every five seconds

OWNED BY: U.S. Coast Guard

SITE MANAGER: U.S. National Park Service as part of the Isle Royale
National Park

PUBLIC ACCESS: Site only; tower closed

GETTING THERE: Accessible by water

CONSTRUCTION AND DESIGN

Construction of the Passage Island Lighthouse began in the summer of
1881 on a rocky cliff by the water's edge. It was completed in 1882 and the
light was lit on July 1, 1882. It was, and continues to be, the most northerly
American lighthouse on the Great Lakes.

The one-and-a-half-story keeper's quarters, which was 26 feet by 30 feet (7.9
m by 9.1 m), and tower were built of red rubble sandstone and has been called
"castle-like" in appearance. Considered among the most beautiful lighthouses

An extraordinary structure, the "Norman Gothic" architecture of the Passage Island
Lighthouse makes it one of the most beautiful lights on Lake Superior. *National Park Service*

on Lake Superior, its "Norman Gothic" architecture style is identical to the Sand Island Lighthouse built in 1881 near the western end of the Apostle Island chain in southern Lake Superior.

Its design was somewhat unusual in that the 44-foot (13.5 m) octagonal cylindrical light tower was placed in the corner of the keeper's dwelling, rising up from a square base, then transitioning into an octagon at the second-floor level. The tower was topped with a gallery and a 10-sided cast-iron lantern, which had been fabricated at the Lighthouse Depot in Detroit, shipped in sections to the site, reassembled, placed atop the tower, and was accessed by a spiral iron staircase within the tower.

The original light was a fourth-order Fresnel lens built by Barbier, Benard & Turenne of Paris, and exhibited a fixed red light utilizing an oil-fired lamp burning inside the lens. The light was visible for 17 miles (27.4 km) and had a focal plane of 78 feet (24 m).

The station was originally equipped with a mechanical 1,500-pound (680.4 kg) fog bell with a clockwork striking mechanism. It was replaced two years later by a 10-inch (25.4 cm) steam-powered whistle fog signal put into operation October 25, 1884. It was housed in a frame structure with corrugated metal on the exterior, smooth steel in the interior, and insulated with lime and sawdust.

On September 12, 1897, the original Fresnel lens was removed and replaced with a new fourth-order Fresnel lens manufactured also by Barbier, Benard & Turenne, exhibiting a flashing white light. The original fourth-order Fresnel lens was sent to Detroit for display at the Dossin Great Lakes Museum.

In 1928, the Passage Island light was electrified and 50 years later, in 1978, the station was fully automated with the installation of a solar-powered electric bulb within the Fresnel lens. Eleven years later, in 1989, the Fresnel lens was replaced by a 7.5-inch (19.1 cm) modern solar-powered optic with a white flash every five seconds, and an electronic horn. The Fresnel lens, which had been installed in 1894 as the station's second Fresnel lens, is on display in the lobby of the Portage Coast Guard Station in Dollar Bay, Houghton, Michigan.

BACKGROUND

As early as the 1860s, mariners and the U.S. Lighthouse Board had identified the need for a lighthouse on Passage Island to mark the northern edge of the narrow, 3.25-mile-deep (5.2 km) water channel between Passage Island and the northern tip of Isle Royale. There had been a dramatic increase in the number of ships traveling the passage due to the discovery of the rich silver deposits at Ontario's Silver Islet—which became the world's richest silver mine—and

the increase in the Canadian grain trade, most being Canadian ships traveling to and from the ports of Port Arthur and Fort William (now the city of Thunder Bay, Ontario). And therein lay a problem.

Passage Island, Isle Royale and the surrounding islands and waters belonged to the United States, but it was Canadian

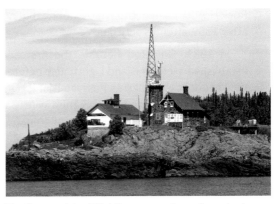

The Passage Island Lighthouse remains an important navigational aid for vessels visiting the port of Thunder Bay. *Charles W. Bash*

ship traffic that would benefit most from the construction of the Passage Island Lighthouse. In 1875, U.S. Congress appropriated $18,000 to build the lighthouse with the condition that Canada reciprocate by constructing a lighthouse that would benefit American shipping on Canada's Colchester Reef near Detroit River on western Lake Erie. In 1880, when the U.S. determined that sufficient progress had been made by Canada on the lighthouse, U.S. Congress released the funds for construction of Passage Island Lighthouse. A year later, in the summer of 1881, construction began, and was completed in 1882. Canada's Colchester Reef Light was completed in 1885.

The Passage Island Light marks the navigable channel in the strait between Passage Island and Isle Royale, and continues to be an important aid to navigation along the principal shipping route between Thunder Bay and the locks at Sault Ste. Marie, Michigan.

Keeper Tales

Robert Singleton was the second acting keeper on Passage Island and a pioneering copper miner. Born in 1820 in Lancaster, England, he had come to the Lake Superior area at age 29 and married Margeurite Webanbonok from Fort William First Nation on September 17, 1849. They lived at Todd Harbor on Isle Royale where Singleton worked at the copper mines and where four of their five children were born (two of his sons later became leaders in the Fort William First Nation). In his book, *Minong: The Good Place Ojibwe and Isle Royale*, author Timothy Cochrane wrote that Singleton may have been an unofficial lighthouse keeper at

Rock Harbor Light in the 1850s, noting that he left the island sometime after 1859, after his wife died.

In 1881, Singleton became the first keeper of Canada's newly established Victoria Island Lighthouse before leaving a year later to be the keeper at Isle Royale's Passage Island Light in September 1882. He was joined on the island by his third wife, 35-year-old Mary (Bushee) Singleton and their three young children. (His second wife, Ann, had died in 1872 at age 29.)

In May 1883, 63-year-old Singleton went to Port Arthur to buy supplies and was struck and killed by a train. A headline in a local newspaper read, "Terrible Accident: The Oldest Pioneer of the North Shore Run Over By a Train and Killed" (*Thunder Bay Sentinel*, May 26, 1883). His death left his family stranded on Passage Island Lighthouse, and they were removed within a month.

After Singleton's death, William F. Demant took over keeper duties on June 19, 1883, and together with his wife and children decided to spend the winter at the lighthouse. Once the navigation season closed, he left his family on Passage Island while he went to Port Arthur to get supplies for the winter. As the story goes, while he was on the mainland, severe cold set in and treacherous ice conditions made his return impossible, leaving his family to spend the winter stuck on the isolated island. Though they had plenty of wood for fires, they battled hunger, barely surviving by snaring rabbits and fishing. When Demant returned to the island in spring of 1884, he found his family close to starvation. Nonetheless, Demant and his family continued living on Passage Island for another decade.

Shipwreck Tales

The lighthouse keepers at Passage Island played a key role in the dramatic rescue of survivors after the Canadian passenger cargo steamer *Monarch* slammed into the northeast tip of Isle Royale.

The 259-foot (78.9 m) *Monarch*, with 42 people on board, had departed Fort William (now Thunder Bay, Ontario) for Sarnia at about 5:25 p.m. on Thursday, December 6, 1906, after taking on a cargo of oats, salmon, wheat, flour, and general merchandise on its last voyage of the season. It was already dark when she headed out into a snowstorm and strong, gusty winds. When the *Monarch* reached Thunder Cape at 6:48 p.m. and changed course toward Passage Island, weather conditions had deteriorated even further with heavy snow, fog, gale

force northwest winds, rough seas, and visibility of about 50 feet (15.2 m). Just after 9:00 p.m., the *Monarch* was several miles off course when she crashed at full speed into the solid rock wall known as the Palisades near Blake Point on Isle Royale.

Except for the 18-year-old watchman, J. Jacques, who drowned, all the passengers and crew safely reached the rocky shore by escaping the sinking ship using the line secured to shore by deckhand James D. McCallum. The survivors huddled in the bitter cold around bonfires to keep warm, set up a makeshift shelter, cooked food salvaged from the ship, and hoped the fire's smoke would get the attention of the lighthouse keepers on Passage Island.

The keepers, who knew that part of the island was uninhabited, saw the smoke, but because of the raging storm, had to wait three days before the first assistant keeper, Klass Harmenga, took the station's open boat to row about four miles (6.4 km) in rough waters to the shipwreck site. As he couldn't land at the Palisades, he pulled in close enough for the *Monarch*'s purser, Reginald Beaumont, to reach the boat and together they rowed back to the Passage Island Light.

Once back at the lighthouse, the steamer *Edmonton*, downbound from Port Arthur, was signaled to stop. Unable to assist the other survivors as she could not get close to the wreck, the *Edmonton* immediately returned to Port Arthur for aid with Beaumont on board, and arrived at about 2:00 a.m. By 6:00 a.m. the tugs *James Whalen* and *Laura Grace* were on their way to Isle Royale to rescue the others. The cold and exhausted survivors—who had been shipwrecked for four days—arrived back in Port Arthur on Monday, December 10, at around 9:00 p.m.

INTO THE TWENTY-FIRST CENTURY

While the wreck of the *Monarch* has disintegrated, large pieces of the wooden wreckage are scattered on the bottom of the lake at depths of 10 to 80 feet (3 to 24.4 m) and the cargo is still lying near the wreck. It remains a popular dive site.

The Passage Island Lighthouse is now part of the Isle Royale National Park and still serves as an active aid to navigation. In 1996, the lighthouse was declared surplus by the U.S. Coast Guard and was subsequently transferred to the National Park Service as part of Isle Royale National Park.

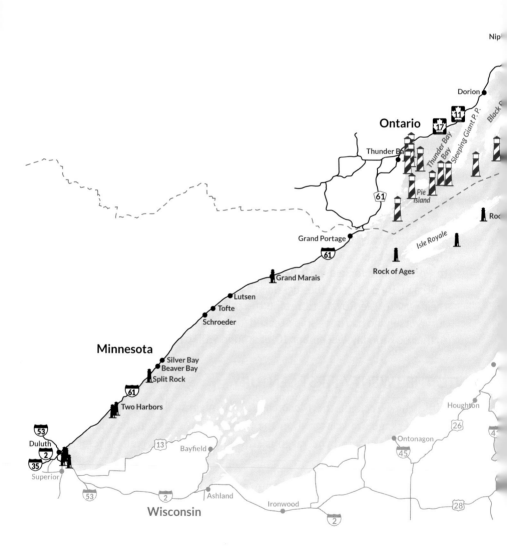

Ontario West

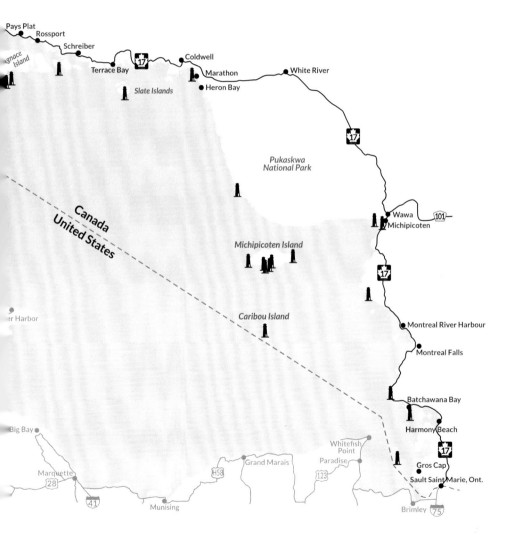

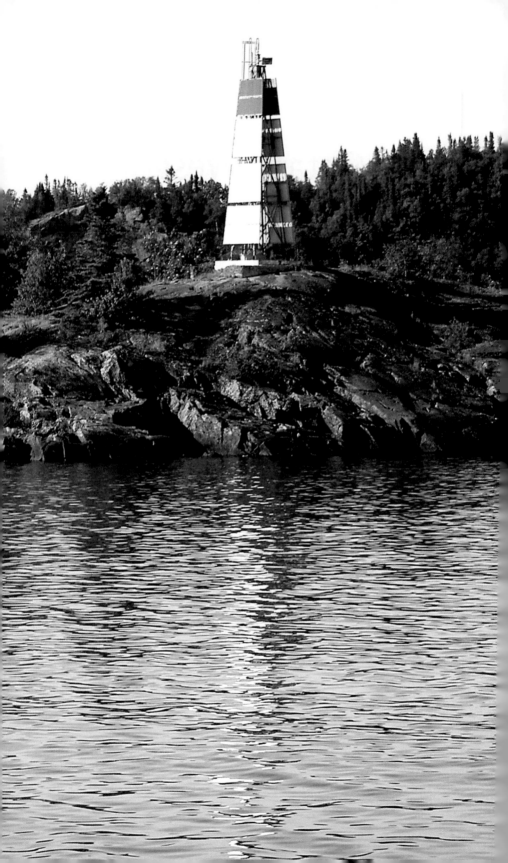

Victoria Island Lighthouse

LOCATION: Western Lake Superior, at the end of the point, northwest end of Victoria Island, about 30 miles (48 km) southwest of the city of Thunder Bay

BUILT: 1881, 1887, 1905

LIT: 1881

AUTOMATED: 1970s

COORDINATES: N 48 04 53, W 89 21 37

STATUS: Active seasonal aid to navigation

CHARACTERISTICS OF LIGHT: Flashing white every four seconds

OWNED BY: Fisheries and Oceans Canada

OPEN TO PUBLIC: Yes

GETTING THERE: Accessible by boat

CONSTRUCTION AND DESIGN

From Canadian government reports, it seems there was a temporary light placed on Victoria Island in 1881. According to their Marine Report of 1882, "By Departmental letter of 9th May 1881, Mr. Richard Singleton was placed in temporary charge of the light at Victoria Island, Lake Superior at salary of $150 per annum." (A year later, in 1882, Singleton, an English citizen, became the lighthouse keeper at the newly constructed American Passage Island Lighthouse at Isle Royale.)

In the Government of Canada's 1888 Sessional Papers, it was reported that the construction work was completed on the island in the 1887 season:

The Victoria Island Lighthouse marks an inside passage between a string of islands and mainland southwest of Thunder Bay. *Great Lakes Lighthouse Keepers Association*

A tower and dwelling house were built on Victoria Island, Lake Superior, as contemplated, and the light put in operation last autumn, the temporary light up to that time shown hoisted on a pole being at the same time discontinued. The light is fixed white, elevated 89 feet [27.1 m] above the lake, and visible fifteen miles [24.1 km] all around horizon, except where intercepted by trees or the north and east parts of the island. The illuminating apparatus is dioptric of small size. The tower is a square wooden building painted white, surmounted by an iron lantern painted red. It stands upon a high rock rising abruptly from the low ground near the western extremity of the island. The building is 30 feet [9.1 m] high from the rock to the vane on the lantern. The keeper's dwelling and outbuildings, also of wood painted white, stand on the lower ground to the south and westward of the tower. The work was done under contract by Mr. John George the contract price being $2,773. Total expenditures in connection with work amounted to $3,949.12.

In September 1904, the lighthouse was being moved to another location when it was damaged beyond repair after a windstorm blew it over. It was replaced the following year with a square 30-foot, (99.1 m) wooden tower with a red and white daymark.

In 1909, repairs were made to the tower. Later, the light was moved to a skeletal tower almost 30 feet (9.1 m) tall with a red and white rectangular daymark. Characteristics of the light was flashing white every four seconds from a height above water of 45 feet (13.7 m) and visible for 14 miles (22.5 km) from all points of approach on the inside channel and from the westward.

The lighthouse was closed in the 1970s, but the light continues to be operational as an active seasonal aid to navigation, flashing white every four seconds with a focal plane of 59 feet (18 m). The light is situated on a square tower with two red and white daymarks.

BACKGROUND

Victoria Island is the southernmost of a long series of small islands stretching northeasterly from Little Trout Bay south of Thunder Bay on Lake Superior almost to Thunder Cape.

The Canadian government built Victoria Island Lighthouse to mark the narrow inside channel between the mainland and the group of islands.

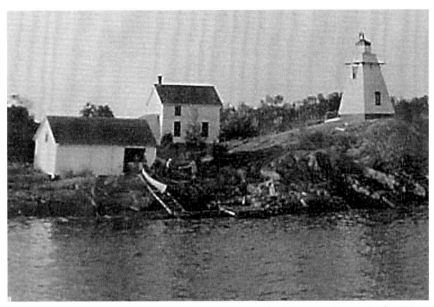

The Victoria Island Lighthouse, keeper's quarters and outbuildings cost just under $4,000 to construct in 1887. *Larry Wright*

Shipwreck Tales

On June 13, 1921, the 115-foot (35.1 m) wood tug *Howard* ran aground on the north side of the reef at the west end of Victoria Island, southwest of Thunder Bay and about 17 miles (27.4 km) northeast from Grand Portage, Minnesota. Built in 1864 in either Wilmington, Delaware, or Philadelphia as *Admiral D. D. Porter* and renamed *Howard* in 1889, the vessel was a former navy gunboat and transport.

After stranding on the reef, the first mate rowed a lifeboat to shore at Cloud Bay and then hiked along Highway 61 for assistance. A tug was dispatched to the *Howard*, and as the tug started to pull her off the reef, the *Howard* sank at the stern and continued on to the bottom of Lake Superior. Some accounts report she was on fire when she sank, but the shipwreck does not show heavy fire damage.

At the time of the accident, the *Howard* appeared to be the oldest vessel operating on Lake Superior.

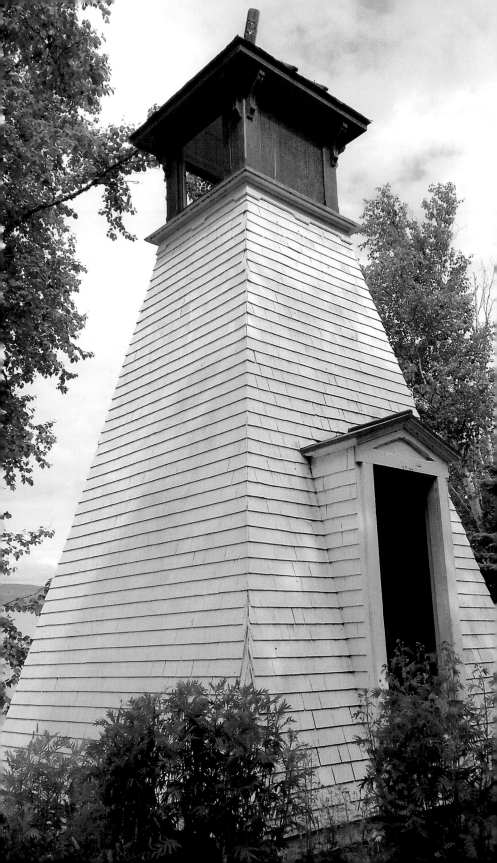

Pie Island Lighthouse

LOCATION:	Western Lake Superior, on the north point of Pie Island at the entrance to Thunder Bay
BUILT:	1895
REBUILT:	1904
LIT:	September 15, 1895
COORDINATES:	N 48 13 46, W 89 10 26
STATUS:	Active aid to navigation; seasonal; lighthouse inactive and abandoned since 1953
CHARACTERISTICS OF LIGHT:	Flashing white light every four seconds on skeletal tower
OWNER:	Pie Island is part of a land claim and is in the process of part of the island being returned to Fort William First Nation; light is owned by Fisheries and Oceans Canada
OPEN TO PUBLIC:	Site open; tower closed
GETTING THERE:	Accessible only by water

CONSTRUCTION AND DESIGN

The original lighthouse was constructed in 1895, 29 feet (8.8 m) above the lake level on the rocky shore at the western entrance to Thunder Bay, south of the wharf which extended 500 feet (152.4 m) at right angles to the shoreline. It was a square pyramidal wooden tower, painted white, tapering upward 23 feet (7 m) from base to vane.

A red lantern on top of the tower displayed a fixed white dioptric lighting using a seventh-order lens from a 34-foot (10.4 m) focal plane and visible

The original lighthouse at Pie Island was moved once and later replaced by a steel tower in 1953. Paul Morralee

for 10 miles (16.1 km) from all approaches except the east. The keeper's house was white and to the northeast of the tower. The station was equipped with a hand-operated foghorn to respond to signals from vessels.

In 1904, the lighthouse was moved from the west side to the northern point of Pie Island, and in 1921, the light was automated.

In 1953, the wooden tower was replaced by a 23-foot-tall (7 m) steel tower topped by a red lantern. The original lighthouse was left standing, but abandoned. In 1982, the light was moved to a 25-foot (7.5 m) square skeletal tower with a red and white rectangular daymark.

Today, the light on Pie Island is displayed from a cylindrical mast with a red and white rectangular daymark. The characteristic of the light is a flashing white every four seconds visible for five miles (8 km).

BACKGROUND

Pie Island is about 7.5 miles (12 km) long and five miles (8 km) wide, about 18 square miles (42 square km) and is located about six miles (9.7 km) south of the city of Thunder Bay, 13 miles (21 km) north of Isle Royale. An interesting anomaly, known as the Peeking Woman, appears when a boat passes the island. Briefly, you can see a woman peeping out from behind the plateau, then disappear as the boat passes.

Indigenous people called the island *Mahkeneeng*, meaning "Tortoise," because they considered it was shaped like a tortoise. To the French it was known as *Ile Pate* or simply *Le Pate*, because the plateau shape looked like an inverted meat pie. The English then translated the French name to Pie Island.

Before the lighthouse was built, there had been silver mines and mining companies on the island, including one operated by the Pie Island Silver Mining Company, as well as a hay farm in the late 1880s.

Keeper Tales

In the early 1900s, Pie Island was in the media spotlight when two keepers of the Pie Island Lighthouse met tragic endings. In 1906, two First Nations men came to the island to bring provisions to 69-year-old Thomas Hamilton, who lived alone and had been the lighthouse keeper since 1899. Unfortunately, when they arrived, they discovered Hamilton's body and estimated he had died about 10 days before their arrival.

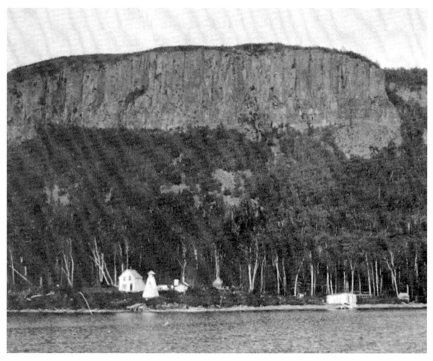

Two elderly lightkeepers died on separate occasions in the early 1900s at the Pie Island Lighthouse. *Library & Archives Canada*

In 1908, James "John" Forbes took on the keeper's job at Pie Island and three years later met an untimely and mysterious death. On October 21, 1911, the *Syracuse Journal* reported that Forbes had been murdered by two men who, after drinking a gallon cask of wood alcohol (which was used to clean the light at the lighthouse) died, and their bodies were found in a cabin in a nearby bay.

However, the death registration for Forbes implied another story. It lists the 75-year-old Forbes, occupation "lighthousekeeper" as having died on October 16 at McKellar General Hospital in Fort William (present-day Thunder Bay, Ontario) due to "excessive drinking of whiskey and wood alcohol" resulting in "alcoholic poison." (Wood alcohol was used to clean the light at the lighthouse.)

Strange Tales

Mermen and murder add to the mystery of Pie Island. One hundred and thirteen years before the lighthouse was built, voyageurs of the fur trade's North West Company reported strange sightings of a sea creature—a merman—in the waters around Pie Island. The best-documented sighting took place on May 3, 1782, and was seen by Venant St. Germain, who felt so troubled by the sighting that 30 years later he went to the King's Bench Court in Montreal to sign an affidavit dated November 13, 1812, to legally record the incident.

According to St. Germain, he was camped at the south end of Pie Island on a clear night when just before sunset he observed an "animal" that appeared to have the upper body of a child about seven or eight years old, with a brownish complexion, arms elevated with what appeared to be fingers on the hands, bright eyes, and features of a human face, about 75 yards (68.6 m) offshore. The merman was also seen by the three men and the Ojibwe woman accompanying St. German. It was the woman who stopped St. Germain from shooting the merman, warning him it may have been "Manitou Niba Nibais" (Nebaunaubay), the God of the Waters and Lakes, who had one of his residences near Pie Island.

In his deposition, St. Germain noted that he had learned "from another voyageur, that an animal exactly similar to that which deponent described, had been seen by him on another occasion when paddling Pate [Pie Island] ..."

INTO THE TWENTY-FIRST CENTURY

Most of Pie Island—including the nature reserve and the lighthouse property, but not the privately-owned land—is in the process of being transferred to the Fort William First Nation as part of a historic land claim.

The Pie Island light is now a solar-operated light on a pole and continues to be maintained by the Canadian Coast Guard.

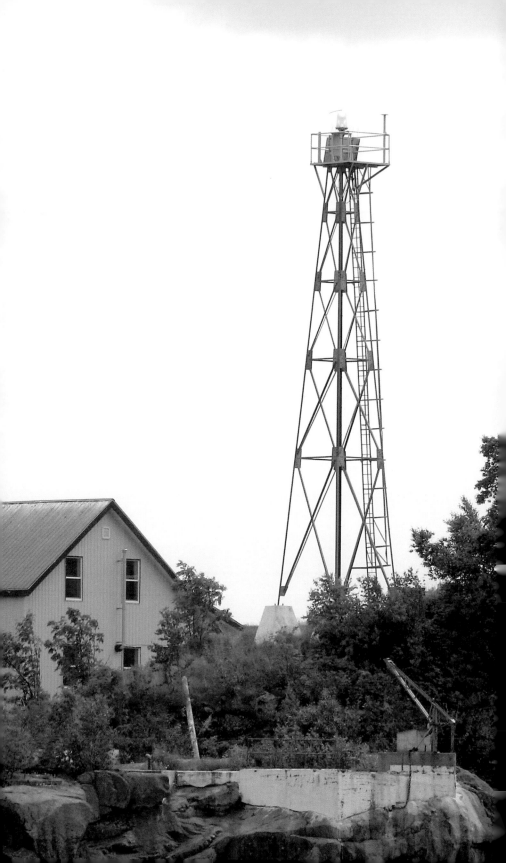

Angus Island Lighthouse

LOCATION: Northwest Lake Superior, near the north end of the small Angus Island, on west side of the 6.8 mile-wide (11 km) entrance to Thunder Bay between Trowbridge Island and Angus Island

ESTABLISHED: Placed in commission on November 21, 1927

AUTOMATED: 1988

COORDINATES: N 48 14 09.5, W 89 00 23.5

STATUS: Active; white flash every 10 seconds

OWNED BY: Fisheries and Oceans Canada

OPEN TO PUBLIC: Site open; tower closed

GETTING THERE: Accessible only by boat or helicopter/float plane

CONSTRUCTION AND DESIGN

The original Angus Island Lighthouse was a white wooden two-story frame dwelling (later replaced with a duplex) with open front veranda, topped with a hip roof and simple pipe railing. On top was a square white wooden lantern with a red roof, with a flashing white light every 30 seconds (later changed to 20, then 10 seconds) at an elevation of 70 feet (21.3 m) with focal plane of 81 feet (24.7 m) and visibility of 16 miles (25.7 km). The contractor for the lighthouse was Kurt Justin of Port Arthur (now part of the city of Thunder Bay) for $14,800.

In 1967, a 34-foot (10.4 m) skeleton tower replaced the original wooden tower; today's skeleton tower is 52 feet (15.9 m).

The end of the 1988 navigation season was also the last year of keepers on Angus Island.

The original Angus Island Lighthouse is gone except for its foundation. This modern, automated light now serves as a beacon for mariners. *Charles W. Bash*

BACKGROUND

After the locks opened at Sault Ste. Marie, Michigan, in 1855, commercial shipping traffic greatly increased on Lake Superior, and Angus Island was on the route into the Lakehead ports. As a navigational aid to mark the shipping route into those ports, the Angus Island Lighthouse was established in 1927.

Boats like the tug *James Whalen* transported the keepers to and from the island until 1961, when the Canadian Coast Guard icebreaker *Alexander Henry* was equipped with a helicopter and used to lift the keeper, his family, and supplies to the island. By the 1980s, a helicopter from Thunder Bay transferred keepers directly.

As one newspaper article in 1961 reported, "Gone are the days when they [keepers] and their supplies were put ashore and left by bullwork and laborious drudgery to get their gear up the rocky, ice-encrusted precipices as best they could."

Shipwreck Tales

The waters run deep by Angus Island, around 400 feet (122 m) in places a short distance from shore, and there are dangerous rock outcroppings. By the time the lighthouse was built in 1927, the island had already become the site of two famous shipwrecks, the *Monkshaven* in November 1905 and the *Leafield* during the "White Hurricane" November storm of 1913.

On November 27, 1905, during the brutal three-day Maafta storm (named after the 430-foot (131 m) *Maafta* steamship that sank in Duluth during the storm), the 249-foot (75.9 m) steel turret "three-island steamer" *Monkshaven* of the Algoma Central Line was carrying a cargo of steel rails when her bow was pushed by a monstrous wave onto rocks near the shore of ice-covered Angus Island. Captain Robertson and his 20 crew members scrambled onto the island where they huddled together under a makeshift shelter, enduring sub-freezing temperatures and bitter blowing winds for the next 96 hours until they were rescued. At one point, the crew went onboard the stranded *Monkshaven* to get their clothes, some provisions, and the lifeboat.

In August 1906, the *Monkshaven* was refloated by wreckers, but her moorings broke during a storm on October 18 and she crashed again on the Angus Island rocks. Totally wrecked, she still lies at Angus Island.

Eight years later, on November 9, at the height of the Great Lakes storm of 1913, the 269-foot (82 m) steel freighter *Leafield* of the Algoma Central Steamship Company had rounded Isle Royale after making her way across Lake Superior from Sault Ste. Marie, Ontario, and headed to Fort William. She had been battling brutal weather conditions of hurricane force winds, whiteout

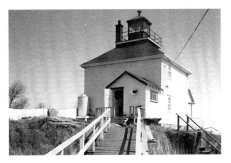

Angus Island was the site of two shipwrecks prior to the establishment of the original lighthouse in 1927. *Ron Walker*

blizzard conditions, rough seas, and monster waves, while hauling a cargo of steel railroad ties and equipment for Canadian Pacific Railway. According to some reports, she grounded on Angus Island and then disappeared, perhaps sliding into deep water; Captain Foote of the Hamonic told the *Duluth News-Tribune* that he and another officer had watched her crest a giant wave before vanishing with her crew of 18, all from Collingwood. From the Lake Carriers Association Report of 1914:

"No lake master can recall in all his experience a storm of such unprecedented violence with such rapid changes in the direction of the wind and its gusts of such fearful speed. Storms ordinarily of that velocity do not last over four or five hours, but this storm raged for sixteen hours continuously at an average velocity of 60 miles per hour [96.5 kmh], with frequent spurts of 70 [112.7] and over ... The testimony of masters is that the waves were at last 35 feet [10.7 m] high and followed each other in quick succession, three waves ordinarily coming one right after the other. "

The steam tug *J. T. Horn* was dispatched from Port Arthur to the scene, but after two days of searching the area, could not find a trace of the ship. As of the end of 2017, the *Leafield* shipwreck has still not been located.

INTO THE TWENTY-FIRST CENTURY

As of 2018, the only structures remaining on Angus Island is the steel tower with the light, fog-alarm building, a couple of small outbuildings, and just the foundations of the original lighthouse tower and keeper dwelling.

Mission Channel Entrance Light

LOCATION: Western Lake Superior, located at outer corner of the breakwater at the entrance to Mission River, on the south side of Thunder Bay, Ontario

BUILT: 1917

REBUILT: 1952

LIT: 1917

COORDINATES: N 48 21 00.3, W 89 12 04

STATUS: Active aid to navigation; seasonal

CHARACTERISTICS OF LIGHT: Flashing green every four seconds

OWNED BY: Fisheries and Oceans Canada

OPEN TO PUBLIC: No; site and tower closed

GETTING THERE: Accessible by boat

CONSTRUCTION

Established in 1917, the Mission Channel Entrance original lighthouse was a square wooden tower 25 feet (7.6 m) high with a red railing upper section and showing a fixed white light. In the 1930 lights list from Canada's Department of Marine and Fisheries, the Mission Channel Entrance light is listed as being on a white wooden pole, with a white shed at the base and white light occulting at two seconds. In 1939, the original white light was changed to flashing green.

In 1952, the light was rebuilt, and is shown on the 1954 Lights List as being on a steel tower on the roof of the fog-alarm building with a focal light above water at 38 feet (11.6).

In 1992, the light was changed to flashing green every two seconds using lens and electricity, with a focal height of 44 feet (13.5 m) above water and visible for eight miles (13 km). The light was displayed from a green skeletal

tower on the 24-foot (7.3 m) one-room square workroom building, which was painted white with red trim and a red gallery on the roof.

In the Canadian Coast Guard's Written Notices to Shipping dated December 9, 2009, it was announced that regarding the Mission Channel Entrance, "Tower permanently changed to white cylindrical tower, green upper portion, focal height of tower has been reduced in height to 9.3 metres [30.5 feet]." The light range is about four miles (7 km).

BACKGROUND

Mission River is the two-mile-long (3.2 km) southwestern branch of three rivers (Mission, McKellar, and Kam) at the delta of Kaministiquia River where it enters the waters of Thunder Bay Harbour. The Mission Channel is dredged and marked with breakwaters to provide a southern entrance into Thunder Bay Harbour, and the light is located at the elbow (junction) where the breakwater meets concrete at the entrance to the Mission River.

The light marks the shipping channel into Thunder Bay Harbour.

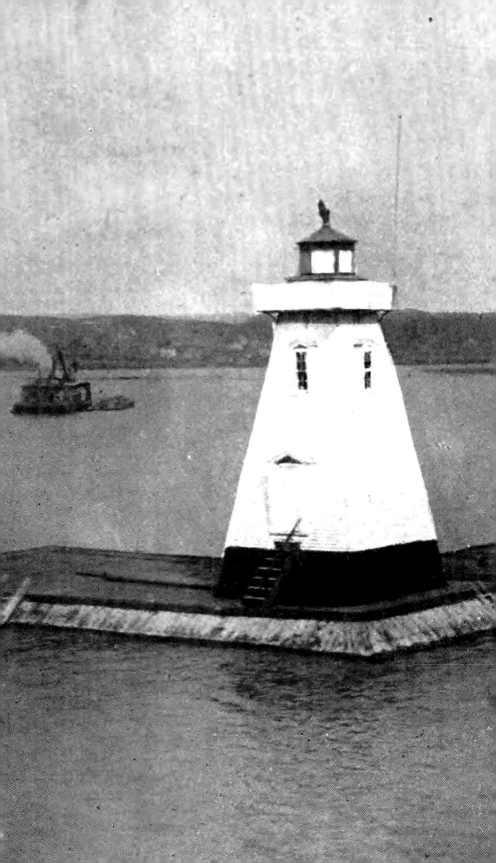

Port Arthur Breakwater Light

LOCATION: Western Lake Superior, at the south end of the northerly breakwater at the main entrance to the harbour

BUILT: 1882

LIT: 1882

EXTINGUISHED: 1940 (replaced by Thunder Bay Main Lighthouse)

CHARACTERISTIC OF LIGHT: Fixed red

CONSTRUCTION AND DESIGN

In 1882, the Canadian Pacific Railway (CPR) built the first lighthouse in Prince Arthur's Landing (Port Arthur, now part of the city of Thunder Bay), when it extended its docks. Located on the southeast corner of one dock, the white square tower had an overall height of 36 feet (11 m), and had a square gallery surrounded by a hexagonal iron lantern and capped with a dome and ventilator stack. The illuminating apparatus was catoptric and displayed a fixed red light visible for seven miles (11.3 m) from a height above water of 43 feet (13 m). The first keeper of the light was John Cooper, in 1882.

In 1883, the town's name of Prince Arthur's Landing was changed by the CPR to Port Arthur, and its population had more than doubled to 3,000 people from 1,275 in 1881.

Between 1883 and 1887, the 2,800 foot (853.4 m) northern section of a new breakwater to protect the harbor of Port Arthur was completed about a half-mile (0.8 km) from shore. Harbor dredging was undertaken to deepen the waters for larger vessels.

Built in 1882, when this portion of the present-day city Thunder Bay was known as Prince Arthur's Landing, the breakwater light was extinguished in 1940. *Larry Wright*

In 1887, the original lighthouse built by the CPR in 1882 was moved 2,320 feet (707.1 m) from its former position at the end of the CPR wharf to the westernmost end of the newly completed wooden northern breakwater. The light was anchored at 31 feet (9.4 m) from the south end of the pier, and displayed a fixed white light, visible for 11 miles (17.7 km). A hand-operated foghorn was on site to answer signals from vessels.

From 1888 to 1890, the 500-yard (457.2 m) southern section of the breakwater was completed, leaving a 350-foot (106.7 m) opening between the two breakwater sections for vessels to enter the harbor.

The Sessional Papers of Canada's Parliament in 1902 recorded that "On the night of October 15, 1901, the light shown from the lighthouse on the breakwater at the entrance to the inner harbour of Port Arthur, Thunder Bay was changed from white to red, and will thereafter be maintained as a fixed red light, in order that it might readily be distinguished from the town lights."

The 1918 List of Lights from the Department of Marine and Fisheries notes the light continues to be fixed red, visible for 11 miles (17.7 km) from a height of 43 feet (13.1 m) above water. The lighthouse is described as a "white square wooden structure on cribwork block, 31 feet [9.4 m] from southern end of northerly breakwater" and that a "hand-horn answers signals from vessels."

BACKGROUND

Before the CPR built the first lighthouse in 1882 at the southeast corner of one of its docks, there was a wooden dock running from Prince Arthur's Landing east-southeast and west-northwest, with an angle to the same running north-northeast and south-southwest with the corner squared off. There were three lights on the dock: green close to shore on the pier, red on the corner of the east-southeast pier, and a white light at the end of the north-northeast pier. Thompson's Coast Pilot Guide of 1878 noted, "This is one of the best-constructed wooden piers in the country and the town is quite a lovely place."

The Port Arthur Breakwater Light was replaced in 1940 by the current Thunder Bay Main Lighthouse.

Kaministiquia River Range Lights: Entrance (Outer) & Inner (Rear)

LOCATION: Western Lake Superior
Entrance (Outer) On the breakwater at the north side of Kaministiquia River
Inner (Rear) On the north side of the old elevator wharf, Kaministiquia River

BUILT: 1873

REBUILT: 1895

COORDINATES: **Entrance (Outer)** N 48 23 53, W 89 12 00
Inner (Rear) N 48 23 37.5, W 89 12 54.5

STATUS: **Entrance (Outer)** Active aid to navigation; seasonal; emergency light; floodlit
Inner (Rear) Active aid to navigation; seasonal

CHARACTERISTICS OF LIGHT: **Entrance (Outer)** Flashing red every 10 seconds
Inner (Rear) Flashing red every five seconds

OWNED BY: Fisheries and Oceans Canada

CONSTRUCTION AND DESIGN: ENTRANCE (OUTER) RANGE LIGHT

The Kaministiquia River Entrance Light was established in 1873 as the outer/front entrance light of two range lights on a five-acre lighthouse site along the Kaministiquia River's north shore.

According to the 1878 Annual Report of the Canadian Department of Marine, the Kaministiquia River Entrance Light is a "white square wooden tower with dwelling house attached" on the banks of the Kaministiquia River. The small square tower showed a fixed white catoptric light from a galvanized

iron lantern, 4 feet (1.2 m) in diameter and containing one mammoth flatwick lamp. The tower had an exterior ladder for the keeper to reach the lantern. The Inspector Report of 1878 stated that the dwelling attached to the tower was too small, and recommended adding a storehouse.

In 1895, the entrance (outer/front) range light was rebuilt, moving it closer to the entrance of the Kaministiquia River and 879 feet (268 m) east-northeast of the river's inner light. In the *Canadian List of Lights & Fog Signals*, signed September 25, 1895, by W. M. Smith, Deputy Minister of Marine and Fisheries, describes some changes to both towers:

> *The two range light towers at the mouth of the River Kaministiquia have each been increased in height [by] 10 feet [3 m]. The back tower [Kaministiquia River Entrance Inner], with dwelling attached, is now 40 feet [12.2 m] high to the vane on the lantern, and is painted white with the square wooden lantern surmounting it painted red.*

> *The front tower [Kaministiquia River Entrance] is a square wooden building, painted white, surmounted by a square wooden lantern painted red.*

> *The lights are respectively 40 and 30 feet [12.2 and 9.1 m] above the level of Thunder Bay, and should be visible 11 miles and 10 miles [17.7 and 16.1 km]respectively.*

In the December 2017 edition of Fisheries and Oceans Canada's *Inland Waters—List of Lights, Buoys and Fog Signals*, the Kaministiquia River Entrance light is described as being a mast on a building "on breakwater at N. side of river entrance," with light characteristics of flashing red every 10 seconds from a focal height of 21 feet (6.7 m) above water. The light is listed as being an emergency light, floodlit and seasonal.

CONSTRUCTION AND DESIGN: INNER (REAR) RANGE LIGHT

The Kaministiquia River Entrance Inner light was established in 1873 as the inner/rear light of two range lights on a five-acre lighthouse site along the Kaministiquia River's north shore.

According to the 1879 Annual Report of the Canadian Department of Marine, the Kaministiquia River Inner (rear) Range Light was a small, square wooden tower painted white, 879 feet (268 m) east-northeast from the main light (entrance/front light). It had a small galvanized lantern 4 feet (1.2 m) in diameter that housed a mammoth flatwick lamp with reflector, giving a fixed white light visible for five miles (8 km). The inspector's report the previous

year had noted that the "lantern is far too small. Keeper has to ascend to the lantern by an outside ladder and has great difficulty in lighting lamp during bad weather."

In the December 2017 edition of Fisheries and Oceans Canada's *Inland Waters—List of Lights, Buoys and Fog Signals*, the Kaministiquia River Entrance Inner Light is described as seasonal, located on a 20-foot (6.1 m) cylindrical mast, with a red and white rectangular daymark on the "N. side of Old Elevator wharf." The light characteristics are flashing red every five seconds, from a focal height above water of 25 feet (7.7 m).

BACKGROUND

The Kaministiquia River, also known as Kaministikwia, and simply "Kam" by locals, rises in Dog Lake and after 60 miles (95 km) of many rapids and waterfalls—including the famous Kakabeka Falls which tumbles down 154 feet (47 m) and nicknamed "Niagara of the North"—empties into the waters of Thunder Bay. Kaministiquia (*Gaa-ministigweyaa*) is an Ojibwe word meaning "river with islands" due to two large islands (McKellar and Mission) at the mouth of the river. The river divides into three channels as it enters Thunder Bay: Mission River (southernmost), McKellar River (central), and the "Kam" (northernmost).

The Kaministiquia River Range Lights were established to guide vessels through the dredged channel at the mouth of the Kaministiquia River.

INTO THE TWENTY-FIRST CENTURY

The Kaministiquia River Range Lights were established—and continue—to guide vessels into the Kaministiquia River, which has Dog Lake as its source.

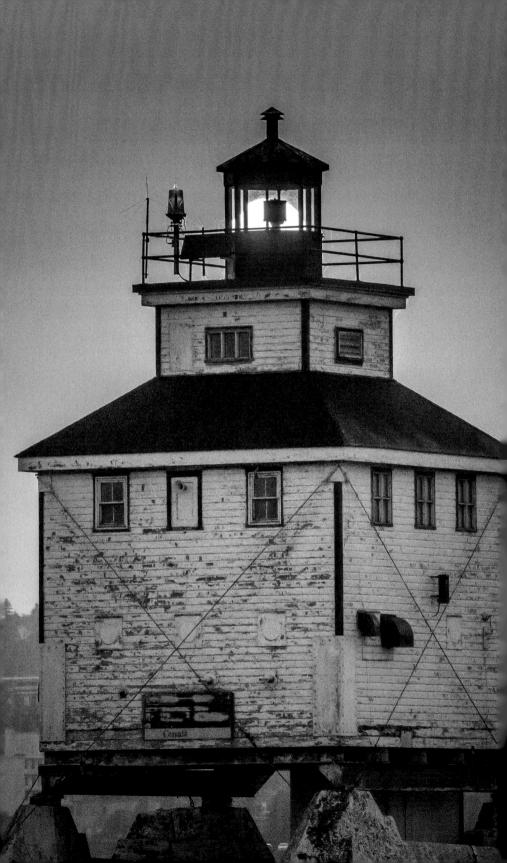

Thunder Bay Main Lighthouse

(formerly named Port Arthur New Entrance, Port Arthur Central
Entrance, and Thunder Bay Central Lighthouse)

LOCATION: Western Lake Superior, at the end of the breakwater on
the north (central) side of the main entrance into Thunder
Bay Harbour

BUILT: 1937

LIT: 1940

AUTOMATED AND DE-STAFFED: 1979

COORDINATES: N 48 25 58, W 89 11 45

STATUS: Active aid to navigation; seasonal; floodlit

CHARACTERISTICS OF LIGHT: Flashing red every five seconds

OWNED BY: Fisheries and Oceans Canada

OPEN TO PUBLIC: No

GETTING THERE: By water

CONSTRUCTION AND DESIGN

Thunder Bay Main Lighthouse was constructed after the demolition of
the Canadian Pacific Railway (CPR) light, which in 1887 had been moved
across the ice from the CPR dock to the cribwork block on the breakwater.
The CPR light replaced the temporary pole light that was put in operation on
August 17, 1886.

Established in 1940, Thunder Bay Main Lighthouse was originally called
Port Arthur New Entrance, then Port Arthur Central Entrance, then Thunder

The Thunder Bay Main Lighthouse was lit in 1940. The "modern" structure was the first
lighthouse on the Ontario North Shore to have a three-piece bathroom and hot and cold
running water. *Christine Johnston*

Bay Central with the 1970 amalgamation of the cities of Port Arthur and Fort William, and eventually, Thunder Bay Main.

The contractor for the new lighthouse was Thunder Bay Harbour Improvements Ltd. In their 1940 Annual Report, the Lake Carriers' Association described the lighthouse:

> A new lighthouse and fog signal was established on the north side of channel on south end of the new Port Arthur breakwater. The station is white square wood, surmounted by red iron lantern. The light, at an elevation of 48 feet, shows a flashing white catoptric light, one flash every 7 1/2 seconds.

The combined keeper's dwelling and light tower had white clapboard siding, red trim, and a hip roof with cedar shakes (later converted to red asphalt shingles). Four concrete pedestals raised the building above the concrete foundation, creating an open space underneath to allow waves to wash over the pier and under the lighthouse. In addition, the corners were reinforced by steel plates and the first-floor windows had steel shutters. Thunder Bay Main Lighthouse was the first lighthouse on Ontario's north shore to have a three-piece bathroom plus hot and cold running water.

The tower arose from the middle of the building's center, topped by a square gallery and polygonal iron lantern displaying a flashing white light at a focal height of 48 feet (14.9 m) above water and was visible for 12 miles (16 km). In 1944, four years after the light was lit, the characteristic of the light was changed from the original flashing white to flashing green, and in 1952, to its current flashing red every five seconds.

BACKGROUND

In 1936, the Canadian government undertook large-scale improvements of the Thunder Bay Harbour, which included constructing a new lighthouse, new main harbor entrance, seaplane base, dredging a larger area in the harbor for deep water vessels, and a 1,630-foot (500 m) addition to the breakwater system.

Three years later, the construction requirements for the lighthouse tender package of 1939 was fairly specific. It called for Canadian-made materials to be used, but if that were not possible, then to use British Empire products. Spruce or fir were to be used for the framing lumber; spruce or red pine for the boarding and rough flooring; birch or maple for all finished flooring; and cedar from New Brunswick or British Columbia to be used for the shingles. The iron railing and lantern room would be supplied by the Canadian Department of Transport.

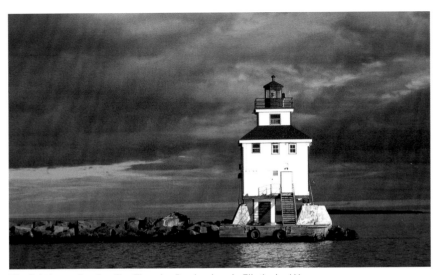

The lighthouse is a familiar Thunder Bay landmark. *Elle Andra-Warner*

Lighthouse Tales

Sometime in early January 1951, when the lighthouse was closed for the season, it was vandalized by unknown persons. It seemed that the perpetrators came by bicycle off the frozen harbor and broke in through a small opening in a 14-inch (35.6 cm) porthole window after they had smashed the half-inch (1.3 cm) glass. The *Fort William Daily Times* reported:

"The damage includes 23 smashed window panes, damage to the wooden stairway, the lamps, two diesel motors, paint spilled on the floor, [and] metal articles such as fire extinguishers put in a steel vice and mangled."

The lighthouse was again in the news 20 years later, when on May 15, 1971, the fully loaded downbound Canadian Steamship Lines freighter *SS Simcoe* (later renamed *Algostream*, scrapped in India in 1996) experienced engine failure and drifted into the pier and breakwater, shifted the lighthouse a few feet, and severed the submarine cable, causing power loss to the area's lighthouses and fog signals.

Power was partially restored to some lighthouses by mid-June. However, it took four months to complete repairs to Thunder Bay Main, during which time the station's keepers were removed and both the lighthouse and main harbor entrance were closed.

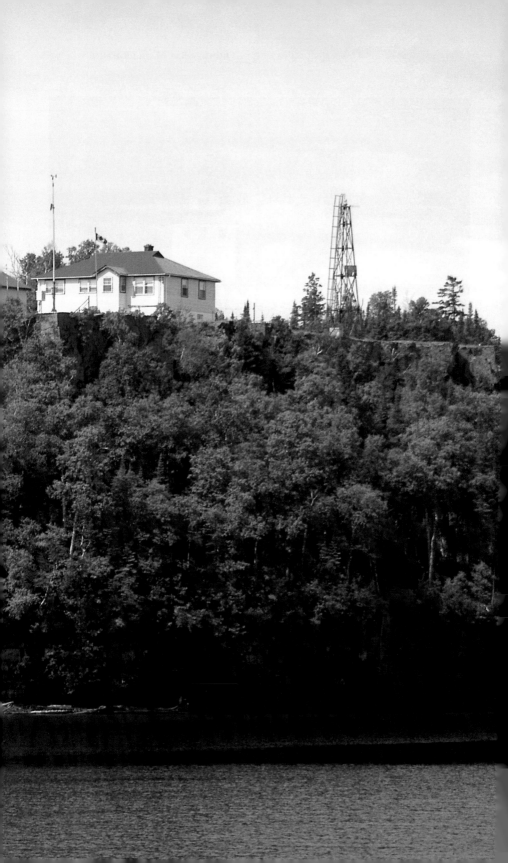

Welcome Island Lighthouse

LOCATION: Western Lake Superior, at the northern point of the east island of the four Welcome Islands, about six miles (10 km) offshore from Thunder Bay

BUILT: 1905–1906

REBUILT: 1959

AUTOMATED: 1974

DE-STAFFED: 1985

COORDINATES: N 48 22 10, W 89 07 14

STATUS: Active aid to navigation; seasonal

CHARACTERISTICS OF LIGHT: Flashing white every 10 seconds

OWNED BY: Except for the lighthouse site which is owned by Fisheries and Oceans Canada, the island is privately owned

OPEN TO PUBLIC: Site open; buildings closed

GETTING THERE: Accessible only by water; access path to reach navigational light

CONSTRUCTION AND DESIGN

Under supervision of Canadian government engineer W. H. Brunell from Ottawa, construction of the original combined light tower and keeper's house began in 1905 on the northernmost point of the east island of the Welcome Islands, about 150 feet (45.7 m) from the water's edge. The Annual Report for 1906 by Canada's Department of Marine describes the light station:

A lighthouse was erected on the northeast extremity of the eastern Welcome Island, and the light was put in operation on the opening

Situated atop a rocky bluff, the Welcome Island Lighthouse was rebuilt in 1959.
Terry Pepper and B and W National Archives

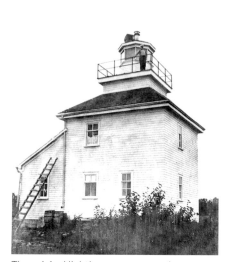

The original lighthouse was a wooden structure with a light atop its roof.
Larry Wright

of navigation in 1906. The lighthouse stands on land 80 feet [24.4 m] above the level of the lake and 160 feet [48.8 m] back from the water's edge. It consists of a square wooden dwelling, with an octagonal wooden lantern rising from the middle of its hip roof. It is painted white, with the roof red and is 38 feet [11.6 m] high from its base to the top of the ventilator on the lantern. The light is a fixed-white dioptric light of the seventh order, elevated 112 feet [34 m] above the level of the lake, and visible for 16 miles [20 km] from all points of approach by water.

A year later, on November 23, 1907, a wooden fog-alarm building was added to the station, and a diaphone plant was installed the following spring. On July 15, 1908, the fog alarm became operational, with its foghorn facing east, about 90 feet (27.5 m) above water, and sounding a group of two blasts every 70 seconds.

On May 12, 1915, the fixed white light was changed to a fourth dioptric oscillating white light, visible for 10 seconds and eclipsed for five seconds, and was changed again in 1936 to a flashing white every 10 seconds.

In 1959, the original lighthouse building was demolished and replaced by a single-story structure and metal lattice tower. The light changed to flashing white every five seconds at a focal height of 138 feet (42.1 m) above the water. In the following year (1960), an additional bungalow was built as the assistant keeper's residence.

Currently, the light beams from a 66-foot (20 m) square skeletal lattice tower, painted red, located northeast of the keeper's house.

The light was automated in 1974, de-staffed at the end of navigation season in 1985, and the station was completely automated in 1986.

BACKGROUND

The Welcome Island Lighthouse was built on the north extremity of the east island of the four islands known collectively as the Welcome Islands, located approximately six miles (9.6 km) from the city of Thunder Bay. The two eastern islands are the largest, each approximately 875 yards (800 m) long and 438 yards (400 m) wide.

Established to mark the ports, the shallow water around the islands, and as the final leading light into Thunder Bay, it is located about four miles (6.4 km) southeast of the south entrance light on the south breakwall, forming the main harbor of Thunder Bay.

Keeper Tales

The first lighthouse keeper was 58-year-old Montreal-born Adolphe Perras, who had arrived in the Lakehead (the collective name for Port Arthur and Fort William) in 1869. Before taking on the keeper's job, Perras was a local miner, entrepreneur, stockholder (Port Arthur & Duluth Steam Packet Company), and past owner/operator of hotels in Port Arthur, Silver Mountain, and Leeblain, plus a brakeman for the Port Arthur, Duluth & Western Railway. He was appointed the keeper for Welcome Island Lighthouse on May 10, 1906, at annual salary of $350 and served until 1913.

His keeper's log entry for April 23, 1907, described an unusual, and somewhat dangerous, event of a car driving over the ice from Fort William (now part of the city of Thunder Bay) to the 108-foot (33 m) tug *James Whalen*, which in the early 1900s transported lighthouse keepers to their stations. Perras wrote,

"April 23 – A real spring day. The *James Whalen* has broken her way beyond Welcome Islands. Yesterday, Al Sellers, Jas Whalen and Captain McAllister went out to *Whalen* on automobile."

In 1936, the tug *Strathmore* took over some of the ferrying of keepers to and from their stations. And from 1961 onward, the Canadian Coast Guard light icebreaker, lighthouse supply, and buoy tender *Alexander Henry* took on the role, anchoring offshore from the lighthouse and then in a marine aerial operation a helicopter would fly the keepers from ship to shore with their supplies. Later, in the 1980s, the Coast Guard helicopter flew them directly from Thunder Bay to their stations.

Keepers were at the lighthouse from 1906 to 1985, with the last keeper being Raymond C. Silver, who served from 1979 to 1985.

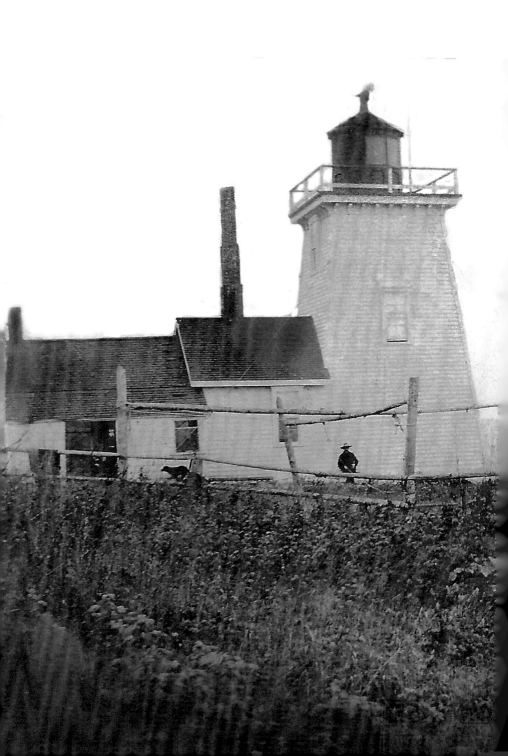

Thunder Cape Lighthouse

LOCATION: Western Lake Superior, on Thunder Cape at the southern tip of Sibley Peninsula (at the foot of the iconic Sleeping Giant land formation) at the entrance to Thunder Bay

BUILT: 1874

COORDINATES: N 48 18 07, W 88 56 19

STATUS: Active aid to navigation; seasonal

CHARACTERISTIC OF LIGHT: White flashing light every four seconds

OWNED BY: Fisheries and Oceans Canada

SITE MANAGER: Thunder Cape Bird Observatory

OPEN TO PUBLIC: Yes, from late April to early June and from August 1 to October 30

GETTING THERE: Accessible by boat, usually from Silver Islet, when water is not too rough. Also by hiking eight miles (13 km) from the Kabeyun Trail Head at Sibley Drive (Highway 587). A mountain bike can be taken as far as "The Chimney," but from there trail is too rough for biking. (Thunder Bay Bird Observatory website.)

CONSTRUCTION AND DESIGN

The original lighthouse had an attached white wooden keeper's dwelling and a white square wooden tower. Its lantern had a revolving white light with revolutions of one minute, using two flat-wick lamps and two 20-inch (50 cm) reflectors; later a fourth lens was added. Focal height above water was 45 feet (13.7 m) and was visible for 12 miles (19.4 km).

Now the site of a bird observatory, the original lighthouse was built to mark the entrance to Thunder Bay and nearby shallow shoals. *National Archives Canada*

The fog-signal building was white with a brown roof, built about 150 feet (45.7 m) south of the lighthouse. The station's original whistle was steam-powered, later changed to a foghorn diaphone operated by compressed air.

In 1924, the station was automated, the lighthouse dismantled, and the last keeper, Allan Murray, moved from the site. The light was replaced with the current steel cylindrical mast, red and white rectangular daymark, with a height above ground of 21 feet (6.5 m).

The lighthouse was built to mark the entrance to Thunder Bay and to indicate underwater shoals

The present automated light replaced the original lighthouse in 1927. *Charles W. Bash*

to the west and south of Thunder Cape and the tip of Sibley Peninsula. Today's automated white light flashes every four seconds from a focal height above water of 35 feet (10.7 m) and is visible for five miles (8 km).

BACKGROUND

According to First Nations legends, Thunder Cape is the home of the Great Thunder Eagle. In his book, *Eagle of Thunder Cape*, author W. S. Piper writes about being part of a large flotilla of canoes headed for Nipigon, and describes what happened when his First Nations companions reached the Cape:

> *A stop was made at Thunder Cape where gifts of food, tobacco and ornaments were offered to Manitou in order that he might appease the wrath of the Great Thunder Eagle and so temper the fury of the great lake that their frail craft might pass safely.*

Piper adds the "impressive natural escarpment was passed with devout humility" as it was also the home of a "band of hairy giants, guardians of this sacred and historic place, who dwelt in a cave under its forbidding ramparts, whose entrance was closed with a panel of stone."

Over the years, the imposing natural landmark of Thunder Cape has become famous as the subject of writers, photographers, and painters.

The massive promontory rising above the light was believed to be the home of the Great Thunder Eagle by Indigenous people. *Larry Wright*

Shipwreck Tales

On May 30, 1888, the 139-foot (42.4 m) three-mast former bark *Maggie McRae*, built in 1872 by Andrews & Son in Port Dalhousie, Ontario, was in tow of the tug *Bruno* in the dark when a field of ice broke a hole in her bow planning and she sank about 10 miles (16.1 km) off Thunder Cape. According to the *Weekly Northwestern Matter* of June 8, 1888, *Maggie McRae* was carrying 25,000 bushels of wheat belonging to the Ogilvie Milling Company and consigned to Montreal.

INTO THE TWENTY-FIRST CENTURY

Some foundations of the original station remain. Since 1991, the Thunder Cape Bird Observatory has been established on the site and is open to the public during their season of late April to early June and from August 1 to October 30.

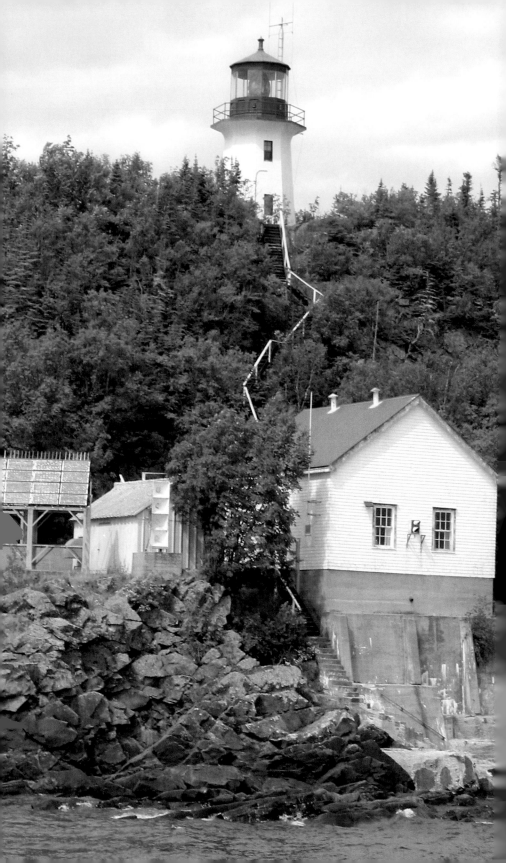

Trowbridge Island Lighthouse

LOCATION: Western end of Lake Superior, on Trowbridge Island offshore from Sibley Peninsula, about 15 miles (24 km) northeast of the city of Thunder Bay

BUILT: 1923–1924

LIT: 1924

AUTOMATED: 1988

COORDINATES: N 48 17 34, W 88 52 22

STATUS: Active aid to navigation

CHARACTERISTICS OF LIGHT: Solar-powered flashing white every five seconds with focal height of 114 feet (34.7 m) above water

OWNED BY: Fisheries and Oceans Canada

SITE MANAGER: Under lease to Canadian Lighthouses of Lake Superior Inc. (CLLS)

OPEN TO PUBLIC: Site open; tower and buildings closed

GETTING THERE: Accessible by boat but docking can be a challenge due to the shoreline cliffs

CONSTRUCTION AND DESIGN

The contract to build the Trowbridge Island lighthouse, fog-alarm building, and dwelling was awarded to J. J. Fitzpatrick of Sault Ste. Marie in the amount of $17,892. The fog-alarm equipment was provided by the Fairbanks-Morse Company and the Ingersoll-Rand Company. Work began on August 9, 1923.

The 39-foot (12 m) white octagonal tower was built at the highest point on the island. Topping the tower is a red decagonal lantern, with 10 large rectangular vertical glass panes and housing a second-order Fresnel lens. It produces

Trowbridge Island Lighthouse marks the north side of the shipping between the mainland and Isle Royale. *Charles W. Bash*

a flashing white light every five seconds, from a focal height of 114 feet (34.7 m) above Lake Superior and visible for 16 miles (26 km). The tower is reached by climbing up a steep 175-step wooden staircase up the hillside situated in the middle of the island.

The fog alarm, a white clapboard building with red roof and trim, is near the shoreline on a concrete crib midway on the western shore of the island.

At the southern end of the island is the two-story keeper's dwelling, a white clapboard duplex—identical to the keeper's dwelling at Battle Island—built for the keeper and assistant keeper. The dwelling has a long white front veranda, red hip roof with half dormers, and is the start of the concrete walkways leading to mid-island, the foghorn house, and the steep wooden staircase to the light tower.

Near the keeper's house is the helicopter pad, built in the mid-1990s near the edge of a cliff. Visible when approaching the island is a derrick high on a cliff, secured to a concrete foundation, that was once used to hoist fuel barrels on slings ashore from vessels. The fuel powered the diesel generators, providing power to the island.

There is no protected harbor. Shoreline cliffs make Trowbridge Island difficult to approach, and unattended boats run the risk of bouncing against the steep rocks. A small docking area on a concrete slab is set up on a spot on the rocky southern point where boats can dock, depending on the lake conditions.

In 1982, the Trowbridge Island light was designated an emergency light, in operation year-round. Six years later, in 1988, the light was automated and de-staffed at the end of the navigation season.

BACKGROUND

In 1924, the Canadian government built a lighthouse on Trowbridge Island to mark the north side (mainland side) of the shipping channel between the mainland and Isle Royale, and to mark the passageway to Thunder Bay and the passage's dangerous reefs.

The small, rocky island was named after New York's Charles A. Trowbridge, one of the original officers of the Silver Islet Mining Company, which owned the silver mine—the world's richest from 1870 to 1884—on nearby Silver Islet. He was related to the president of the Silver Mining Company, Alexander Sibley, as Trowbridge's uncle, Charles Christopher Trowbridge, was married to Sibley's sister. His uncle was a former mayor of Detroit and a member of the 1820 Lewis Cass expedition exploring the wilderness of Lake Superior and

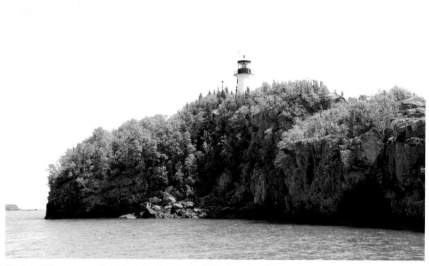

Rocky cliffs surrounding the island make it difficult to land boats on Trowbridge Island. *Elle Andra-Warner*

upper region of the Mississippi Valley. (Alexander Sibley was also the brother of Minnesota's first governor, Henry Hastings Sibley.)

Shipwreck Tales

The waters around the island have been the scene of several famous shipwrecks.

On November 17, 1906, during a sudden snowstorm with strong wind gusts and pelting snow, the 255-foot (68.6 m), 1,175-ton Canadian steamer *Theano* bound for Port Arthur (now part of the city of Thunder Bay) with a cargo of steel rails was pushed off course into Trowbridge Island, smashing broadside into the rocky shoreline and crushing in her side. For two hours, her crew of 20 tried desperately to save her, but the water was pouring in faster than the pumps could handle, so they abandoned ship in two lifeboats before *Theano* exploded and sank. One lifeboat with 11 crew members was rescued by the passing steamer *Iroquois*; the other lifeboat with nine men had a harrowing journey to reach Port Arthur. Captain George Pearson later described it:

"Once clear of the steamer we hoisted a sail and went to work with oars. Each lifeboat carried a light, and although we managed to keep

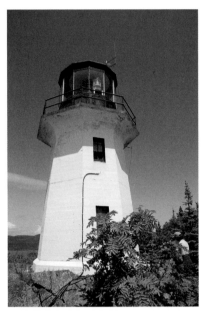

The classic lighthouse tower has been restored and maintained by Canadian Lighthouses of Lake Superior, Inc.
Elle Andra-Warner

ours burning we lost sight of the other within an hour of the time we set sail.

"The trip across Thunder Bay was the most terrible I have ever experienced. One minute we were 20 feet [6.1 m] below the surface and the next we would be on the crest of a gigantic wave, with the bow of our boat pointing downwards. Again a wave would break over us, drenching every man to the skin. At times it was impossible to see the men in the opposite end of the boat and it was only during the lulls, which came infrequently, that we were able to assure ourselves that no one had been washed overboard. Numb, exhausted, and almost overcome with exposure, we arrived in Port Arthur about 11:00 AM. I am sure we could not have survived another 6 hours."

Fortunately, no lives were lost. It wasn't until 2005 that *Theano* was located in 360 feet (110 m) of water.

In 1953, the 424-foot (129.2 m) *Scotiadoc* (launched in 1904 as the *Martin Mullen*) sank near the island in heavy fog and rain after colliding with the 451-foot (137.5 m) freighter *Burlington*, resulting in one death among her 29 crew members. The *Scotiadoc* shipwreck was located in 2013 by a group of shipwreck hunters in more than 850 feet (259.1 m) of water, giving her the distinction of being the deepest known shipwreck in the Great Lakes.

INTO THE TWENTY-FIRST CENTURY

Restoration and maintenance continues to be carried out by the CLLS, including updating and reconditioning the dock, carrying out conservation work, fixing the floor of the lighthouse keeper's dwelling, painting the tower, and upgrading the island trails and wooden staircase.

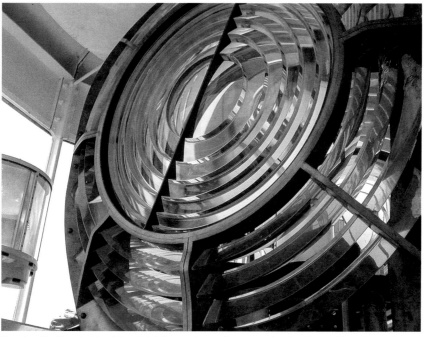

Topping the Trowbridge Island Lighthouse tower is a second-order Fresnel lens. It produces a flashing white light every five seconds, from a focal height of 114 feet (34.7 m) above Lake Superior and is visible for 16 miles (26 km). *Lois Nuttall*

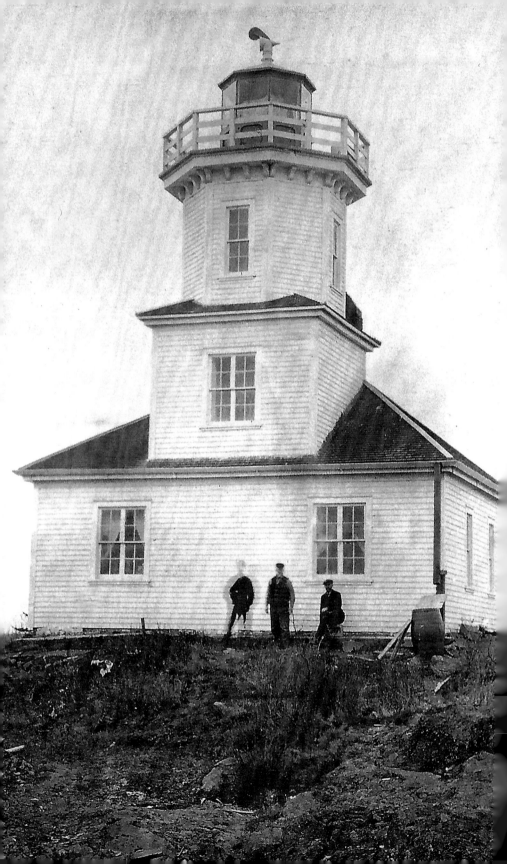

Point Porphyry Light
(also known as Porphyry Point Light and Porphyry Island Lighthouse)

LOCATION: Western Lake Superior, on the southwestern tip of Edward Island at the entrance to Black Bay; about 26 miles (42 km) east of the city of Thunder Bay; about five miles (8 km) east of Silver Islet; and seven miles (11.3) north of United States–Canada border

BUILT: 1873, 1960

LIT: July 1, 1873

AUTOMATED AND DE-STAFFED: 1989

COORDINATES: N 48 20 24, W 88 38 54

STATUS: Active aid to navigation; seasonal; emergency light

CHARACTERISTICS OF LIGHT: White flash every 10 seconds (flash one second; eclipse nine seconds)

OWNED BY: Fisheries and Oceans Canada

MANAGED BY: Canadian Lighthouses of Lake Superior Inc. (CLLS)

PUBLIC ACCESS: Yes

GETTING THERE: Accessible by water, float plane, and helicopter

CONSTRUCTION AND DESIGN

Porphyry Point Light was one of the three lighthouses the Canadian Parliament approved for construction in 1872 on Lake Superior to assist in the lake's rapidly expanding trade. The other two were both on Michipicoten Island, with Chimney Lighthouse lit on August 28, 1872, and Agate Island Lighthouse lit on September 23, 1872.

Point Porphyry Lighthouse was first built in 1873. One of the lightkeepers moved as this long-exposure photo was taken, which is why he appears headless. *Larry Wright*

Porphyry was lit on July 1, 1873, making it the fourth Canadian lighthouse put in operation on Lake Superior. The name "Porphyry" comes from the black volcanic rock with feldspar and quartz crystals on which the lighthouse is built.

In the Sixth Annual Report of Canada's Department of Marine and Fisheries published in 1874, the new lighthouse was described as:

> *Another very superior lighthouse ... recently erected at Porphyry Point, Lake Superior, which has already been of much service to the steamboat trade on the lake. Mr. Donald Ross was appointed keeper of this light on 10th April last, at salary of $400 per annum. The tower is a square wooden building, painted white, and the light is a fixed white catoptric, and can be seen at a distance of 16 miles [25.7 km].*
> *The lighting apparatus consists of five No.1 circular burner lamps and 20-inch [50.8 cm] reflectors. It was lighted for the first time on the 1st of July, 1873.*

The combined lighthouse was a two-story keeper's dwelling with the light tower rising from the hip roof. The base of the 36-foot-tall (11 m) tower was square, with the middle section octagonal, topped by an octagonal 9-foot-diameter (2.7 m) iron lantern. At a height above water of 56 feet (17.1 m), the light was visible for 16 miles (25.7 km).

A rectangular white wooden fog-alarm building was built in 1907 about 150 feet (45.7 m) back from the edge of Porphyry Point and about 25 feet (7.6 m) northeast of the lighthouse. The building housed a 3-inch (7.6 cm) duplicate diaphone plant with two six-horsepower kerosene engines which was placed in service the following year, on July 15.

A fourth-order lens replaced the original catoptric light in 1911. Thirty-three years later (1944), the characteristic of the light was changed from fixed white to flashing green, and in 1947 to flashing white.

In 1960, the original light tower was replaced with a 48-foot-high (14.5 m) square cylindrical tower supported by iron skeletal framework, of which one side is covered with slotted slats to serve as a daymark. The structure is topped with a lantern room and gallery, and has a focal plane of 82 feet (25 m).

In 1989, the lighthouse was automated and the station de-staffed.

BACKGROUND

The lighthouse was built to mark the north shore of the lake, to assist with marking the northern channel above Isle Royale into Thunder Bay, and

to light the entrance to Black Bay along the shore to Silver Islet and to Thunder Bay.

In the early days, the tug *James Whalen* transported the keepers to their stations at the beginning of the navigation season and picked them up at the end of the season. In the mid-1950s, the Canadian Coast Guard icebreaker and lighthouse tender *Alexander Henry* took over the ferrying, followed for a time by aerial lift by helicopter from the *Henry* to the light station, and finally flying direct by Coast Guard helicopter from Thunder Bay.

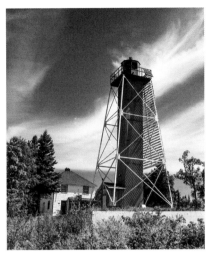

The steel tower erected in 1960 is covered with slotted slats on one side to serve as a daymark. *Lois Nuttall*

Keeper Tales

From 1873 to 1989, when the lighthouse was automated, there were a total of eight head keepers that tended the light. The first keeper was Donald Ross with his wife and two children, and the last was Gordon Graham, who left at the end of the 1988 navigation season.

The longest-serving of the eight head light keepers was Scottish-born Andrew Dick, who lived year-round with his family at Porphyry Point Lighthouse. Appointed in 1880 at $400/year, he stayed for the next 30 years, retiring in 1910 at age 78. He and his wife Wasseabinoke (also known as Caroline), from Pays Plat, had 10 children—five boys and five girls. When his wife died in 1884, four months after giving birth to their tenth child, Dick was left on the island to raise their children, ages four months to 19 years, with the children all pitching in to help.

He kept a diary for his own records, recording items like daily wind and weather conditions, ships passing, visitors, birds, animals, cooking, fishing, and any matters of special interest. On March 3, 1889, he wrote, "All open water here. Saw a snowbird—first this spring." On January 19, 1890, "Plenty [of] caribou tracks on the main land." He wrote about their meals, which included vegetables (tomatoes, beans, and beets) from his large vegetable garden, smoked meat, rabbit, caribou steak, eggs,

pot barley soup, stuffed caribou heart, boiled caribou tongue, roast of caribou, stewed chicken and dumplings, apple pie, and tea.

When his oldest child, Agnes, died in 1901, he wrote on Wednesday, June 24: "Agnes died tonight at 7 o'clock PM the same month she was born in, her mother died same month and same date. Agnes age 36 years." The next day he wrote, "We got to work early this morning and dug a grave then brought the scow over to the house and took the remains to the Boat House and put them in the Grave."

After retiring in 1910, Andrew Dick moved to Port Arthur (Thunder Bay) where he died on April 17, 1917.

The keepers were an enterprising lot. Edward McKay, head keeper from 1922 to 1945, supplemented his keeper income by selling hundreds of pounds of fish each week to the Booth Fishing Company, getting paid six cents a pound for lake trout, four cents a pound for whitefish, and one cent a pound for pickerel.

A warm and fuzzy story involved keeper Dave Sokalsky in the 1970s, who helicoptered back to Porphyry Point from Thunder Bay, at his own expense, to search for his lost cat. As the story goes, during his last year at the lighthouse, he had taken a kitten with him for company and they had a wonderful relationship. After locking down the lighthouse in November, Dave packed all his things that had to be serviced on shore. But when the Canadian Coast Guard helicopter came to pick him up, his beloved feline companion was nowhere to be found and he had to lift off, leaving his cat behind, alone on the island. Heartbroken, Dave paid the cost for a helicopter ride back to the Porphyry to find his lost cat. When he arrived, his cat was waiting at the door of the lighthouse. Dave bundled her up in his long coat for the ride back to city, where the cat enjoyed a long life.

Shipwreck Tales

On November 8, 1929, the lake freighter *Thordoc* was downbound from Port Arthur to Montreal with 2,000 pounds (907.2 kg) of flour when she grounded on Porphyry Point. The *Brooklyn Daily Eagle* (Brooklyn, New York) reported on November 11, 1929:

"*Thordoc* of the Paterson Steamship Lines is on the rocks at Point Porphyry 42 miles [67.6 km] from Port Arthur at entrance to Black Bay. Vessel piled into rocks during dense fog yesterday. Crew safe. When vessel struck, the crew took to the boats, rowing in the early morning

darkness for several hours before making landing near the Point Porphyry Lighthouse."

Another newspaper said the "boat is reported to be high upon a ledge and in danger of breaking up in the event of a storm. Captain A. Peterson is still at the scene of the wreck, but members of the crew were brought to Port Arthur this afternoon on a fishing tug. The wrecking tug *Strathmore* is en route to the stranded vessel."

The *Thordoc* was abandoned by the underwriter as a total loss, however, a salvage contract successfully refloated her on December 5, 1929, and towed her to the shipyards at Port Arthur for repairs. The Paterson Steamship Lines repurchased her and she was back in service until March 30, 1940, when she was stranded and abandoned on Winging Point about 10 miles (16.1 km) southwest of Louisbourg, Nova Scotia.

Apparently, when attempting to lighten *Thordoc's* load while stranded on the Porphyry reef, the crew threw many bags of flour overboard. Keeper Edward McKay was among others in the area who secured enough of the abandoned flour to last them several years.

INTO THE TWENTY-FIRST CENTURY

Since 2010, the Porphyry Point Lighthouse site has been managed by the non-profit Canadian Lighthouses of Lake Superior Inc. under lease from the Fisheries and Oceans Canada. According to the CLLS, visitors can use the boat ramp at Silver Islet to get on the water. Landing is suggested at the northwest bay of the island, just south of Walkers Channel, where there are two docks with capacity of a draft of 4 feet (1.2 m) for boats; sailing craft can moor in the bay. Amenities include a picnic table, fire pit, camping area, and boat house. At the point itself, there are two dwellings (room rentals available), the light tower, fog-alarm building with a bank of modern free-standing foghorns outside it, and camping areas.

During summer months, there is CLLS staff to greet visitors and show them around the site. Further information is available at CLLS website https://clls.ca.

No. 10 Lighthouse
(also known as Shaganash Lighthouse)

LOCATION: Western Lake Superior, on the west end of Island No. 10, west of Shaganash Island, east of Edward Island, about 16 miles (25.7 km) north of the eastern tip of Isle Royale and about 15 miles (24.1 km) east of Porphyry Point Lighthouse on the North Channel

BUILT: 1910

COORDINATES: N 48 26 10, W 88 28 50

STATUS: Active aid to navigation; seasonal

CHARACTERISTICS OF LIGHT: White flashing light every four seconds

OWNED BY: Fisheries and Oceans Canada

SITE MANAGER: Canadian Lighthouses of Lake Superior Inc. (CLLS)

OPEN TO PUBLIC: Grounds open; tower closed but open upon request

GETTING THERE: Accessible only by boat

CONSTRUCTION AND DESIGN

The original lighthouse, built in 1910 for $2,484.90, was a square wooden keeper's dwelling with a hip roof, topped by a square wooden lantern, fifth-order lens, and exhibited a fixed white light at a height of 36 feet (11 m) above water. In 1912, the station was equipped with a hand-operated foghorn to answer signals from vessels during foggy weather.

Fire destroyed the original station in November 1921. It was replaced the following year with the current 24-foot (7.5 m) white-with-red-trim square

Located on lonely Island No. 10, the current lighthouse was built in 1922. *Paul Morralee*

pyramidal wooden tower with red iron lantern and gallery. Focal height above the water is 36 feet (11 m).

The station was fully automated, and the last keeper left the station at the end of the 1954 navigation season. In 1982, the light was electrified and switched to the current solar-powered flashing white light.

The only known picture of the original lighthouse appears in the book *A Trip of the Great Lakes* (1913), taken in September 1912 by the book's author Raymond S. Spears.

With the site now managed by the non-profit organization CLLS, the group has repainted the lighthouse as well as added a picnic table and portable toilet for visitors.

BACKGROUND

Built by Canada's Department of Marine (now Oceans and Fisheries Canada), No. 10 Lighthouse was built to guide mariners on the route to Lakehead ports by marking the narrow inside passage along the North Channel between Isle Royale and the mainland.

Lighthouse Tales

In September 1912, American author and adventurer Raymond Smiley Spears rowed his skiff along the north shore of Lake Superior from Fort William to Michipicoten, stopping along the way to visit some of the lighthouses, including Shaganash. In his book, *A Trip of the Great Lakes*, he describes his first sighting of the lighthouse while a few miles away:

"It was a lighthouse, built there for the purpose of lighting the way of barges loaded with lake shore sand on their way to Port Arthur for use in buildings. Somehow, I do not remember having seen anything that seemed so lonesome as that light there on Great Shaganash Island. The place was so utterly away from everything, separated by islands and channels, and miles of woods."

Spears rowed in and landed at the lighthouse, somewhat to the surprise of William Iles Fairall, the 68-year-old keeper born in Isle of Wight in England, who was serving his first year at the lighthouse. Spears praised the island, "It was quite the most natural place I had seen, with water and islands and wild mainlands untampered by rude or commercial hands of mankind."

The only known photo of the original Shaganash Island Light. *Raymond S. Spears*

After staying for a short visit and having the boom for his sail fixed by Fairall, Spears moved on, heading for another island 10 miles (16.1 km) distant. (Eight years later, on April 10, 1921, keeper Fairall died at the lighthouse at 76 years of age.)

INTO THE TWENTY-FIRST CENTURY

The lighthouse and site continues to be renovated and maintained by the CLLS. Further information is available on the CLLS website https://clls.ca.

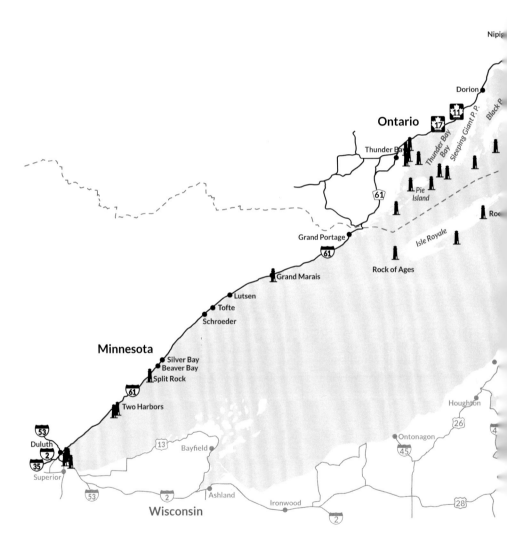

Ontario North

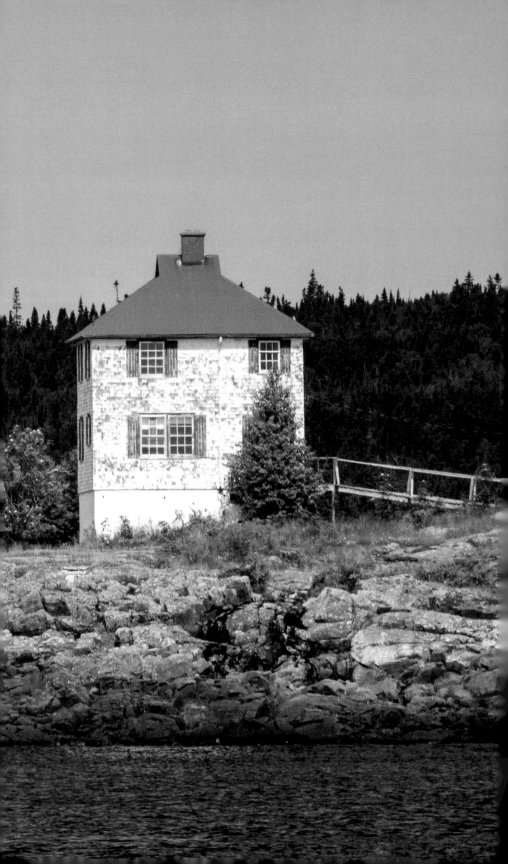

Lamb Island Lighthouse

LOCATION: Northwest Lake Superior, on the tiny isolated Lamb Island on the southeast side of Black Bay Peninsula, about 90 miles (144.8 km) northeast of the city of Thunder Bay

BUILT: 1876

LIT: May 15, 1876

DE-STAFFED: 1990

COORDINATES: N 48 36 12.4, W 88 08 34.5

STATUS: Active aid to navigation

CHARACTERISTICS OF LIGHT: White flash every five seconds

OWNED/MANAGED BY: Fisheries and Oceans Canada

OPEN TO PUBLIC: Site open; tower closed

GETTING THERE: Accessible by boat

CONSTRUCTION AND DESIGN

Built and lit in 1876 but not operational until 1877, the Canadian Department of Marine's 1877 Annual Report described the original Lamb Island Lighthouse as follows:

This is a square wooden tower, with dwelling-house attached, and stands on the middle of the Island, 90 feet [27.4 m] above the lake. The tower is 46 feet [14 m] high from base to vane, and this light can be seen for 20 miles [32.2 km]. The lantern is constructed of iron, 8 feet [2.4 m] in diameter, and has four circular lamps, No. 1, with 19-inch [48.3 cm] reflectors, size of glass, 36 x 36 inches [91.4 x 91.4 cm]. It is a white fixed catoptric light.

The Lamb Island Lighthouse, located off the outer side of the Black Bay Peninsula, was staffed with lighthouse keepers from 1877 to 1989. *Lois Nuttall*

The report noted that the deck of the lantern leaked and a new cover was required. Otherwise, the station was in "good order," with John Michelson as the first keeper. The report also mentions that Michelson had built a 29 by 14.5-foot (8.8 by 4.5 m) boathouse constructed of lumber left by contractors, as well as using lumber found on shore.

In 1896, the lighthouse was reported to be in "bad state of repair" due to continued leaks and was rebuilt at a cost of $818.46. In 1909, a fourth-order Fresnel lens replaced the original catoptric light and 17 years later, in 1928, a fog-signal building with a diaphone foghorn was added (originally it was a hand-operated foghorn). In 1930, the characteristics of the light was changed from fixed white to a white flash every 25 seconds. In 1961, the original tower was replaced by a 40-foot (12.2 m) square pyramidal steel skeletal white tower with a focal plane of 100 feet (30.5 m).

BACKGROUND

The lighthouse became operational in 1877, 10 years after Canadian Confederation, which brought Canada into existence. To support the growing marine traffic on Lake Superior carrying supplies, mining extractions, and the expected influx of immigrants to Western Canada, the Canadian government built the Lamb Island Lighthouse as a coastal light to lead vessels to Thunder Bay, to warn of nearby shoals, and as a marker for the western side of the narrow channel into Nipigon Bay.

Keeper Tales

From 1876 to 1989, there were 19 keepers at Lamb Island Lighthouse, with the longest-serving being Andrew Alexander for 33 years (1897 to 1931). The last known keeper was Charles Lorne Gibson, who left at the end of the navigation season in 1989. The lighthouse was de-staffed in 1990.

In 1937, lighthouse keeper Arthur John Newman took charge of Lamb Island Lighthouse with his wife, Mabel Emma Jenn, who had been brought to Canada at age 17 by the British children's charity Dr. Barnardo's Homes, established in 1866. (Between 1882 and 1939, Barnardo's sent 30,000 children to Canada; today it is called Barnardo's, with more than 5,000 employees.) The couple married on March 31, 1925, in Port Arthur, Ontario, had four children, and were lighthouse keepers at No. 10 Lighthouse (also known as Shaganash or Magnet

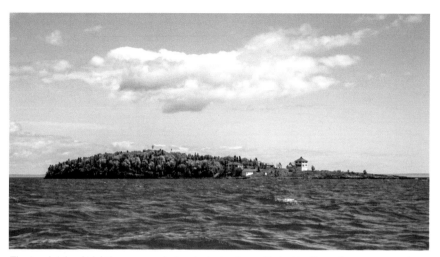

The Lamb Island Lighthouse was designated a heritage site by the Canadian government in 2015. *Lois Nuttall*

Point) before coming to Lamb Island. Mabel wrote the article "Life on a Lighthouse" in the December 1946 issue of *Ups and Downs*, the magazine of the Canadian Branch of Dr. Barnardo's Homes:

"For sixteen years we have lived on a lighthouse! This is a more important station here, so we have to stay wide-awake and keep twenty-four-hour watch. We are one happy family, I'm glad to say. This work means we can all work together and never be apart. Some of our well-meaning friends call this a God-forsaken job, but we don't look on it as such ... We like to watch the storms on the lake, but at the same time we never forget to ask God's blessing on the sailors."

When Arthur Newman died at the lighthouse in November 1951, his son Arthur Jr. flew in on a small plane to finish the keeper's duties for the season. Mabel flew out on the outgoing flight; however, the plane was too small to carry Arthur's body and a tug was called to bring him out. Mabel died 40 years later; both are buried at Riverside Cemetery in Thunder Bay, Ontario.

INTO THE TWENTY-FIRST CENTURY

In 2015, Lamb Island Lighthouse was granted heritage site designation under the Heritage Lighthouse Protection Act by the Canadian Government. On the site, seven related buildings were identified as contributing to the heritage character of the lighthouse: the 1961 keeper's dwelling, the 1952 assistant keeper's dwelling, the 1960 generator building, the pump house, the 1928 fog plant, the 1912 boathouse, and the survival building.

IN MEMORY OF
THOMAS LAMPSHIRE
... ISLAND LIGHTKEEPER
DIED 1863

St. Ignace Lighthouse

LOCATION: Western Lake Superior, on Talbot Island, just south of St. Ignace Island (the second-largest island in Lake Superior) and about 62 miles (100 km) east of Thunder Bay

BUILT: 1866–1867

LIT: July 1, 1867

DE-COMMISSIONED: 1873

STATUS: No longer in existence; only overgrown foundation ruins remain. When it was established in 1867, it was the first Canadian lighthouse on Lake Superior.

OPEN TO PUBLIC: Island open to public

GETTING THERE: Accessible by boat

CONSTRUCTION AND DESIGN

Built on tiny Talbot Island, the St. Ignace Lighthouse was one of six "birdcage" lighthouses constructed in Ontario in 1866. It was commissioned in 1867, the same year as Canadian Confederation. The two-story lighthouse was a simple but functional 20-foot-square (6.1 m) wooden box building topped by a smaller square box with a cast iron "birdcage" lantern gallery held together with eight metal hoops that arched around the lantern, giving it the appearance of a birdcage. An Argand lamp with a 16-inch (40.6 cm) reflector was the usual light source in birdcage-style lanterns.

BACKGROUND

St. Ignace Lighthouse was the first lighthouse erected by the Canadian government on Lake Superior, established in 1867, the same year that Canada was

A cross marks the grave of Thomas Lamphier, a lighthouse keeper who died unexpectedly at the remote St. Ignace Lighthouse, which some call the "lighthouse of doom." *Lois Nuttall*

created by the British North American Act of 1867. Although placed on Talbot Island, it was known as the St. Ignace Lighthouse.

The sliver-shaped rocky spit of land was considered by the area's Ojibwe people to be cursed and haunted by evil spirits, but the Canadian government ignored their words and established the light station on the island.

Keeper Tales

Though only in existence for five years, from 1867 to 1872, the St. Ignace Lighthouse has a dark history, earning the title of Lake Superior's Lighthouse of Doom.

Its first light keeper, William Perry, arrived on Talbot Island in 1867. His first season went well, and after navigation closed in November, he headed out in his small open boat for the Hudson's Bay Post at Nipigon, about 25 miles (40.2 km) away. At that time, light keepers were expected to arrange their own transportation off the islands at the end of the shipping season. Perry never arrived at his destination. The following spring, 14 miles (22.5 km) short of his destination, his body and abandoned boat were found on the mainland shore on a bay near the Silver Islet community. The bay was later named Perry Bay in his honour, and is the location of the famous Sea Lion rock formation.

After Perry's death, Thomas Lamphier, a retired Hudson's Bay Company (HBC) mariner originally from Yorkshire, England, was hired as the lighthouse keeper along with his First Nation wife from Hudson Bay as his unpaid assistant. Lamphier—who had served as a HBC boatman, seaman, and sloop master from 1831 to 1862 at Moose Factory, Sault Ste. Marie and Lake Superior—had over 23 years' sailing experience on Lake Superior, including sloopmaster/skipper on the 40-ton schooner *Whitefish* and *Isabel*.

The Lamphiers planned to stay the 1868–1869 winter on the island, and to better accommodate them the government built a separate, winterized keeper's house. Shipping season ended, navigation closed without any problems, and winter freeze-in set in. Then, the unexpected happened. Thomas suddenly became ill and died in midwinter, leaving his wife stranded alone on the remote tiny island with the body. A strong, resourceful woman, she wrapped Thomas in canvas and wedged his body into a rock crevice behind the lighthouse. Rescue didn't arrive until spring when a passing canoe party of Ojibwe people saw a woman— Lamphier's wife, whose black hair had turned white during the winter— frantically waving, and they landed on the island. They took Thomas's

body and buried him on nearby Bowman Island. A white cross now marks his grave with a bronze plaque, "In memory of Thomas Lampshire, Talbot Island Light house, died 1869." ("L a m p s h i r e" should have been "Lamphier.")

Although the St. Ignace Lighthouse was on Talbot Island, Thomas Lamphier was buried on nearby Bowman Island, shown here. *Lois Nuttall*

Two years, two keepers, two deaths. Was the island really cursed?

St. Ignace Light's third keeper, Andrew Hynes, closed the lighthouse for the season, loaded his small boat, and under clear weather set off toward Silver Islet, about 50 miles (80 km) southwest of Talbot Island. But Lake Superior is known for sudden, ferocious winter storms and soon, Hynes found himself in the midst of one. He battled the lake and the elements for 18 days before finally reaching Silver Islet where he died from exposure a few days later.

In the government's 1872–1873 annual marine report, it notes that two of the three keepers had died trying to return from the lighthouse and that, "...owing to this fact, and to the light now being of comparatively little importance to navigation in Lake Superior, it has been decided to discontinue it."

The lighthouse was abandoned, having already become known as the Lighthouse of Doom. Six years after ignoring warnings from the Indigenous people about the hexed Talbot Island, the lighthouse that the government had insisted was absolutely essential was deemed to be of "little importance."

According to local lore, on foggy nights, the lighthouse continues to be an unofficial beacon, even without a light. Apparently, like the eerie warning of a lighthouse fog bell over water, the stick-banging sound made by commercial fisherman on the side of the lighthouse during foggy nights guided others into the safe harbor.

Stories persist that sometimes a white-haired woman can be seen silently walking through the trees on Talbot Island.

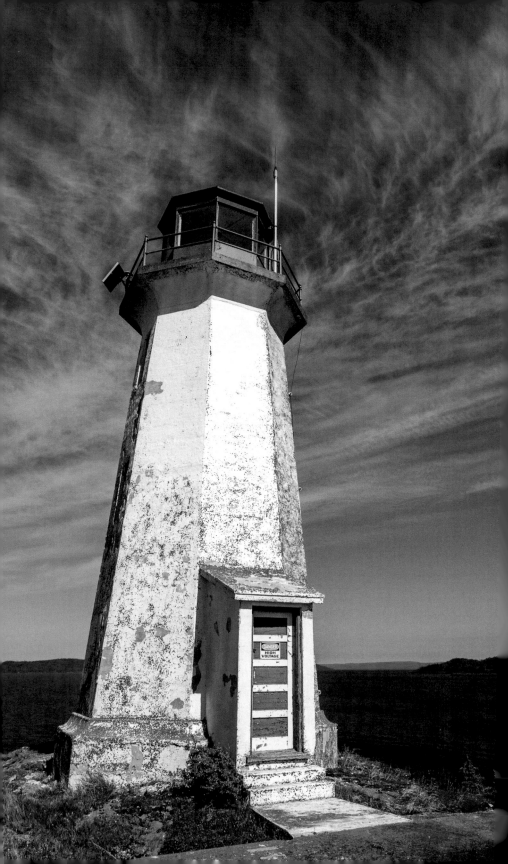

Battle Island Lighthouse
(also known as Battle Island Light)

LOCATION: Northwest Lake Superior, on the southwest point of Battle Island, seven miles (11.2 km) out from Rossport. It is the northernmost Canadian lighthouse on the Great Lakes.

BUILT: 1877 (original); 1915 (current)

LIT: August 27, 1877; May 12, 1915

AUTOMATED AND DE-STAFFED: 1991

COORDINATES: N 48 45 06, W 87 33 26

STATUS: Active aid to navigation; seasonal

CHARACTERISTICS OF LIGHT: Flash three white, 24 seconds (flash, four-second interval, flash, four-second interval, flash, 16-second interval)

OWNED BY: Fisheries and Oceans Canada

SITE MANAGED BY: Friends of Battle Island Lighthouse

PUBLIC ACCESS: Grounds only

GETTING THERE: Accessible only by water; charters are available in Rossport, Ontario

CONSTRUCTION AND DESIGN

The original lighthouse at Battle Island was built by Joseph White in 1876–1877, and placed in operation on August 27, 1877. The tower and keeper's dwelling were separate structures, with the tower located about 300 feet (92 m) from the house. In their 1877 report, Canada's Department of Marine described the new light station:

The Battle Island Lighthouse is the northernmost lighthouse on the Great Lakes.
Richard Main

The lighthouse on Battle Island exhibits a revolving catoptric light, showing alternately red and white, and attaining its greatest brilliancy every one-and-a-half minute. It is elevated 105 feet [32 m] above water mark, and in clear weather should be seen 18 miles [29 km]. The tower is square wooden building, 30 feet [9.1 m] high from base of structure to vane of lantern, and is painted white. The keeper's dwelling is situated a little distance from the lighthouse. This light was put in operation on the 27th August last.

Construction began in 1914 to replace the original tower with the current octagonal reinforced concrete structure topped with a gallery and a red octagonal lantern. Built on a steep rock face, the 43-foot (13 m) white tower with a height above water of 117 feet (36 m) was completed the following year and placed in operation on May 12, 1915. The characteristics of the new white flashing light were: flash, four-second interval, bright flash, four-second interval, bright flash, 16-second interval. The illuminant was petroleum vapor burned under an incandescent mantle.

Parks Canada has described the new tower as a "revival of classically inspired architecture during early twentieth century."

The same year (1915), a new two-story duplex keeper's house was built to house a keeper and assistant keeper as needed. Also completed was a square wooden building to house a fog alarm, which blasted a 3.5 second alarm every 30 seconds, and replaced the original hand-operated foghorn.

BACKGROUND

The original Battle Island Light was built in 1877 to guide vessels into the Wilson and Simpson channels on their way to the eastern entrance of Nipigon Bay, like the *Erin* carrying rails and equipment and *Spartan* carrying men and food supplies to the nearby small village of McKay's Landing (present-day Rosslyn) for the construction of the national mainline of the Canadian Pacific Railway. The current lighthouse was built in 1914–1915 to better serve the increased maritime traffic of the pulp industry and commercial fishermen.

A mystery about Battle Island which continues to baffle people: How did the island get the name "Battle Island"? The most often-told explanation goes back to 1885 when the Canadian militia were on their way to Western Canada to crush the North-West Rebellion. As the story goes, the militia were travelling on frozen Lake Superior from the village of Jackfish to Rossport—a land gap where there was no railroad—when snipers fired at them when they were

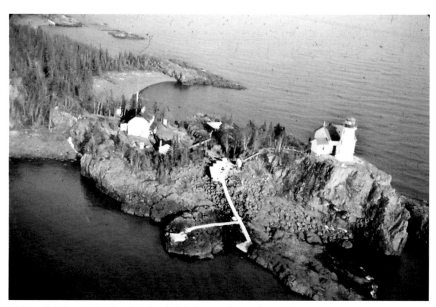

This aerial view of the Battle Island Lighthouse shows the rocky terrain on which it's built.
Ron Walker

by the island, which supposedly was thereafter named Battle Island. But the story is a myth. Ten years earlier, in 1875, the island was already listed as Battle Island in the records of the Department of Marine.

Keeper Tales

The first official lighthouse keeper on Battle Island was 40-year-old Charles Stephen McKay, who first lit the light on August 27, 1877, and stayed for 36 years, retiring at age 76 in 1913. McKay's Harbour (today's Rossport) was named after Charles and his father Alexander McKay, a fur trader who operated a small post at Pays Plat. Charles McKay's sailing ventures are now legendary. One year, he left Battle Island in early December and rowed/sailed his small skiff nearly 300 miles (482 km) along the northern shore of Lake Superior to his family home in Sault Ste. Marie, Ontario, arriving on Christmas Eve. Another time, he rowed/ sailed in open water from Battle Island to Port Arthur (now Thunder Bay), a distance of about 80 miles (130 km). Upon his retirement, Charles received the Imperial Service Medal presented by British King George for completing 25 years of meritorious service.

An accidental drowning took the life of 37-year-old lighthouse keeper Malcolm Sutherland in 1932 after his motorboat capsized. Sutherland

had been the lighthouse keeper since 1922. After Sutherland's death, his wife Eunice completed the keeper duties for the season. Their son, John J. Sutherland, took charge of the station the following year (1933), serving until 1948.

In the 1950s, Battle Island keepers had to deal with a "moose on the loose," when a young, lone moose decided to make its home on the island. As the moose grew, he created havoc in the garden and ruined equipment, earning the name Obnoxious. Things turned ugly when Obnoxious became a dangerous nuisance, snorting and charging keeper George Brady when he stepped outside, at times even cornering him in the light tower. The situation caught the attention of media, resulting in Brady receiving letters from across Canada and the U.S. By the fall of 1954, Brady had had enough of Obnoxious. After one failed attempt by the game warden to capture Obnoxious, the warden successfully got the moose into the water and directed him to another island. Obnoxious never returned.

By the end of the 1991 navigation season, all the lighthouses on the Great Lakes had been automated. The last keeper of Battle Island Lighthouse was the assistant keeper Bert Saasto, who also had the distinction of being the last lighthouse keeper taken off the Great Lakes. He was first appointed to Battle Island in 1978, and retired 13 years later in November 1991. However, Saasto continued to return to Battle Island each summer as the resident caretaker until his death in 2013.

Shipwreck Tales

At the east end of Battle Island, a ship's boiler sits on shore with another one nearby in 10 feet (3 m) of water, marking the shipwreck site of the 181-foot (55.2 m) steamer *Ontario*. On the afternoon of Thursday, August 10, 1899, during a summer snowstorm, she was driven ashore and stranded before being destroyed by waves. Her crew was rescued, but the *Ontario* was a total loss of approximately $12,000.

According to the Port Huron newspaper the *Daily Times* (August 11, 1899), "The *Ontario* had in tow the *Wawanosh*, owned by Sarnia parties and the *Eureka* owned by W. D. Ragan of this city. The *Wawanosh* reached Rossport and a tug rescued the *Eureka*. The vessels were bound for Nipigon, Ontario, for a load of pulpwood for the Sulphite Fibre Works of this port."

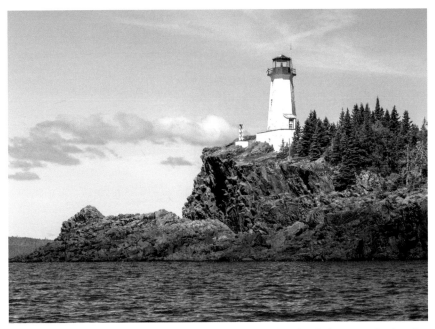

You can charter a boat in Rossport to visit the Battle Island Lighthouse and enjoy the surrounding scenery. *Lois Nuttall*

INTO THE TWENTY-FIRST CENTURY

Battle Island Lighthouse is operated by the Friends of Battle Island Lighthouse under lease from Fisheries and Oceans Canada. The tower was recognized as a Federal Heritage Building June 27, 1991.

Slate Islands Lighthouse

LOCATION: Northeast Lake Superior, on the summit of a hill on the southeast side of Sunday Point on Patterson Island, the largest island of the Slate Islands

BUILT: 1903

LIT: 1903

AUTOMATED AND DE-STAFFED: 1989

COORDINATES: N 48 37 16, W 86 59 45

STATUS: Active aid to navigation

CHARACTERISTIC OF LIGHT: Pair of white flashes every 15 seconds (flash, eclipse 3.5 seconds, flash, eclipse 11.5 seconds every 15 seconds)

OWNED BY: Fisheries and Oceans Canada

OPEN TO PUBLIC: Yes, site only; tower closed

GETTING THERE: Accessible only by water

CONSTRUCTION AND DESIGN

Slate Island Lighthouse was built in 1903 by contractor William Fryer of Collingwood, Ontario, who also built the Lake Superior lighthouses at Otter Island and Ile Parisienne for Canada's Department of Marine (today's Fisheries and Oceans Canada). When completed, it was the highest light on the Great Lakes.

Situated on the summit of a hill on the south side of Sunday Harbour on Patterson Island—the largest of the Slate Islands archipelago—the 36-foot (11 m) octagonal wooden tapering tower was painted white and topped by a polygonal iron lantern painted red. The white fixed light exhibited from the seventh-order Fresnel lens was a height of 224 feet (68.2 m) above the waters of

A replica of the Slate Islands Lighthouse exists in nearby Terrace Bay. *Lois Nuttall*

the lake. In 1914, the characteristics of the light changed from fixed white to its current flashing white of double-flash every 15 seconds (flash, 3.5 seconds, flash, 11.5 seconds).

Unique to the Slate Island, Otter Island, and Ile Parisienne Lighthouses is the beaver-shaped weathervane on top of the gallery.

The original keeper's wooden dwelling, painted white with red trim, was built in 1903 on the beach at the foot of Sunday Bay, northeast of the light. To get to the light, it was a steep trek to the hilltop tower. Later, two modern keeper's buildings were built on the south shore of Patterson Island, south of the lighthouse, along with a fog-alarm building, generator building, and survival building.

An automatic radio beacon was installed in 1926, and in the mid-1930s, a generator was put in service to keep the light lit round the clock. The lighthouse staff was reduced from three keepers (one head keeper and two assistant keepers) to two keepers (one head keeper and one assistant keeper).

In 1989, the light was fully automated and visible for 20 miles (32.2 km). In 1989—after 86 years of lighthouse keeper services—the station was de-staffed. Also removed was the last operational pneumatic foghorn system on the Great Lakes, which is now on display at the visitor centre of the Neys Provincial Park.

BACKGROUND

Slate Islands Lighthouse was built on Patterson Island, the largest of the Slate Islands, as a navigational point for mariners, a marker to the entrance into Jackfish Harbour and the bustling railway town of Jackfish, Ontario (now a ghost town), and as a marker for vessels heading into Nipigon Bay. The lighthouse also served as a beacon for vessels seeking refuge from storms.

The Slate Islands archipelago is formed of two main islands (Patterson and Mortimer), five minor islands, and numerous islets, located south about eight miles (12.9 km) offshore from the railway town of Terrace Bay. The Ontario government established the Slate Islands Provincial Park in 1985 as an Ontario Natural Environment Provincial park to protect the archipelago. The lighthouse, however, is not part of the park.

Unlike other islands in Lake Superior, the Slates have an unusual story behind their existence. The leading theory about the formation of the Slate Islands is they were created when a large meteorite, perhaps one mile (1.5 km) in diameter, crashed into Earth about 450 million years ago. Upon impact, the meteorite vaporized, forming a crater estimated at about 18.6 miles (30 km)

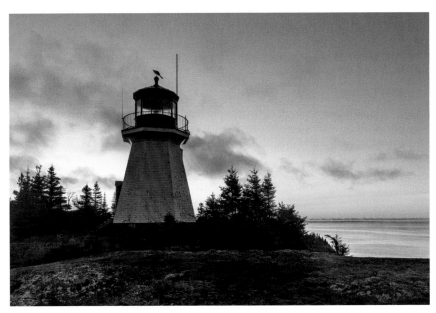

The Slate Islands were likely formed by a meteorite strike creating unusual geology. *Richard Main*

in diameter, with the edge close to the mainland. As the theory goes, most of the crater has eroded away, and it is the central uplift area that became the Slate Islands. The rock is mainly of metamorphose volcanic rock more than 2.7 billion years old.

Located on the islands are examples of shatter cones, conical-shaped rare geological features formed by shock waves from the meteor impact that shattered the rock. McGreevy Harbour on Patterson Island is home to one of the world's largest known exposed shatter cones, measuring about 30 feet (9.1 m) long.

The Slate Islands Provincial Park has the notable distinction of being home to Ontario's largest herd of rare boreal woodland caribou (*Rangifer tarandus caribou*). The first record of woodland caribou was in 1907, when a lighthouse keeper noticed their tracks along the ice bridge connecting the Slates to the mainland. Over the years, the caribou population grew to around 600 in 1984 before declining to a couple of hundred in 1995. Two albino caribou were tagged here in the 1980s by the Ontario Ministry of Natural Resources. Woodland caribou are recognized as a "threatened species" by both Canada's Species at Risk Act and Ontario's Endangered Species Act.

Keeper Tales

Eight head keepers tended the Slate Island Lighthouse for 86 years, from 1903 when the station was established to 1989 when the station was automated and de-staffed.

The first keeper was Peter King of Port Arthur (now Thunder Bay) who served from 1903 to 1908; the last keepers were Orton Rumley and his wife Ruth (assistant keeper), who served 10 years from 1979 to 1989.

The longest-serving keeper was John (Jack) Bryson, from 1948 until 1978. In his early days, Bryson, his wife Flora, and their four sons were transported to the station by the tug *James Whalen*. They were picked up at end of the navigation season, usually about mid-December when Lake Superior could be stormy and wild. During the Bryson's December trip back to Port Arthur about 1950, the waters were so rough the tug stopped at Trowbridge Island Lighthouse for two days. When the ice-coated *Whalen* finally reached Port Arthur, the thick ice on the cabin door had to be chopped off before the passengers could get out.

In the 1950s, the Canadian Coast Guard icebreaker/lighthouse tender *Alexander Henry* began transporting the keepers, their families, and supplies to their stations; in the mid-1970s, helicopters began flying them direct from Thunder Bay to their station. (The *Alexander Henry*, launched in Port Arthur in 1958, decommissioned in 1985 and sent to Kingston as a museum ship for the next 32 years, was returned to Thunder Bay in June 2017. She is now a museum ship moored at the city waterfront at Prince Arthur's Landing, Marina Park.)

When Bryson retired after 30 years in 1978, the Coast Guard leased to him the original keeper's dwelling—which he and his family had been fixing up prior to Jack's retirement—to use as a summer home. Currently, the family continues with the arrangement of leasing and maintaining the structure.

INTO THE TWENTY-FIRST CENTURY

Built in July of 2011, a 50-foot (15.2 m) replica of the Slate Island Lighthouse was built in the town center of Terrace Bay just off the Trans-Canada Highway and given the name Terrace Bay Lighthouse.

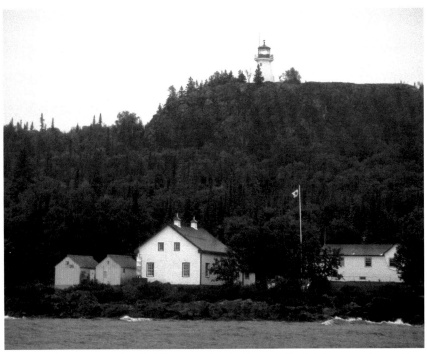

The keeper's quarters and outbuildings were located beneath the lighthouse on the south side of Patterson Island, facing the open lake. *Larry Wright*

Today, on the south side of Patterson Island, remains the two keeper's dwellings and buildings that once housed the fog alarm and generator plus the survival building. The original keeper's white with red trim house is still located on Sunday Bay, northeast of the lighthouse.

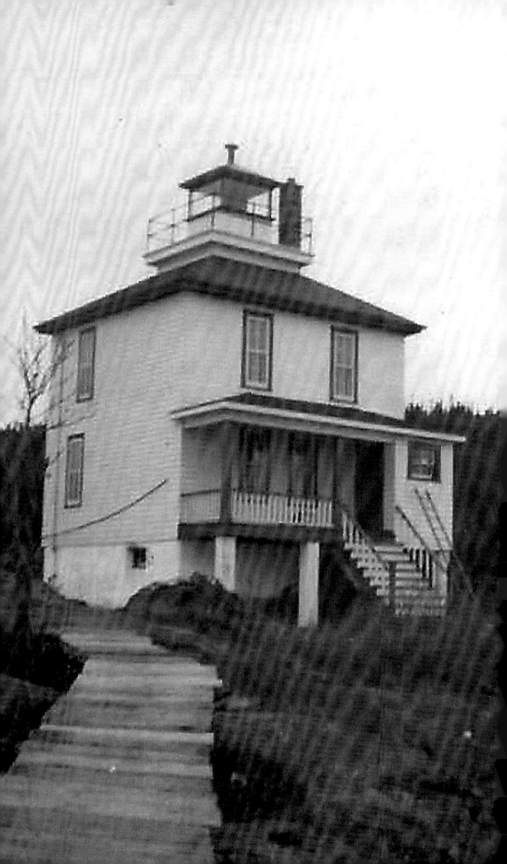

Hawkins Island Light
(formerly known as Peninsula Harbour Light)

LOCATION: Northeast Lake Superior, on the southwest end of
Hawkins Island at the entrance to Peninsula Harbour, near
present-day Marathon, Ontario

BUILT: 1891

COORDINATES: N 48 43 10, W 86 25 54

STATUS: Active aid to navigation; seasonal

CHARACTERISTICS OF LIGHT: Flashing white every four seconds

GETTING THERE: Site accessible by boat

CONSTRUCTION AND DESIGN

Built in 1891, the station was a combined square wooden building with a
keeper's dwelling and white tower. The 56-foot (17.1 m) tower was topped with
a red iron lantern that displayed a white flashing light every 30 seconds using
lamps and reflectors. Focal height was 105 feet (32 m) above the water and vis-
ible for 16 miles (25.7 km). A hand-operated foghorn was used to respond to
ship's signals during reduced visibility.

The lighthouse was demolished in 1975. It was replaced by square skeleton
tower with white slatwork daymark. Height above ground is 42 feet (12.8 m)
with flashing white light every four seconds. The focal height above water is 89
feet (27.1 m) and visible for five miles (8 km).

Demolished in 1975, the Hawkins Island Light marked the entry to Peninsula Harbor, where
the community of Marathon is located. *Larry Wright*

BACKGROUND

The lighthouse station was situated on the 146-acre island—later named Hawkins Island—to mark Peninsula Harbour and Lake Superior's north shore.

According to Marathon's Historical Plaque, the first record of Peninsula Harbour is on a map drawn in 1650, currently kept in Paris. Peninsula Harbour is also clearly outlined on a map published by the Jesuits, and is based on the 1667 circumnavigation of Lake Superior by Father Claude Allouez.

Approximately 1.8 miles (3 km) wide and 2.5 miles (4 km) long, Peninsula Harbour is sheltered from Lake Superior waters by the two islands of Hawkins and Blondin, and by the two peninsulas Ypres Point to the north and the Peninsula to the south. The harbor has multiple coves, including Jellicoe, Beatty, and Carden.

Because of its deep, sheltered location, Peninsula Harbour—present-day Marathon—was chosen in the early 1880s by railway builder William Van Horne as the regional base during construction of the Canadian Pacific Railway (CPR) along Lake Superior. According to the Marathon & District Historical Society, about 12,000 workers were living in Peninsula Harbour at its peak, working on building this difficult stretch of the railway.

After 1944, when a pulp mill was constructed at Peninsula by Marathon Paper Mills of Canada Ltd., the community took on the name of Marathon, with the Geographical Name Board of Canada officially designating it the Town of Marathon in 1988.

Opposite the former mill site is Hawkins Island, officially named in 1968 after the lighthouse station's second and longest-serving lighthouse keeper David Beacon Hawkins, who was at the lighthouse from 1922 until his retirement 26 years later, in 1948. A street in the town of Marathon is also named in his honor.

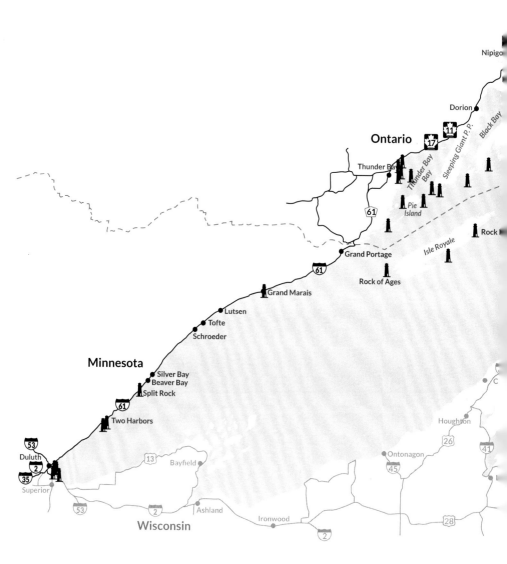

Ontario East

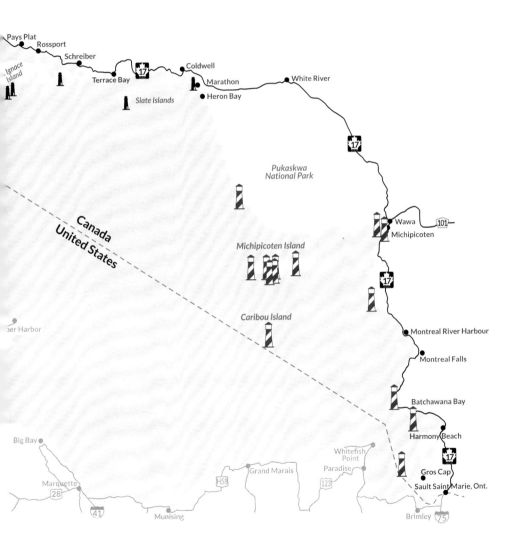

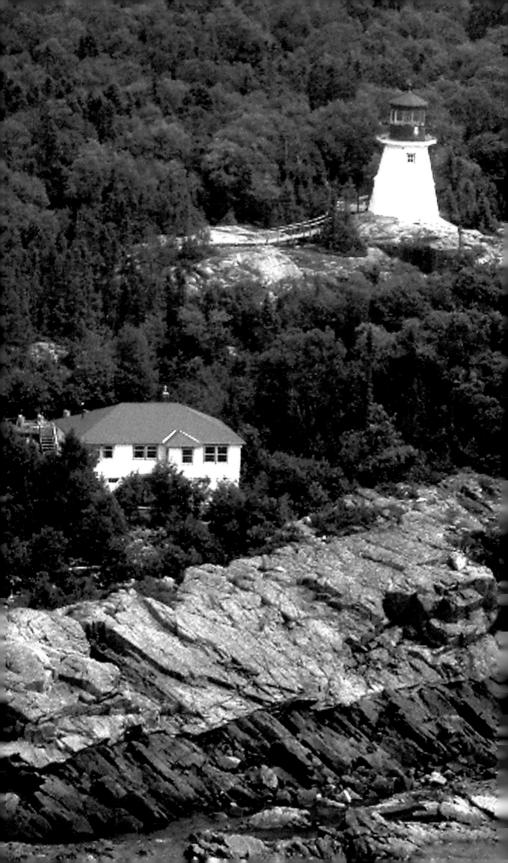

Otter Island Lighthouse

LOCATION: Northeast Lake Superior, on the northwest tip of small
Otter Island, north of Michipicoten Island and 137 miles
(220.5 km) west of Sault Ste. Marie

BUILT: 1903

LIT: October 23, 1903

COORDINATES: N 48 06 42.2, W 86 04 00.1

STATUS: Active aid to navigation; seasonal

CHARACTERISTICS OF LIGHT: Flashing white every 10 seconds (flash one second;
eclipse nine seconds)

OWNED/MANAGED: Owned by Fisheries and Oceans Canada, Canadian Coast
Guard

SITE MANAGER: Pukaskwa National Park

OPEN TO PUBLIC: Site open; tower closed

GETTING THERE: Accessible only by boat

CONSTRUCTION AND DESIGN

Otter Island Lighthouse was constructed by William Fryer, who also built
the Ile Parisienne Lighthouse and Slate Island Lighthouse. Interestingly, all
three lighthouses were topped by a rotating beaver-shaped weathervane.

The light tower is an octagonal wooden concrete structure, painted white,
with sloping sides and topped by a gallery and red iron lantern. The first light
was a temporary fixed white light in 1903, a seventh-order dioptric lens in the
lantern with a focal height above water of 97 feet (29.6 m) and was visible for
10 miles (16.1 km). The two-story main keeper's wooden dwelling was a white
clapboard structure with red roof and trim, located on the south side of Big

Remote Otter Island Lighthouse, part of Pukaskwa National Park, is the site of tragic
occurrences. *Larry Wright*

Davies harbor inside the north point of the island. The assistant keeper's single-story dwelling used the same paint scheme, as did the boathouse.

In 1910, a hand-operated foghorn was added to the site. Four years later, in 1914, a long-focus reflector replaced the station's lens, changing the characteristics of the light to flashing white every eight seconds. The illuminant was petroleum vapor burned under an incandescent mantle. The operation of the light was temporarily discontinued in 1918 and was replaced the following year with an unattended acetylene light occulting at short intervals. A diaphone fog alarm was established on a clifftop in September 1920, about 400 feet (122 m) west of the lighthouse.

In 1988, the lighthouse became an emergency light operating all year round and is solar-powered, producing a flashing white light every 10 seconds with a focal height above water of 97 feet (29.6 m). Close to the white hexagonal tower is a helicopter pad, used by the Canadian Coast Guard when making maintenance calls to the light.

BACKGROUND

The remote island lighthouse was built in 1903 as a coastal light to help mark the shipping route on northern Lake Superior.

On April 28, 1978, by order-in-council, the Canadian government transferred the Otter Island Lighthouse site to the Pukaskwa National Park.

Keeper Tales

Keepers staffed the station from 1903 to 1987, with the first keeper being Robert McMenemy (1903 to 1916) and the last being William Wougweleeux (1985 to 1987). The station was de-staffed in 1988.

In 1912, American author of western and adventure stories Raymond Spears (1876–1950) paddled around Lake Superior and rowed to Otter Island Light to say good morning to the keeper, Captain McMenemy. Spears described the stopover in his book, *A Trip on the Great Lakes: Description of a Trip, Summer 1912 by a Skiff Traveller, Who Loves Outdoors.* When Spears told the captain that he had better be moving, the keeper said, "No, I don't think you will for a few days. You see, there is a big storm coming and the wind has come up a good deal—look!" He was right.

The storm set in and Spears ended up staying for seven days, writing, "We got along well together." During his stay, Spears observed that the keeper always carried a broomstick with him when he crossed to the

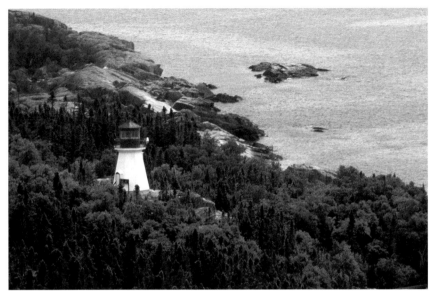

The octagonal concrete tower remains a seasonal beacon for mariners. *Larry Wright*

lighthouse, night or day, and when Spears asked why, the captain replied, "It is to keep the wolves off!"

McMenemey's tragic death a few years later was the result of a decision made by the Canadian government. In 1915, the Canadian government advised its lighthouse keepers that the government would no longer provide transportation to and from their lighthouse stations in the spring and fall. The keepers would now have to travel using a sailboat issued by the government to each station. In the book, *Great Lakes Lighthouses—Encyclopedia*, authors Larry and Patricia Wright write:

"After closing for the season, he did not make it to civilization but was later found by Indian trappers, sitting frozen against a tree. When a new keeper arrived the next spring, he found McMenemey's note saying that he was quite ill but was leaving for Michipicoten Harbour. It was believed that he landed to warm himself and drifted into unconsciousness."

Tragedy struck again on December 1, 1930, when the assistant keeper, 68-year-old Johnny Moore, was killed in a fall from the tower, his body discovered in the snow by keeper Gilbert McLachlan. Using the station's fog alarm, the keeper tried to signal passing ships until finally, 12 miles (19.3 km) away, Jack Mills from Pukaskwa heard the signal. Mills went to the island, then returned home to send a telegram for assistance, but couldn't get through due to bad weather. It was another 12 days before transport came to pick up McLachlan at the end of the navigation season, along with Moore's body.

Quebec Harbour Range Front Light and Quebec Harbour Range Rear Light

LOCATION: Eastern Lake Superior, on the north shore of Quebec Harbour on Michipicoten Island

BUILT: 1917

LIT: 1918

COORDINATES: N 47 43 00.5, W 85 47 54.3
(Rear Range Light 000 51', 214 m from Front Light)

STATUS: Active aid to navigation; seasonal

CHARACTERISTICS OF LIGHT: Continuous red light

OWNED BY: Fisheries and Oceans Canada

MANAGED BY: Michipicoten Island Provincial Park

PUBLIC ACCESS: Site open; tower closed

GETTING THERE: Accessible by water

CONSTRUCTION AND DESIGN

REAR RANGE LIGHT

Established in 1918 as the Quebec Harbour Range Rear Light, the tapering square tower was a 42-foot-tall (12.8 m) structure built about 600 feet (182.9 m) inland on the harbor's north shore. The white wooden structure topped by a gallery and lantern was built on higher elevation behind the Front Range Light. It displayed a continuous red light from a focal plane of 66 feet (20.1 m), and shone in one direction from the tower's only window, which faced the water.

Today's 17-foot (5.2 m) Front and Rear Range Lights continue to guide small vessels into Quebec Harbour. *Larry Wright*

FRONT RANGE LIGHT

The Quebec Harbour Front Range Light was the original slightly tapering Agate Island Lighthouse moved in 1917 by scow to the north side of Quebec Harbour to be the Front Range Light. The 32-foot (9.7 m) wooden tower was built in 1872 and its 8-foot-diameter (2.4 m) iron lantern displayed a fixed white light produced by two mammoth flat-wick lamps with 16-inch (40.6 cm) reflectors and 30 by 36-inch (76.2 by 91.4 cm) glass. From a focal plane of 32 feet (9.8 m), the light was visible for 10 miles (16.1 km). Once the Agate Island Lighthouse was moved to Quebec Harbour to be the Front Range Light, the lantern was modified to shine in only one direction.

With both the Front and Rear Range Lights shining in only one direction, vessels would find Quebec Harbour following a line of the two range lights into harbor.

QUEBEC HARBOUR RANGE LIGHTS: FRONT AND REAR

In 1938, the Front Range tower became a storage facility and its light was removed after being moved back to make room for the construction of a new combined keeper dwelling and light structure at Quebec Harbour. The new building had a truncated hip roof, two windows, and an open porch facing the water. The light was displayed from a dormer at the center of the building's south rooftop and except for this dormer, there were no windows at the upper level. Lighthouse supplies and equipment were stored on the second level, and the main level was the keeper's residence.

In the 1940s, the dwelling's open porch was closed and windows were added to the upper level. In the 1950s, the original Rear Range Light was replaced by a light on a 42-foot (12.8 m) steel tower.

A new keeper's house, a duplex, was built in 1963 on Davieaux Island for both the keeper and the assistant; by the late 1960s, the keeper's dwelling at Quebec Harbour (built in 1938) was abandoned and the Front Range Light moved from the center dormer to a higher location on the roof. In the early 1970s, the center and dormer windows were all closed, and a fluorescent orange vertical stripe was added to the front of the empty house as a daymark.

BACKGROUND

Quebec Harbour (historic name Refuge Harbour) is a natural harbor 2.5 miles (4 km) long and half a mile (0.8 km) wide, and is the only sheltered harbor on the south coast of Michipicoten Island. The harbor is well-known

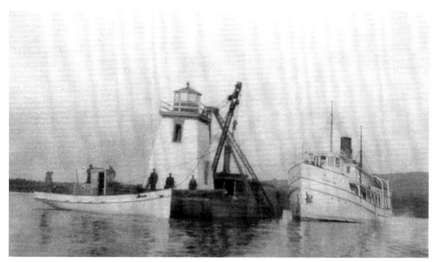

In 1917, Agate Island Lighthouse was moved to become the Front Range Light. *Ron Walker*

as a refuge for vessels during Lake Superior storms. In 1916, to better mark Quebec Harbour, the Canadian government decided to build a new lighthouse on Davieaux Island (then called Long Island) just outside the harbor entrance, and establish Front and Rear Range Lights at the back of the harbor.

In 1839, the Hudson's Bay Company had set up commercial fishing at Quebec Harbour. The fishing operations were subsequently taken over by various companies starting with A. Booth Packing Company of Chicago (at the time, the largest fish firm in the U.S.) in 1860.

In 1934, Purvis and Son took over the fish camp and expanded operations at Quebec Harbour. A seasonal fishing station with crews of 35 to 40 men from May to October, it grew to a community of about 70 people and had facilities such as docks, an icehouse, cookhouse, freezing plants, bunkhouses, houses, and a blacksmith's shop. Except for a skeletal crew, most returned to the mainland after the fishing season. By the 1930s, the fishing village was a ghost town. The Purvis Fishery ceased operations in 1957 and three years later, in 1960, sold the operation to Ferroclad Fishery out of Maimanse.

INTO THE TWENTY-FIRST CENTURY

The Front and Rear Range Lights continue to guide small vessels into Quebec Harbour. Each range light is now on a 17-foot (5.2 m) skeleton tower, carrying a daymark colored white with an orange vertical stripe. The continuous fixed red Front Range Light has a focal height above water of 21 feet (6.4 m), while the Rear Range Light has a focal height above water of 66 feet (20.1 m).

Davieaux Island Light

LOCATION: Northeast Lake Superior, on the summit at the southern end of Davieaux Island (originally called Long Island), sheltering Quebec Harbour on the south side of Michipicoten Island

BUILT: 1918

LIT: 1918

AUTOMATED: 1997

COORDINATES: N 47 41 40.9, W 85 48 40.6

STATUS: Active aid to navigation; seasonal

CHARACTERISTICS OF LIGHT: Flashing white every 20 seconds (flash 0.5 seconds, eclipse 19.5 seconds)

OWNED BY: Fisheries and Oceans Canada

SITE MANAGER: Michipicoten Island Provincial Park

OPEN TO PUBLIC: Site open; tower closed

GETTING THERE: Accessible only by boat

CONSTRUCTION AND DESIGN

Construction of a new lighthouse on the summit of Davieaux Island—formerly known as Long Island—was completed in September 1918. The lighthouse was west of the passage into the entrance to Quebec Harbour of Refuge, located in the middle of the south coast of Michipicoten Island.

The Lake Carriers' Association published the following description of the new lighthouse in 1918:

The Davieaux Island Lighthouse is situated near the approach to Michipicoten Island's Quebec Harbour. *Larry Wright*

The new lighthouse is on land 92 feet [28 m] above the level of the lake and is 100 feet [30.5 m] from the north shore of the island, and 2,400 feet [731.5 m] from its east extremity in latitude 47 degrees, 41 minutes, 42 seconds; longitude west 83 degrees, 48 minutes, 40 seconds.

The light is shown from a white reinforced concrete octagonal tower, surmounted by a red, octagonal iron lantern and is visible seventeen miles from all points of approach. The light is at a height of 129 feet [39.3 m] above the level of the lake, the tower having a height of 44 feet [13.4 m] from its base to the top of ventilator on the lantern. Petroleum vapor burned under an incandescent mantle is the illuminant.

The hand foghorn heretofore maintained at the old lighthouse will continue to be operated from the same place. It is used to answer signals from steamers in the vicinity of the station in thick weather.

The 44-foot (13.4 m) tower had a pedimental door (triangular gable over the doorway) and five tower windows; three of the five windows faced north over Quebec Harbour and the other two faced south over Lake Superior. The octagonal gallery was surrounded by a pipe iron railing and housed a red iron lantern that used kerosene lamps, reflectors, and clockwise mechanism to produce a flashing light. In 1963, the light was converted to electricity using a generator and batteries.

The hand foghorn from the old lighthouse at Chimney Point continued to be operated from the same place, answering signals from steamers in thick weather until 1919, when a fog bell was established at the east end of Davieaux Island. Eight years later (1928), a fog signal building was added to the site and in 1965, an electric fog signal was installed.

Other buildings on site were a white wood frame boathouse built on the north side of Davieaux Island, a shed to store kerosene, and a "shelter shed" to protect the keeper if trapped by inclement weather.

During a 1939 storm, the boathouse was destroyed; it was rebuilt and destroyed again by weather in 1940. Three years later (1941), a new boathouse was constructed. A helicopter pad was later added to the site.

In 1964—a year before a keeper's house was built on Davieaux Island—the assistant keeper escaped injury when fire destroyed the shelter shed, resulting in the assistant spending the summer in a tent near the helipad. More misfortune came his way when in the fall a brutal storm washed the tent into the lake, leaving him without shelter. At the time, the main keeper looked after the range lights in Quebec Harbour, while the assistant keeper looked after Davieaux Island Light.

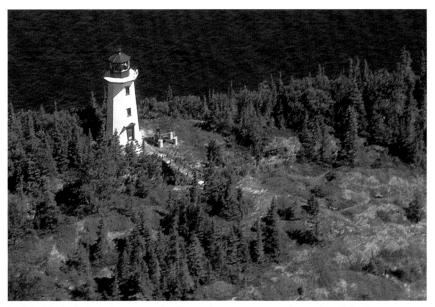

Built in 1918, the light is now serviced by maintenance crews that arrive via helicopter.
Larry Wright

In 1991, the Davieaux Island Lighthouse was de-staffed and was automated in 1997. Light is exhibited on the white hexagonal tower with a focal height above water of 129 feet (39.3 m).

BACKGROUND

The original 1918 lighthouse on Davieaux Island was built to warn mariners of the nearby shoals that were south and west of the island, and to guide vessels to the approach to Quebec Harbour. According to a U.S. Lake Survey Pilot Guides bulletin of 1914, there was a rocky ledge with 7-feet least depth (2.1 m) south of Agate Island and west of Michipicoten Island, as well as a boulder shoal with 7-feet least depth (2.1 m) in the center of the channel opposite the southeast end of Agate Island.

Davieaux Island Lighthouse signaled to vessels the approach to Michipicoten Island and to the range lights to enter Quebec Harbour of Refuge.

Keeper Tales

The Davieaux Island Lighthouse was lit in 1918 by its first lighthouse keeper, Charles Davieaux. He had taken over keeper duties of the two Michipicoten Island lighthouses built in 1872 at Chimney Point (known now as Purvis Point) and Agate Island from his father, Hyacinthe Davieaux, who was the keeper from 1881 until he died in 1910. Hyacinthe lived with his wife and children, including son Charles, at the keeper's dwelling at Chimney Point.

Once appointed in 1910, Charles would row out each day from Chimney Point to Davieaux Island (then called Long Island) to light the lamps about an hour before sunset. Then at about midnight, he would climb up to the lantern to trim the lamp wicks, check the fuel, and wind the clockwork weights. He usually stayed at the island throughout the night and would extinguish the lamps in the morning before rowing back to the main lighthouse.

Charles (1863–1949) was the lighthouse keeper until 1933, at age 70, when his son Joseph took over keeper duties for the 1933 navigation season. Charles moved to Sault Ste. Marie with his wife and family, where they had bought a 10-acre farm. He died in 1949 at age 86. In honor of the long years of service by Charles Davieaux, his father, Hyacinthe, and their families, the Canadian government renamed Long Island "Davieaux Island."

In 1938, a keeper's dwelling was built at the Quebec Harbour's Front Range Light and in 1965, a new $30,000 duplex to house both the head and assistant keepers was built on Davieaux Island.

Shipwreck Tales

On November 14, 1906, a violent gale pushed the 205-foot (62.5 m), 1,101-ton Canadian steamer *Strathmore* onto the rocks and sank her in the waters around Michipicoten Island. She was carrying 31,000 bushels of wheat from Fort William (now part of Thunder Bay) to Kingston. Captain Patrick Sullivan and his 12-member crew had launched the yawl, battled through the waves to shelter on the island, and two days later, the tug *Boynton* rescued them off the island. The recovered anchors are now at a park in Sault Ste. Marie, Ontario.

Just about one mile (1.6 km) away from the *Strathmore* is another shipwreck. It was 23 years later, on October 22, 1929 when a ferocious snowstorm with 50 mph (80.5 kmh) winds, pelting snow and gigantic

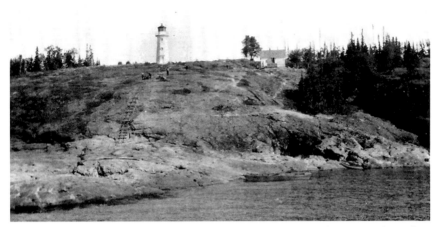

This early photo shows a ramp made of timbers extending from the light tower to the rocky shore. *Larry Wright*

waves tossed the 324-foot (98.8 m), 3,195-ton *Chicago* around in such raging seas that Captain P. C. Farrell lost control. Historian-author Julian Wolff described in his book, *Lake Superior Shipwrecks*, that *Chicago* "was given an out-of-control ride of more than 150 miles [241.4 m] southwest of Michipicoten Island" and grounded in the surrounding shallow waters.

According to Wolff, the crew stayed on board overnight, but the next day Captain Farrell gave the order to abandon ship before *Chicago* sank. Two lifeboats had been launched for the 32-member crew; both successfully made it to Michipicoten Island where they set up camp and prepared for a long wait for rescue.

After two days of failed rescue attempts because of high seas, first by the passing Canadian steamer *Goderich*, then by the tugs *James Whalen* and *Strathmore*, 24 of the crew members were rescued by lifeboats from the U.S. Coast Guard cutters *Seminole* and *119*. The other eight crew members had hiked 10 miles (16.1 km) to Quebec Harbour and were met by the USCG's cutter *119*. No lives were lost, but *Chicago* was a total loss at $167,500.

Chimney Point Lighthouse
(also known as the Old Quebec Harbour Lighthouse)

LOCATION:	Northeast Lake Superior, at the tip of Chimney Point (Magnetic Point) peninsula forming the east side of Quebec Harbour on the southern shores of Michipicoten Island
BUILT:	August 1872
DECOMMISSIONED:	1918
STATUS:	Inactive
OPEN TO PUBLIC:	Yes
GETTING THERE:	Accessible by boat

CONSTRUCTION

The lighthouse was built by contractor Captain Charles Perry, similar to the original Porphyry Point Lighthouse in western Lake Superior, combining the keeper's house and wooden tower in a unique three-story building with large rectangular windows on all levels.

Rising from a side of the single-story keeper's house was the square tower, 32-feet (9.7 m) in height from base to vane. The tower was topped by an octagonal gallery supported by carved wooden corbels and housed an octagonal iron lantern capped with a dome and ventilator shack. In 1873, a year after the station was established, a fog bell weighing 960 pounds (435.4 kg) was added to help ships find the harbor in dense fog.

The lantern's fixed white light was originally produced with five No. 1 circular-burner lamps set in 20-inch (50.8 cm) reflectors. However, by the time

Constructed in 1872, the Chimney Point Lighthouse marked the entrance to Michipicoten Island's Quebec Harbour until it was abandoned in 1918. *Larry Wright*

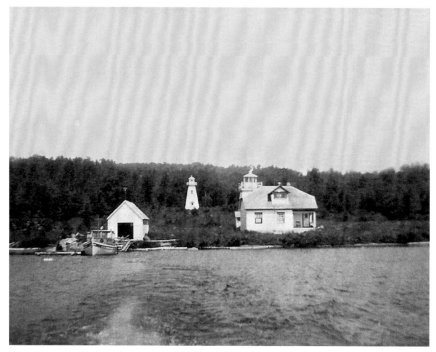

View from a motor launch leaving Michipicoten Island. *Larry Wright*

Darius Smith, the Canadian Superintendent of Lighthouses above Montreal, visited the lighthouse in 1878, the light had been changed to what he described as, "white catoptric light from an iron lantern 8 feet [2.4 m] in diameter, containing three mammoth flat-wick lamps, with 20-inch [50.8 cm] reflectors." Focal height above the water was 56 feet (17.1 m) with visibility for 13 miles (21 km).

BACKGROUND

In 1872, the Canadian government built lighthouses at both Chimney Point and Agate Island to mark the entrance to Quebec Harbour for local commerce and commercial fishing, and also to provide coastal lights for the increasingly busy east-west shipping route along Lake Superior's north shore. The two lights also signaled a safe harbor for ships during storms. Quebec Harbour, a natural harbor, is 2.5 miles (4 km) long, .5 miles (0.8 km) wide, and deep enough for good anchorage.

In 1916, the Canadian government decided to build a new lighthouse at Long Island (later renamed Davieaux Island) just outside the entrance to

Quebec Harbour, and to move Agate Island Lighthouse to Quebec Harbour as one of the range lights. When the new light changes were completed and lit in 1918, the Chimney Point Lighthouse was abandoned and left to the elements. The site is now overgrown with vegetation and all that remains are some stone and mortar ruins.

Keeper Tales

The first keeper of the two lighthouses at Chimney Point and Agate Island was Peter McIntyre. When he died in 1881, Hyacinthe Davieaux became the keeper of both until his death in 1910, at which time his son Charles took over the duties. Although the Chimney Point Lighthouse was extinguished in 1918, the story goes that the keepers of the new Davieaux Island Lighthouse and the Quebec Harbour Range Lights (after 1918) continued to live at the keeper's dwelling at Chimney Point until a new house was built in 1938 at the Quebec Front Range light.

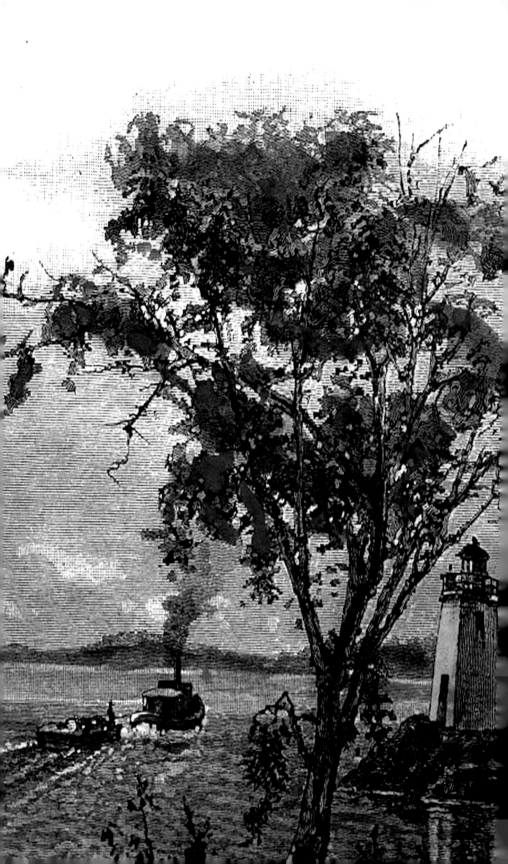

Agate Island Lighthouse

LOCATION: Eastern Lake Superior, on small, rocky Agate Island just inside Quebec Harbour, Michipicoten Island in northeastern Lake Superior

BUILT: 1872

LIT: September 1872

COORDINATES: N 47 42 30, W 85 47 0

STATUS: No longer on Agate Island. In 1917, it was moved by scow to the north side of the harbor to be the Quebec Harbour Front Range Light.

GETTING THERE: Accessible only by boat

CONSTRUCTION AND DESIGN

The original wooden slightly tapering light tower was built in 1872, with an 8-foot (2.4 m) diameter iron lantern that displayed a fixed white light produced by two mammoth flat-wick lamps with 16-inch (40.1 cm) reflectors, 30 by 36-inch (76.2 by 91.4 cm) glass and measured 20 feet (6.1 m) from the base to the vane. From a focal plane of 32 feet (9.8 m), the light was visible for 10 miles (6.1 km).

Once the Agate Island Lighthouse was moved to Quebec Harbour, the lantern was modified to shine in only one direction.

BACKGROUND

In the late 1880s, as the maritime traffic was increasing on Lake Superior, the Canadian government approved the building of three lighthouses on Lake

An artist's depiction of the Agate Island Lighthouse, which was moved from this site in 1917. *Larry Wright*

Superior. Two of the three would be built at the entrance to Quebec Harbour on the south side of Michipicoten Island to support the increased mining and commercial fishing industry, and to mark the way to safe refuge for ships in stormy weather conditions. The two lighthouses at Quebec Harbour were on Agate Island and Chimney Point (Magnetic Point).

Agate Point Lighthouse was built to guide mariners between the two small islands—Long Island (later renamed Davieaux Island) and Hope Island—about half a mile (1 km) outside the harbour entrance, and into Quebec Harbour.

In 1916, to better mark Quebec Harbour as a sheltered refuge for ships, the Canadian government decided to build a new lighthouse on Davieaux Island just outside the harbor entrance, and to establish range lights at the back of the harbor. In 1917, the channel leading into the harbor was deepened, and in the same year, the Canadian government moved the Agate Island Tower by scow to be the Quebec Harbour Front Range Light, and built a new light tower as the Quebec Harbour Rear Range Light.

When the new lights were lit in 1918, the old Chimney Point Lighthouse was extinguished and abandoned.

Keeper Tales

The keeper was responsible for the two lighthouses on Agate Island and Chimney Point, and the first one to be appointed was Peter McIntyre, in 1872. He had previously served as the keeper of Point Pelee Reef Lighthouse on Lake Erie.

The last keeper was Charles Davieaux (1910 to 1918), who had taken over the position after the death of his father, Hyacinthe Davieaux, in April 1910. According to authors Larry and Patricia Wright (*Lighthouses of the Great Lakes*), three years after taking over the keeper duties from his father, Davieaux contacted the editor of Rod and Gun in Canada with a million-dollar idea that needed some mentoring and investment. In his pitch to the editor, he identified himself as a lighthouse keeper, extolled the beauty and scenery of Michipicoten Island with its "30 lakes and streams which are abundantly furnished with brook trout," and lamented the loss of fur-bearing animals over the past 40 years, including beaver, caribou, and foxes.

"Now, Mr. Editor, can you give me an idea how to get rich men to stock this Island once more. Stocking it would mean millions in ten years," wrote Davieaux, who had come to the island as a youngster when his

father was lighthouse keeper. "I have been living on the Island for thirty-two years and if I had the means to-day to restock it I would go right ahead and do so with all kinds of fur-bearing animals. I shall be pleased to furnish information to any person who will interest themselves in the matter."

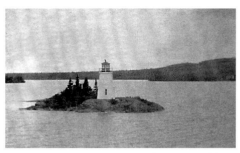

The waters near Michipicoten Island are studded with rocks and shoals. *Ron Walker*

While the rich men didn't appear, the good news is that Michipicoten Island now does have plenty of wildlife, particularly beaver, birds, and caribou. The island is administered by Ontario Parks as the Michipicoten Island Provincial Park (a few areas, like the lighthouse sites, are excluded from the park).

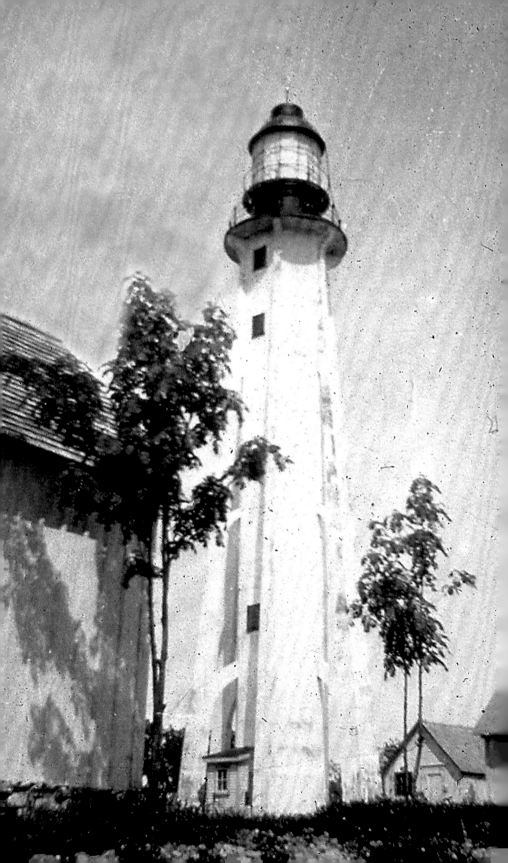

Michipicoten Island East End Lighthouse
(also known as Michipicoten Island Light)

LOCATION: Northeast Lake Superior, on the banks of the northeast
end of Michipicoten Island at Point Maurepas
BUILT: 1910–1912
LIT: 1912
AUTOMATED AND DE-STAFFED: 1988
COORDINATES: N 47 45 13.6, W 83 35 48.6
STATUS: Active aid to navigation; seasonal
CHARACTERISTICS OF LIGHT: Flashing white every 10 seconds (flash one second;
eclipse nine seconds)
OWNED BY: Fisheries and Oceans Canada
OPEN TO PUBLIC: Tower closed; site open
GETTING THERE: Accessible by water

CONSTRUCTION AND DESIGN

Construction on the light station began in the fall of 1910 on the north-east end of Michipicoten Island on Point Maurepas. The white light tower is one of only nine dramatic "flying buttress" lighthouses, built in Canada between 1907 and 1915, all built from plans designed by Lt. Colonel William P. Anderson, Chief Engineer and Superintendent of Lighthouses for Canada's Department of Marine and Fisheries. Only six of the original nine are still in existence, two of which are on Lake Superior—Michipicoten Island East End Lighthouse and Caribou Island. Both light towers are designed by Parks Canada as Classified Federal Heritage Buildings because of their architectural

The East End Lighthouse was first lit in 1912 and remains a working navigational beacon.
Larry Wright

and historical significance. (During his career, Lt. Colonel Anderson designed and oversaw more than 500 lighthouses and fog-signal buildings.)

In its Directory of Federal Heritage Designations, Parks Canada describes the Light Tower at Michipicoten Island:

> *It is an advanced example of the reinforced-concrete, flying-buttress towers developed early in the twentieth century in locations which required strong wind resistance. Its form is an adaption of a prototype built in Belle Isle, Newfoundland, in 1908, and the resulting tapered elegance and height of the light tower distinguish it from its predecessors.*

Parks Canada noted that "The tower's architectural significance is primarily embodied in its six flying buttresses (each supported by double arches) flanking a tapered tower of particular elegance."

Built in 1911 and lit in 1912, the white hexagonal tapered tower stands 79.8 feet (24.3 metres) above ground, is tapered, and has a central column surrounded by six flying buttresses supported by double arches. The central tower column with steel pillars at the corners was encased in reinforced concrete and each of the stabilizing six buttresses are steel, clad in concrete. Colonel Anderson called the flying buttress light towers the ultimate "ferro-concrete" lighthouse design.

Crowning the light tower is a circular iron lantern room, which houses a third-order Fresnel lens, exhibiting a flashing white light every 10 seconds, with a focal height above water of 84 feet (25.6 m) and visible for 15 miles (24.1 km).

The light station also included a keeper's dwelling, oil house, and boathouse. In 1928, a radio beacon building was added and in 1953, a keeper's bungalow, boat landing, and diaphone fog alarm.

The original third-order Fresnel lens is now displayed at the Coast Guard base in Parry Sound, Ontario.

BACKGROUND

With the increased shipping on Lake Superior, mining on Michipicoten Island, and the need to mark the offshore shoals and reefs, the Lake Carriers Association requested the Canadian government add a light at the east end of Michipicoten Island in 1908. At the time, there were two lighthouses about midway on the island's south shore: Chimney Island (Purvis Point) and Agate Island. The government agreed and in 1911, Michipicoten Island East End Light was built on Point Maurepas (sometimes referred to as Point Maurepas Lighthouse).

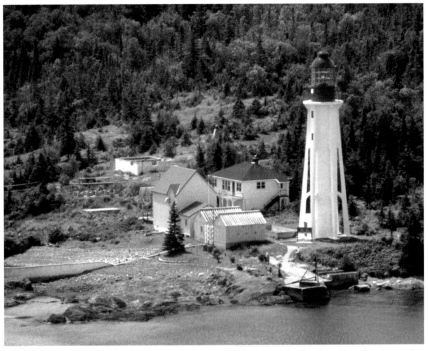

One of only nine flying buttress lighthouses built across Canada, the East End Lighthouse is a remote, yet extraordinary Lake Superior landmark. *Larry Wright*

Keeper Tales

In 1915, the Canadian government advised its lighthouse keepers that the government would no longer be providing transport to and from lighthouses, though each station would be provided with a sailboat. Keepers and their families would have to get themselves to their stations before the opening of the navigation season and then in the late fall (November or December) return at the close of the navigation season, which on Lake Superior was the most dangerous time of the year. The new policy made it particularly risky for the keepers of remote lighthouses on Lake Superior, like William Sherlock, who was hired in 1912 as the first keeper of Michipicoten Island East End Lighthouse.

On December 14, 1916, Sherlock and his son James closed up the lighthouse and started the 28-mile (45 km) trip to Gargantua Harbour on the mainland in their motorized open sailboat. It was a harrowing eight-day journey, as later told by Sherlock in an article "Lighthouse Men Are Almost Frozen Coming to Sault" in the *Sault Star*:

"We left the lighthouse on the 14th of the month, because our docks had been swept away by the ice and the seas and we saw that if we waited

any longer we wouldn't be able to get out. We started out at two in the afternoon in an 18-foot [5.5 m] boat and after we had gone about 14 miles [22.5 km] we ran into a northeaster. Our pump froze and we had to take to the oars. It was 12 degrees below zero [-24 degrees Celsius] at Gargantua that night. Our boat began to take in water and we gradually had to throw away everything we had to keep afloat. First we threw away 25 gallons [94.6 l] of oil, then an emergency sail we were carrying and finally our provisions. Our bodies were caked in ice and we could hardly bend either our legs or arms. One of the oars slipped away from my son in the afternoon and he reached for it but slipped over the side of the boat; but fortunately I grabbed him and got him out of the water."

They landed at Leach Island a short while later, made a fire, and stayed for three days with nothing to eat except a few biscuits, while William repaired their boat. On December 18, at 4:30 in the afternoon, they left the island, and headed out on a three-mile crossing with James rowing and his father bailing, in the bitter cold and wind. After five hours, they reached the shore between Gargantua and Telegram Rock, and then struggled through snow to reach Gargantua Harbour. They arrived on December 22, and then left with the keeper Charley Miron from Gargantua Lighthouse for Sault Ste. Marie. Both father and son had badly frozen hands and feet when they reached the city late on December 26, but they recovered.

The following year (1917), William Sherlock was back at his lighthouse at the start of the navigation season. In December at the end of the shipping season, he again set out on the dangerous Lake Superior, crossing to the mainland. But this time he didn't arrive; his body and boat were never found. His wife, Mary Christine Sherlock, took over the lighthouse keeper duties from 1918 to 1925 and later his son Melvin served for 19 years at the lighthouse, starting as assistant in 1962 and then head keeper from 1974 to 1981.

Romance was in the air when in September 1972, after a romance by correspondence, the head lighthouse keeper Joseph Thibeault married Ann Whitehorse in a wedding story that caught the attention of international media. With Lake Superior surf providing a backdrop, Thibeault, an Ojibwe, was dressed in full regalia as he rode on horseback on the beach of Michipicoten Harbour to the wedding ceremony. Here's what the *Sedalia Democrat* (Missouri) published on September 27, 1972 about the couple:

"They met briefly in Toronto, where Ann was living, some years ago. Later they started writing each other, and Ann's letters eased the loneliness in Joe's life as lighthouse keeper on Michipicoten Island. They

became engaged by mail two years ago. The groom, a former fisherman who has been light-keeping for 10 years, was dressed in Indian regalia as he rode up to the beach on horseback for the outdoors wedding ceremony. The bride, from New Waterford, Nova Scotia wore a long, brightly hued dress which Joe said signified nature's colors and life."

Lighthouse Tales

In 1960, the yacht *Aquila* ran aground on the northwest corner of Michipicoten Island while cruising Lake Superior. The yacht was owned by Robert F. Carr, the executive VP of the Dearborn Chemical Company, Chicago, a family company that became part of General Electric. The east end lighthouse keeper James Frederick "Fred" Francis tried to help free the boat, was unsuccessful, and he contacted Port Arthur (now Thunder Bay) for assistance.

The next morning, the CGS (Canadian Government Ship; after 1962, it would be Canadian Coast Guard Ship) lighthouse supply and buoy tender the *C.P. Edwards* arrived, fastened a 2-inch (5.1 cm) hawser around the yacht's hull and pulled her off the island with minimum damage.

INTO THE TWENTY-FIRST CENTURY

Most of Michipicoten Island and offshore shoals and islands within 1.5 miles (2.5 km) of the shoreline have been designed as a Provincial Park since December 11, 1984. It is classified as a natural environment park. Some property exclusions from the park include the lighthouses, beacon, and range lights.

In 1990, the Michipicoten Island East End Light Tower (not the other buildings) was designated a Classified Federal Heritage Building.

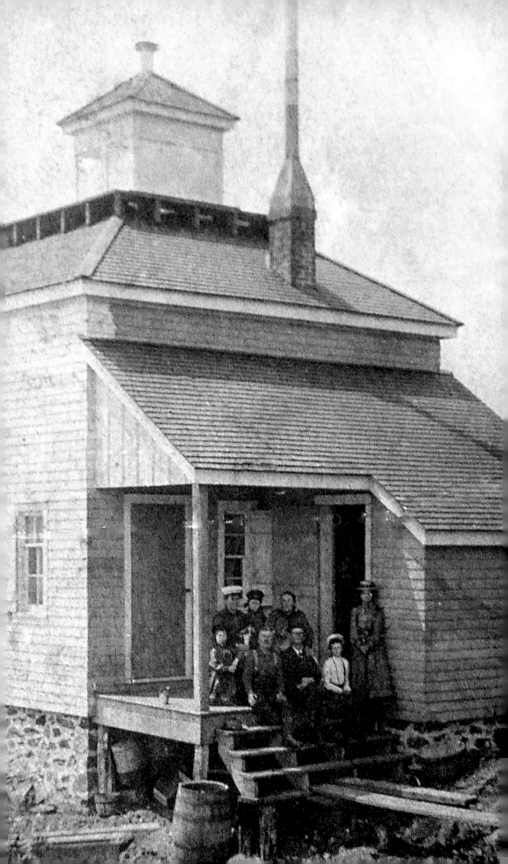

Michipicoten Harbour Lighthouse
(formerly known as Little Gros Cap Lighthouse)

LOCATION: Northeast Lake Superior, on the southeast tip of Perkwakwia Peninsula on Michipicoten Bay at the entrance to Michipicoten Harbour

BUILT: 1902

LIT: 1902

AUTOMATED: 1989

DE-STAFFED: 1991

COORDINATES: N 47 56 32.9, W 84 54 26.7

STATUS: Active aid to navigation; seasonal; emergency light

CHARACTERISTICS OF LIGHT: Flashing white every 10 seconds (flash one second; eclipse nine seconds)

OWNED BY: Fisheries and Oceans Canada

OPEN TO PUBLIC: Grounds only; tower closed

CONSTRUCTION AND DESIGN

The original Michipicoten Harbour Lighthouse was built in 1902 by J. Candlish Kennedy of Owen Sound, Ontario, for contract price of $2,750. The station was situated on the southeast end of Little Gros Cap peninsula (now called Perkwakwia Point) at the entrance to Michipicoten Harbour. It replaced a temporary lens lantern that had been maintained since the opening of the 1902 navigation season. The new light was lit in August 1902. The Annual Report of the Canadian Department of Marine of 1902 describes the

An early photograph of the Michipicoten Harbour Lighthouse. *Larry Wright*

new station, which was on the mainland, though the keeper had to travel by water to get there:

> *The lighthouse is a square wooden building, surmounted by a square wooden lantern rising from the middle of the cottage roof. The building and lantern are painted white. The roof of the building is red. The lighthouse is 31 feet [9.4 m] high from its base to the top of the ventilator on the lantern, and is located on the summit of Little Gros Cap on land 46 feet [14 m] above the level of the lake, and 120 feet [36.6 m] back from the water's edge.*

> *The light is fixed white light, elevated 70 feet [21.3 m] above the water level of the lake; it should be visible 14 miles [22.5 km] from all points of approach by water, but not visible from the wharves in the harbour. The illuminating apparatus is dioptric of the seventh order.*

The lighthouse, which had a hand-operated foghorn, was similar to the Corbeil Point Lighthouse at Batchewana Bay, Ontario. In 1943, a diaphone alarm replaced the foghorn and three years later (1946), a radio beacon was installed and synchronized with the fog alarm. To house extra personnel on-site, a single-story frame keeper's dwelling was also added.

The original wooden lighthouse with its combined tower and keeper's house was replaced in 1967 with the current 40-foot-tall (12.7 m) square skeletal steel tower, and the 1902 lighthouse was demolished. The characteristics of the light, which had been changed in 1930 from fixed white to flashing white every 30 seconds, was now changed to flashing white every 10 seconds (flash one second; eclipse nine seconds) at a focal height above water of 88 feet (26.8 m).

BACKGROUND

By 1165 B.C., Indigenous people had settled seasonally in the Michipicoten area. Later, when the Ojibwe people arrived, they called the place Michipicoten, meaning "big bluffs," perhaps referring to the cliffs on the south side of the bay. The name is now one of Ontario's oldest place names, first appearing on explorer Samuel Champlain's map of 1623.

The Michipicoten River, which empties into Michipicoten Harbour, is the start of a 435-mile-long (700 km) canoe route to James Bay and Hudson's Bay, linking Lake Superior and the Great Lakes with Canada's far north. It was a route used by European fur traders and explorers who started arriving here in the late seventeenth century. The first fur trade post was established here in about 1725 by the French, and it would be almost 200 years before the last trading post was closed in 1904 by the Hudson's Bay Company.

The steel tower shown just left of the Canadian flag replaced the original lighthouse in 1967. *Larry Wright*

Moving forward in time, the village got an economic boost when the nearby Helen Mine, owned by Algoma Steel Corporation, started operation on July 1, 1900. The mine operated 24 hours a day and employed about 400 people. The village was booming, and by end of 1900, had a 275-foot-long (84 m) wood dock with twelve 50-ton ore bins, 600-foot (183 m) pier, 180-square foot (16.7 square m) warehouse, sawmill, company store and office, three-story hotel, and cabins for workers. There were also five large locomotives and 100 steel ore cars. In addition, the company had four steel steamships transporting the ore, first to Midland, Ontario, and the U.S., and later mainly to the Soo where the company had built a new smelter. In 1902, to mark the entrance to the harbor and as a coastal light on the north shore, the Canadian government built Michipicoten Harbour Lighthouse.

From 1900 to 1918, the Helen Mine was Canada's largest producer of iron ore. Helen Mine closed in 1918, reopened in 1937, and closed permanently in 1996.

Michipicoten Harbour—once a bustling industrial centre with mining, logging, forestry, railway, and shipping, was deserving of its title, "The Biggest Little Port on the Great Lakes"—is all but abandoned today.

Keeper Tales

Lighthouse keeper William Daniel Reid had a particularly difficult time getting back home to Sault Ste. Marie ("Soo"), Ontario, at the end of the 1916 navigation season. According to Reid, he set out in his 16-foot (4.9 m) rowboat to row the six or seven miles (9 to 11 km) to Michipicoten Harbour where he was going to catch the train for the Soo. Coming into the harbor, huge ice fields blocked his way, forcing him to go around the ice, adding 24 hours to his row.

"At times I had to get out on the cakes, haul up my boat and chop the floes apart, so I could proceed. Luckily I had an axe with," Reid later told a newspaper reporter. "When I did get to Michipicoten Harbour, the ice prevented me from reaching shore; I had to get out, wade through the ice and water, a distance of 25–30 yards [23 to 27 m]; was wet when got to land."

With temperatures hovering around minus 23 degrees Fahrenheit (-31 degrees Celsius), Reid's clothing froze, and he looked like a "frozen snowman." There were no houses at the harbor where he could dry his clothes. So, wet and cold, he walked back to his lighthouse, a distance of about seven miles (11.3 km) over mountains and hills as there was no trail from the harbor to Perkwakwia Point. Reid dried out his clothes, stayed a day and night, then headed back to Michipicoten Harbour, eventually arriving in the Soo.

In 1921, the Canadian government rescinded its policy of requiring the keepers to find their way to and from their stations, and with the start of the navigation season in 1922, was once again providing transport. So, on April 18, 1922, William Reid was on board the 108-foot (33 m) lighthouse tender *Lambton* to be dropped off at his Michipicoten Harbour Lighthouse, along with the four keepers headed for Caribou Island and Ilse Parisienne. They left Sault Ste. Marie, Ontario, at 10:30 a.m. on April 18, but never reached their destinations.

The tug *G. R. Gray*, owned by Lake Superior Paper Co. Ltd. in the Soo, was one of the ships that went searching for the *Lambton*, as reported in one newspaper article:

"In the faint hope that there may be some survivors of the Government tug *Lambton*, now given up as lost near Caribou Island in Lake Superior, the tug *G. R. Gray*, in [the] charge of Captain Ramsay, left the Sault last night at 8 o'clock for the scene of the disaster. Besides keeping a watch along the shore for any indication of life, the crew on the *Gray* will search for wreckage, in an endeavour to positively identify the

craft which, it is now known foundered. Their search will be a difficult one, as the shifting ice in the lake is hazardous to the smaller craft and the changing winds give a vessel little hope of release once it is caught in the floes."

The *Lambton* went down in a spring storm somewhere between Caribou Island and Whitefish Bay. All 22 people aboard went down with the vessel.

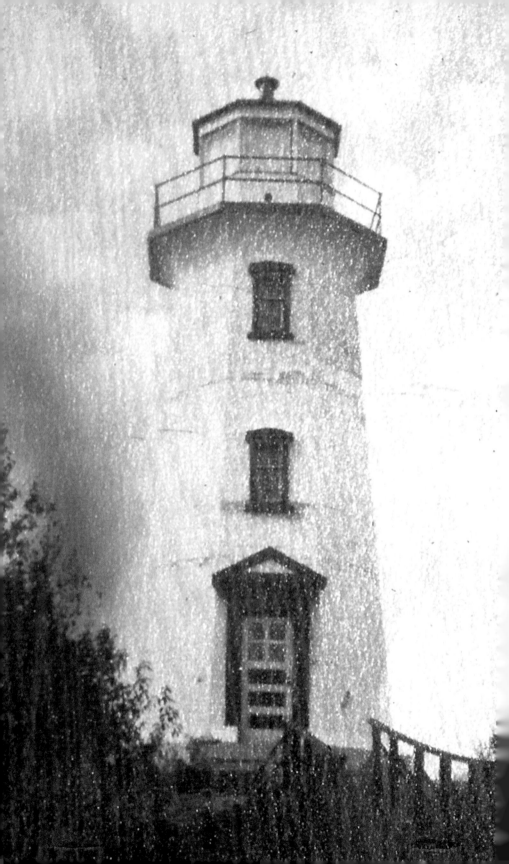

Gargantua Light

LOCATION: Northeast Lake Superior, on the summit of small, rocky
Gargantua Island situated at the entrance to Gargantua
Harbour and anchored to the island's rock by four cables

BUILT: 1889

LIT: 1889

AUTOMATED: 1948

COORDINATES: N 47 33 29.6, W 84 57 48.9

STATUS: Active aid to navigation; seasonal

CHARACTERISTICS OF LIGHT: Flashing white every four seconds

OWNED BY: Fisheries and Oceans Canada

MANAGED BY: Lake Superior Provincial Park

OPEN TO PUBLIC: Site open; tower closed

GETTING THERE: Accessible only by boat

CONSTRUCTION AND DESIGN

In the "Notice to Mariners" section of the *Canada Gazette*, No. 45 of 1889,
it notes that:

*A lighthouse has been erected and put in operation by the
Government of Canada on the summit of a small island in the mouth
of Gargantua Harbour, on the northeast coast of Lake Superior in the
District of Algoma.*

Constructed in 1889, the original 43-foot (13 m) tower was a hexagonal
wooden building, painted white, topped with a red iron lantern. The original
light was a fixed white from a seventh-order lens, elevated 97 feet (29.6 m)

A historic photograph of the Gargantua Light. *Larry Wright*

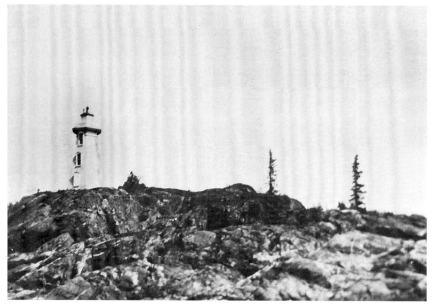

The Gargantua Light was destroyed by a windstorm in 1940. *Larry Wright*

above the level of the lake and visible for 17 miles (27.8 km). Illuminating apparatus was dioptric of small size.

The original tower was blown away during a windstorm in November 1940. The keeper's shack, which was 170 feet (52 m) inland, received little damage at first; however, storm waters swept over it and froze the building, trapping the assistant keeper inside, who was later chopped out with an axe. The lighthouse was rebuilt the following year.

In 1949, a skeletal tower replaced the lighthouse, and in 1980, the light was switched to a cylindrical mast with a red and white rectangular daymark with a height above ground of 17 feet (5.3 m).

BACKGROUND

Gargantua Harbour was the site of a fishing village when in 1889 a small lighthouse was built at the bay entrance to mark safe harbor and to guide the fishing vessels to the sheltered docks of the harbor. The town featured several buildings and an ice house for packing the fish before shipping them out to Sault Ste. Marie, Ontario. Its busiest times were in the 1930s and 1940s.

In the article "On the North Shore" in the June 11, 1891 edition of *Forest & Stream*, writer Alex Starbuck describes Gargantua Harbour as "one of the finest harbors of refuge on lake, and shows a wealth of wild, entrancing beauty

in its moss-covered and storm-beaten rocks, ragged shoreland and receding hills, in whose ravines huge shadows linger and whose tops blaze with morning glory."

Unfortunately, the commercial fishing for lake trout and herring was largely destroyed by the invading sea lamprey, which first arrived in Lake Superior in 1938. By the 1960s, the fishing industry was almost non-existent and the marine traffic to the harbor had decreased significantly.

What remains of the old fishing village are several foundations, a wooden building, relics of a wharf, and the top of a steam engine in the middle of the harbor.

Shipwreck Tales

The steam engine poking out of the waters of Gargantua Harbour belongs to the shipwreck of the supply vessel *Columbus*. When launched in 1874 in Detroit as the *John Owen*, she was the largest of the early Detroit River tugs. Renamed *Columbus* in 1907, the ship spent three summers transporting vital supplies to outposts in eastern Lake Superior.

During the night on September 10, 1910, the 136-foot (41.5 m) *Columbus* caught fire while docked at Gargantua Harbour. When flames were noticed coming out of the ship stacks, people onboard were quickly evacuated off the ship. To save the destruction of the docks and the town's buildings, the lines were cut to set *Columbus* free. The fiery tug floated into the harbor and sank where it is today, in about 20 to 30 feet (6.1 to 9.1 m) of water. No lives were lost and no one was injured.

Keeper Tales

In an 1896 article "Trouting on the North Shore" (in *Outing*, a monthly magazine), the writer W. O. Henderson mentions meeting Louis Miron, the first keeper at Gargantua Lighthouse:

"He was an observant and intelligent man, well rounded up with the experience such a man may get on the north shore. He had been to Nepigon [Nipigon] with the Marquis of Lorne, and, what was more of interest to us, he had been at many scarcely known points on north shore where large trout in great quantities are to be taken."

Gargantua Harbour was once the site of a commercial fishing community. *Larry Wright*

"Three times Miron had been to Hudson's Bay, a full seven hundred miles [1,126.5 km], going by canoe up the Michipicoten and down the Moose River. On quickest trip he reached the bay on the eleventh day after leaving Superior making 35 portages, and shooting 175 rapids on the way. Their quickest return trip was made in seventeen days."

It should be noted that for almost six decades (from 1889 to 1948), three generations of the Miron family were keepers of Gargantua Lighthouse. The first keeper was Louis Miron Jr. in 1889. He retired at age 71 in 1912 and Miron Island was named in his honor. He was followed by his son Charles as the keeper of Gargantua Lighthouse in 1912, and then by Charles's son Thomas in 1942.

INTO THE TWENTY-FIRST CENTURY

A replica of Gargantua Lighthouse is on display at the visitor centre at Lake Superior Provincial Park at Agawa Bay.

Thanks to adventure tourism, boaters, paddlers, and hikers on the Coastal Hiking Trail, visitors to Gargantua Harbour are increasing.

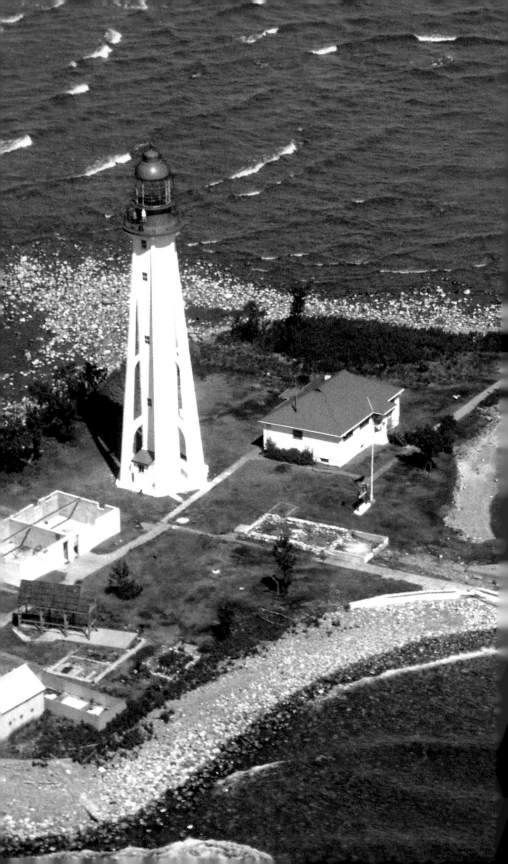

Caribou Island Lighthouse

LOCATED: Northeast Lake Superior, on small Lighthouse Island, about 1.5 miles (2.4 km) southwest of Caribou Island and about 65 miles (104.6 km) from the Canadian mainland

BUILT: 1886; 1912

LIT: Fall 1886; 1912

AUTOMATED AND DE-STAFFED: Mid-1970s

COORDINATES: N 47 20 23, W 85 49 32

STATUS: Active aid to navigation; seasonal

CHARACTERISTICS OF LIGHT: Flashing white every 10 seconds (flash one second, eclipse nine seconds)

OWNED BY: Fisheries and Oceans Canada

OPEN TO PUBLIC: Site open; tower closed

GETTING THERE: Accessible only by water

CONSTRUCTION AND DESIGN

Established in 1886 with the name Caribou Island Lighthouse, the station was actually built in the center of the small, rocky island which became known as Lighthouse Island, located about one mile (1.6 km) southwest of the larger Caribou Island.

The contract to build the lighthouse was awarded to John George and David Currie of Port Elgin. Completed and put in operation on August 26, 1886, it was a combined station with the 60-foot (18.3 m) white wooden tower extending up from the one-and-a-half-story keeper's house.

Designated as a Federal Heritage Building, the flying buttress Caribou Island Lighthouse lies offshore in Lake Superior. *Larry Wright*

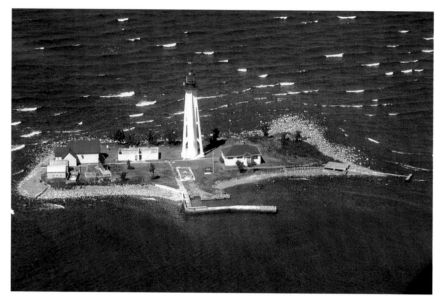

The lighthouse is located on a tiny rock island about one mile southwest of Caribou Island.
Larry Wright

The white revolving light flashed every 10 seconds, was elevated 76 feet (23.2 m) above the level of the lake, and was visible for 15 miles (24.1 km). The octagonal wood tower was 80 feet (24.4 m) in height from base to vane, painted white, with red lantern. The wood fog-alarm building was square, painted white with brown roof and located 100 feet (30.5 m) south of the tower; the compressed air horn sounded a blast of five seconds every 30 seconds.

In 1912, the original tower was replaced by a "flying buttress" light tower, one of only nine built in Canada. Designated a Classified Federal Heritage Building in January 4, 1990, Parks Canada calls the tower "a landmark in the evolution of light tower design" and "among the most impressive lights on the Great Lakes." Parks Canada describes the Caribou Island Lighthouse as:

A highly visible structure from the waters of Lake Superior, the Light Tower on Caribou Island is the dominant element of a lightstation complex that occupies a small, isolated island. The elegantly tapered profile of the concrete tower is emphasized by six flying buttresses that surround its central column. Crowning the tall tower is a fully automated red lantern.

Built during a transitional phase in the development of reinforced concrete lighthouse construction in Canada, the six buttresses of Caribou Island illustrate a short-lived but uniquely Canadian experiment in tower design and construction.

In terms of structural design, the flying buttresses were designed to provide stability and resistance to lateral thrust and vibration with a minimum of material. Reinforced concrete floors on the interior added to the lateral bracing. The Department experimented with both mesh and solid bar reinforcing steel and took particular care with the placement of the steel.

The Gothic architectural style was designed by Lt. Colonel William F. Anderson, Chief Engineer of Canada's Department of Marine and Fisheries. Only six of the nine are still in existence and of those six, two are on Lake Superior: Caribou Island Lighthouse and Michipicoten Island Light.

The 104-foot (31.5 m) white tapering hexagonal tower of reinforced concrete with six graceful flying buttresses was topped by a gallery and circular metal lantern, both painted red. The second-order Fresnel lens by Chance Brothers & Co. of Birmingham, United Kingdom, replaced the former revolving white light. It displayed a flashing white light in groups of three flashes every 10 seconds and was visible for 15 miles (24.1 km).

The station site also had houses for the keeper and assistant keeper, an oil house, boathouse, L-shaped dock, and concrete connecting walkways.

A radio beacon was established in 1944 at the lighthouse and a flashing white electric winter light was installed in the gallery. In 1948, a new surface coating was applied to the tower, and in the early 1960s, the light was electrified when diesel generators were installed.

In 1992, the station became solar-powered and a twelve-volt D/C rotating beacon was installed, replacing the second-order Fresnel lens. Currently (2018), the light is displayed on a white hexagonal tower with a focal height above water of 121 feet (36.9 m) and visible for nine miles (14.5 km).

BACKGROUND

Caribou Island is in Canadian territorial waters about three miles (4.8 km) north of the Canada-U.S. international boundary, as laid out under the Treaty of Ghent.

Approximately 3.5 miles (5.6 km) long and 1.5 miles (2.4 km) wide, it covers 1,600 acres in area. A dangerous reef known as "Six Fathom Shoal" stretches more than a mile (1.6 km) north of the north point of the island (in 1975, the *SS Edmund Fitzgerald* may have grounded on the shoal before sinking about 17 miles [27 km] from Whitefish Bay). Southwest of the lighthouse there is a shallow reef 2.5 miles (4 km) long only 11 feet (3.4 m) below the lake's surface.

Considered the most remote lighthouse on Lake Superior, Caribou Island Lighthouse was constructed due to the increased shipping activity on Lake Superior as the route used by ships to western ports nearby, and to warn mariners of the dangerous Caribou shoals.

Keeper Tales

Caribou Island Lighthouse was the most remote station on Lake Superior, located about 65 miles (104.6 km) from the Canadian mainland. At the close of the 1904 shipping season, there was concern that the two Caribou Island Lighthouse keepers—Wilbrod Demers and his assistant Fred Pelletier—had gone missing. Twice when the tug *James Reid* went to the island to pick up the keepers, there was no response to the captain's signals, and ice conditions prevented the tug from making a landing. Another tug, *Boynton*, also met no response when her captain signaled as she passed by, unable to go closer due to ice conditions. On December 23, the *Reid* set out for a third attempt to land on the island and reach the lighthouse. As they were preparing their special equipment to tackle the ice, a small boat was frantically battling its way toward the tug with the two keepers on board. Apparently, Demers and Pelletier missed the other pickup attempts because they couldn't get packed up in time, fearing each time they were now stranded for the winter.

Lighthouse keepers had to be resourceful when posted to a remote location like Caribou Island Lighthouse. In 1912, for his first year as keeper of Caribou Island Lighthouse, George Johnston brought along plenty of ammunition for hunting, but forgot to bring a rifle—so, he made himself a homemade rifle to hunt game on Caribou Island. And when he broke his leg in an accident, Johnston set the bone, splinted the leg, and made a pair of crutches to get around. Johnston stayed as keeper at Caribou with his family for another 10 years, until 1922.

Johnston was still keeper in 1915, when the Canadian government informed its keepers that they would no longer provide transportation to and from lighthouses. Instead, each station was issued a 28-foot (8.5 m) sailboat to make the journey. Traveling between the lighthouse and the mainland in a small boat became a hazardous part of working at Caribou Island Lighthouse. To improve his chances of survival, Johnston equipped his open sailboat with a kerosene engine, a small cabin, and a coal heater, but even with these measures, he nearly perished leaving the island in 1919. Shipping season closed on December 15, but because of bad weather, Johnston and his assistant were stranded on the island

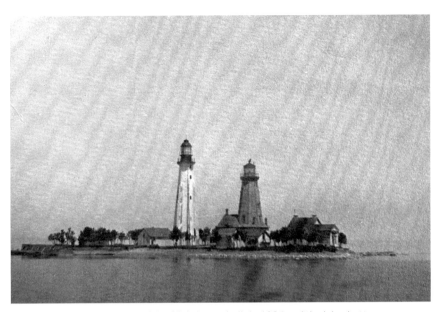

An early photo showing the original lighthouse built in 1886 and the lying buttress lighthouse built in 1912. *Larry Wright*

for 10 days. They finally set sail on Christmas Day, headed 30 miles (48.2 km) north to Quebec Harbour, a fishing station on Michipicoten Island where they intended to stay the night, but they never arrived. Another storm and dangerous ice conditions forced their small boat back into open water to wait out the storm. It was New Year's Day—an epic seven days after leaving the lighthouse on December 25—before they finally reached the mainland.

In 1922, the Canadian government reversed its policy and began again transporting lighthouse keepers by ship to and from their lighthouse stations.

INTO THE TWENTY-FIRST CENTURY

The second-order Fresnel lens, removed in 1992, is on display at the Canadian Coast Guard Base in Parry Sound, Ontario. Today Caribou Island is owned by a private American conservation foundation.

Coppermine Point Lighthouse

LOCATION: Southeast Lake Superior, on the bluff at the northwest end of Coppermine Point, about 46 miles (74 km) north of Sault Ste. Marie, Ontario

BUILT: 1901

REBUILT: 1908

AUTOMATED: 1923

DEACTIVATED: 1969

COORDINATES: N 46 59 02.8, W 84 47 14.7

STATUS: Active aid to navigation; seasonal

CHARACTERISTICS OF LIGHT: Flashing white every four seconds

OWNED BY: Fisheries and Oceans Canada

OPEN TO PUBLIC: Grounds only

GETTING THERE: Hibbard Bay, off of Highway 17 (Trans-Canada Highway) about 60 miles (100 km) northwest of Sault Ste. Marie, Ontario

CONSTRUCTION AND DESIGN

The first navigation light at Coppermine Point was established in 1901 by the Algoma Central Steamship Line as a navigational aid for their vessels carrying iron ore from their mine at Michipicoten Harbour to Sault Ste. Marie. It was a fixed white light, shown from a lens lantern at a height of 46 feet (14 m) above the water and visible for 12 miles (19.3 km); the illuminating apparatus was dioptric of the seventh order. The lantern was on top of a white open-framed square pyramidal wooden 12-foot-high (3.7 m) tower.

Deactivated in 1969, the Coppermine Point Lighthouse is still standing. *Charles W. Bash*

In 1904, Canada's Department of Marine took over the responsibility for the Coppermine Point Light and hired as its keeper John Joseph Roussain. He looked after the light until his death in 1909, at which time his son, Frank Edward, took over keeper duties.

Four years later, in 1908, the original light structure was removed and J. C. Kennedy of Owen Sound constructed a new square pyramidal 32-foot (9.8 m) wooden tower with pedimental door and window. It had sloping sides, wide at the base and narrowing upward to the gallery, which housed a red octagonal iron lantern. The fifth-order Fresnel lens displayed a fixed white light, lit on September 15, and was visible for 13 miles (20.9 km) from a height of 61 feet (18.6 m) above water.

The year 1923 saw major changes at the lighthouse. In the fall of 1923, the crew of the lighthouse supply and buoy tender *Grenville* (which had been built in 1915 in Toronto by Polson Iron Works for Canada's Department of Marine and Fisheries), replaced the fixed white light with an unattended AGA acetylene light that automatically turned the beacon on and off. As a result, the station's second lighthouse keeper, Frank Edmund Roussain, was no longer required, and the Coppermine Point Lighthouse was de-staffed and abandoned.

In the 1950s, the light was moved to a skeletal tower, and the Canadian Coast Guard slated the old 1908 tower for demolition. Ernie Demers was given permission to tear it down for scrap, but there was a glitch—Demers was a history buff and decided instead to save the lighthouse. In 1969, Demers moved the lighthouse about two miles (3.2 km) north to Hibbard Bay to become part of his Lighthouse Restaurant and Tavern complex, located about 60 miles (96.6 km) northwest of Sault Ste. Marie, Ontario.

The restaurant/tavern no longer exists. The lighthouse, now privately-owned, still stands, though in disrepair.

At the Coppermine Point site, the Canadian Coast Guard still owns and maintains the light on a cylindrical mast, red and white rectangular daymark, displaying a flashing white light every four seconds from a height above water for 14.4 miles (23.2 km).

BACKGROUND

The first light was placed at Coppermine Point in 1901 by the newly formed Algoma Central Steamship Line. The company had purchased four steamships from England to launch a Great Lakes freighter fleet to transport iron ore

The lighthouse was rebuilt in 1908. *Larry Wright*

mined at Helen Mine from Michipicoten Harbour to the steel mill in Sault Ste. Marie, as well as pulpwood and supplies.

After the Canadian government took over the light in 1904 and replaced it with a new structure in 1908, the Coppermine Point Lighthouse became a landmark for ships in Lake Superior, with its light marking the northeast entrance to Whitefish Bay for downbound vessels. The U.S. lighthouse across the bay at Whitefish Point marked the southeast entrance.

Lighthouse Tales

The lighthouse gained artistic recognition when A. Y. Jackson (1882–1974), the Canadian painter and founding member of the famous Group of Seven, visited the area in the 1950s and painted the Coppermine Point Lighthouse while offshore in a boat. The painting, entitled *Coppermine Point—Lake Superior*, is an oil on wood panel, the image about 10 by 13 inches (25.4 by 33 cm), and is in the collection of the Art Gallery of Algoma, Sault Ste. Marie, Ontario.

Corbeil Point Lighthouse

(formerly Corbay Point, name changed by the Canadian Geographic
Board in the early 1900s)

LOCATION: Northeast Lake Superior, on Corbeil Point, a rocky
headland located on the west side of the entrance to
Batchewana Bay on the northeastern shore of Lake
Superior, about two miles (3.2 km) southwest of the town
of Batchewana Bay and about 31 miles (50 km) north of
Sault Ste. Marie, Ontario

LIT: October 1, 1873

AUTOMATED AND DE-STAFFED: 1955

EXTINGUISHED: 1962

COORDINATES: N 46 53 35, W 84 36 5

STATUS: Light was extinguished in 1962. The lighthouse building
still exists and has been a residence since 1972, owned
by the Batchewana First Nation of Ojibwe on Obadjiwan
Reserve 15E.

GETTING THERE: Accessible by road

BACKGROUND

The name Batchewana Bay is from the Ojibwe *Badjiwanung* for "waters that
bubbles," a term to describe the turbulent waters in the current that passes
Corbeil Point.

The lighthouse was built on part of the reserve lands of Batchewana First
Nation—accorded to them with the signing of the historic 1850 Robinson-
Huron Treaty, between 15 First Nation bands (including Batchewana) and the
Crown. In June 1859, the Batchewana "surrendered for sale" these lands to

The Corbeil Point lighthouse building is now a residence owned by the Batchewana First
Nation. *Charles W. Bash*

the Crown, and the Corbeil Point Lighthouse was built on a 115-acre parcel of these lands.

It would be 92 years later, in December 1966, after the lighthouse was no longer required, that the property was returned to the Batchewana First Nation as part of the reserve named Obadjiwan Reserve 15E.

CONSTRUCTION AND DESIGN

The original white octagonal wood tower in 1873 was 63 feet (19.2 m) high, with three octagonal windows facing away from the water and an attached one-story clapboard dwelling (wood siding using thin, horizontal boards) for the keeper.

The 8-foot (2.4 m) octagonal lantern had a fixed white light on the catoptric principle with two circular burner lamps with 20-inch (50.8 cm) reflectors, and two flat-wick lamps with 16-inch (40.6 cm) reflectors. In 1878, four mammoth flat-wick lamps with 16-inch (40 cm) reflectors were installed. The light was 79 feet (24.1 m) above the lake level and could be seen for 20 miles (32.2 km).

In 1930, the structure was destroyed by fire after being struck by lightning during a severe storm. A new lighthouse was built, a square two-story wooden building with a hip roof, topped by a lantern room. The lantern was a seventh-order lens, used kerosene lamps, and had a fixed white light visible for 11 miles (17.7 km).

Later, the fixed white light was changed to fixed green, then flashing green, visible for 11 miles (17.6 km). In 1962, the light was deemed unnecessary, and was extinguished.

Lighthouse Tales

The first keeper, David Crawford, was reputed to make moonshine during his 10 years as the Corbeil Lighthouse keeper, from 1873 until his death in June 1883 in Sault Ste. Marie, Ontario, from heart disease and complications of pneumonia. His son, Andrew Crawford, took over as Corbeil's second keeper from 1883 to 1890.

Fire destroyed the lighthouse during a severe electrical storm in the fall of 1930. According to authors Larry and Patricia Wright in their book, *Great Lakes Lighthouse Encyclopedia*, the light's third keeper, William "Billy" Reil, was "sitting reading by his coal oil lamp when lightning not only struck the lighthouse but also struck his lamp, spreading fuel and fire

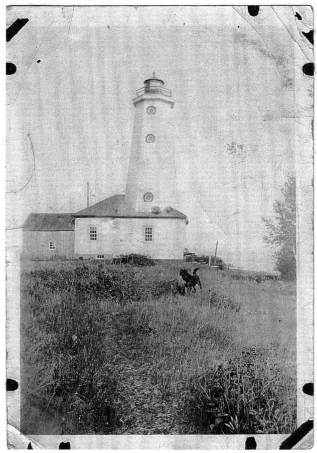

A historical photo showing the original lighthouse, which was destroyed by fire in 1930. *Larry Wright*

everywhere." Billy Reil and his 20-year-old daughter, Philemon, escaped the fire, but lost all their belongings. A temporary light from a pole was installed by Reil until the new lighthouse was built. Reil, who married Jane Paksowe, an Ojibwe woman from Batchewana on June 6, 1901, was Corbeil Point's lighthouse keeper for 31 years, from 1915 to 1946.

A veteran of the Second World War, Henry D. Nolan was appointed keeper after Reil's retirement, and together with his wife, Franny, wintered at Batchewana Bay after navigation season. When Nolan died in early 1953, Franny temporarily took over lighthouse duties until the next keeper, Robert Collins, arrived in late 1953.

Collins, the last keeper, was taken off the station in 1955 when the Corbeil Point Light was automated. Seven years later, in 1962, the light was permanently extinguished.

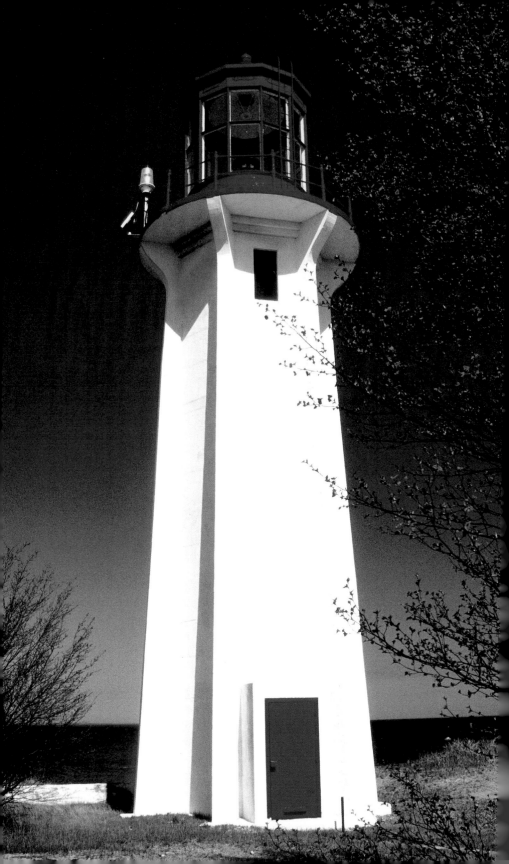

Ile Parisienne Light

LOCATION: Eastern Lake Superior, on the southwestern tip of Ile Parisienne (also known as Parisian Island) on the Canadian side of Whitefish Bay, one mile (1.6 km) east of the Canada-U.S. boundary line and approximately 16 miles (25.7 km) northwest of Sault Ste. Marie, Ontario

BUILT: 1911

LIT: September 15, 1912

COORDINATES: N 46 38 54, W 84 42 48

STATUS: Active aid to navigation; seasonal; solar-powered modern optic; listed in the Canadian Register of Historic Places as a Recognized Federal Heritage Building in 1991

CHARACTERISTICS OF LIGHT: Flashing white every 10 seconds (flash one second; eclipse nine seconds)

OWNED BY: Fisheries and Oceans Canada

OPEN TO PUBLIC: No; view from water

CONSTRUCTION AND DESIGN

In August 1911, builder and architect William Fryer from Collingwood, Ontario, was contracted for $14,650 to build a lighthouse, dwelling, oil shed, boathouse, and wharf on Ile Parisienne. The station became operational on September 15, 1912.

The lighthouse was a hexagonal reinforced concrete white tower, built with six tapered exterior wall buttresses, flared ribs at the platform, a gable roofed entrance, small windows, and a prominent, 10-sided red lantern topped with a beaver weathervane. The 54-foot (16.6 m) tower was 50 feet (15.2 m) from

Located on the eastern end of Lake Superior, the Ile Parisienne Lighthouse is a beacon for mariners entering and leaving Whitefish Bay. *Larry Wright*

the water's edge. The original light was a second-order dioptric type, occulting white light with a focal height above water of 53 feet (16.1 m) and was visible for 16 miles (25.7 km).

The dwelling for the keeper and the assistant was a rectangular white wooden double-dwelling with a hip roof, and was located 120 feet (36.6 m) from the lighthouse.

The fog-alarm building was a square white wooden building with gable roof and was located 25 feet (7.6 m) from shore and 70 feet (21.3 m) from the lighthouse. The foghorn—an air-operated diaphone, compressed by an oil engine—was elevated 23 feet (7 m) above the level of the lake.

A helicopter pad and dock was later added to the site.

BACKGROUND

Ile Parisienne is an uninhabited island, approximately six miles (9.7 km) from northern to southern tip with a width of approximately 1.5 miles (2.4 km) at the southern end and narrowing to about 0.66 mile (1.1 km) near the northern end.

In 1912, the lighthouse was established as a navigational aid for the increased shipping traffic on Lake Superior. Located on the major shipping lanes to and from the Soo Locks, its beacon still guides ships in and out of Whitefish Bay.

Shipwreck Tales

Author Julius Wolff writes about Ile Parisienne in his book *Shipwrecks of Lake Superior* (1987), "The frequent rough waters, shoals and dense fog surrounding the island resulted in the loss of many lives due to collisions, foundering, and capsizing of ships."

The first recorded shipwreck on Lake Superior occurred off Ile Parisienne during a fur trade feud in August 1816 between the rival fur-trading companies North West Company (NWC) and Hudson's Bay Company (HBC) in British Canada (the country of Canada didn't exist until 1867). HBC's Lord Selkirk had arrested leaders of NWC at their inland headquarters at Fort William (now part of Thunder Bay), and was transporting the prisoners in three Montreal canoes to York in Upper Canada for trial. After stopping for dinner on Ile Parisienne, the canoes were continuing their journey when a strong wind blew in, capsizing the lead canoe in rough waters off the island, drowning nine of the 21 people on board.

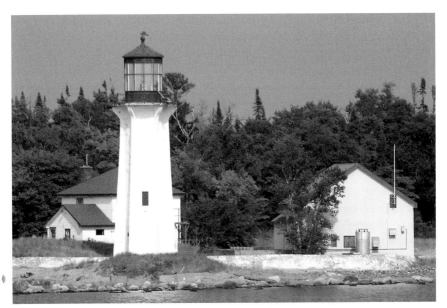

The lighthouse as viewed from the water. *Charles W. Bash*

On September 29, 1891—before the lighthouse was built—the 174-foot (53 m) schooner-barge *Frank Perew* was carrying coal and was in tow of the steamer *H. K. Fairbank* when she broke away during a storm and foundered. Captain J. M. Marquey and his crew of six abandoned ship in the yawl, struggled with rowing through waves for six hours headed for Ile Parisienne. They had nearly reached shore when, within 660 feet (201 m) of the beach, their boat capsized. Only one survivor, Charles Larrabee of Buffalo, made it to shore and wandered around the island until he was rescued the next day by two fishermen.

Loss of life also occurred on September 16, 1905, when fire broke out on the 233-foot (71 m) wooden schooner-barge *V. H. Ketchum* (*Ketcham*) in the waters off the island. The vessel was loaded with iron ore and was on its way from Duluth to Cleveland. Recognizing the danger, the captain beached her in 23 feet (7 m) of water just off Ile Parisienne, where she burned to the waterline. The *Buffalo Morning Express* on September 18, 1905 reported:

"When it was seen the vessel was doomed, the nine members of the crew, including Mrs. B. Ames, the cook, launched the lifeboat and prepared to row to the steamer *Nottingham*, which had the *Ketchum* in tow. In attempting to lower the woman safely into the small boat, the craft was capsized, throwing the nine people in the water. Without a moment's hesitation, mate Andrew Anderson jumped to the rescue as she was going down for last time; he reached her just as she disappeared

beneath the surface. Seizing her by the clothing, he turned and attempted to return to the ship, but the seas were carrying him farther away. Tiring from his exertions and borne down by the weight of the helpless woman, his efforts became feeble and the two sank before the eyes of the other members of the crew, who could offer no assistance. The remaining crew members were rescued by boats from the *Nottingham*."

Even after the lighthouse was built in 1912, ship accidents continued to happen, including on June 26, 1916, when the steamship *Panther* sank off the island after colliding during fog with the *James H. Hill*; no lives were lost. Then on December 8, 1927, the 252-foot (76.9 m) steel freighter *Lambton* (built as *Glenafton* in 1921 at Port Arthur Shipbuilding Co. in present-day Thunder Bay, Ontario) was heavily damaged when she smashed into a reef and became stranded on the island. Two men died trying to reach shore after the crew abandoned ship. *Lambton* was recovered the following year and rebuilt as a barge.

INTO THE TWENTY-FIRST CENTURY

In 2001, to protect the uninhabited island, the Ile Parisienne Conservation Reserve was created by the Canada Public Lands Act. The reserve encompasses the entire island except two areas: the privately owned 114 acres of land and the 10-acre water lot at the southeast end, which had been sold to a fishing company in 1902 but never developed, as well as the lighthouse site at the southwestern tip, approximately one mile (1.6 km) from the private land parcel. The reserve includes a 1.4 U.S. nautical-mile (1.6 km) marine zone extending from the shore into Whitefish Bay. The reserve is managed by the Ontario Ministry of Natural Resources.

Within the conservation area, there are no campgrounds, facilities, or structures. Water access to the conservation reserve from boat launches at Goulais Point and Gros Cap involves crossing a large expanse of open water. As Lake Superior can be unpredictable and dangerous, the boat ride can vary from 30 minutes to more than two hours. The shallow water surrounding the island limits the size and type of vessel that can land on the island's shore; generally canoes, kayaks, and inboard/outboard motors can access the shore.

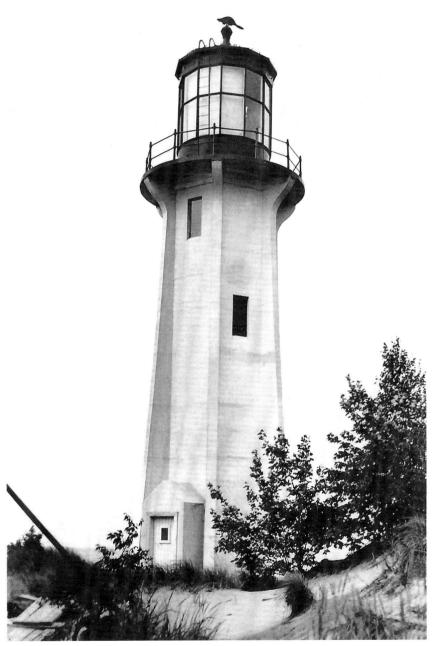

Unlike most northern shore lighthouses, Isle Parisienne is built on sand rather than rock.
National Archives Canada

SELECTED BIBLIOGRAPHY

Andra-Warner, Elle. *Lighting the Lake's Northern Edge.* Lake Superior Magazine, August-September, 2007.

Bourrie, Mark. *True Canadian: Great Lakes Stories.* Toronto: Key Porter Books, 2004.

Bowen, Dana. *Shipwrecks of the Lakes.* Cleveland: Freshwater Press, 1971.

Butts, Edward. *Tales of Great Lakes Lighthouses: Guiding Lights, Tragic Shadows.* Toronto: Lynx Images, 2005.

Chisholm, Barbara. *Superior: Under the Shadows of the Gods.* Erin, ON: Lynx Images, 1998.

Cochrane, Timothy. *Minong—The Good Place, Ojibwe and Isle Royale.* East Lansing, MI: Michigan State University Press, 2009.

Department of Marine. Annual Report, various years.

Douglas, Daniel G. V. *Northern Algoma: A People's History.* Toronto: Dundurn Press, 1996.

Government of Canada, Department of Marine and Fisheries. Various reports/years.

Government of Canada. Sessional Papers, various years.

Government of Canada, Canadian Coast Guard. List of Lights, Buoys and Fog Signals, various years.

Gutsche, Andrea, and Cindy Bisaillon. *Mysterious Islands: Forgotten Tales of the Great Lakes.* Erin, ON: Lynx Images, 1999.

Isle Royale National Park. "Cultural Resource Interactive Mapping Project," Isle Royale Institute. http://iri.forest.mtu.edu/

Lighthouse Digest Magazine. Various articles. http://www.lighthousedigest.com/

Marsh, John S. and Bruce W. Hodge. *Changing Parks: The History, Future and Cultural Context of Parks and Heritage Landscapes.* Toronto: Frost Centre for Canadian Heritage and Development Studies, 1998.

Nute, Grace Lee. *The American Lake Series: Lake Superior.* Indianapolis: Bobbs-Merrill, 1944.

Ontario Parks. "Michipicoten Post and Michipicoten Island Background Information," 2004. http://www.ontla.on.ca/library/repository/mon/11000/246085.pdf

Ratigan, William. *Great Lakes Shipwrecks and Survivals.* Grand Rapids, MI: Wm. B. Eerdmans Publishing, 1975.

Rowe, Johanna. "Harbour Might Not Be Hub of Activity it Once Was But Keep History Buffs' Minds Busy." Sault Star (Sault Ste. Marie), November 24, 2012.

_____. "Guiding Vessels for More than a Century." Sault Star (Sault Ste. Marie), April 25, 2011.

Spears, Raymond S. *A Trip on the Great Lakes: Description of a Trip, Summer 1912, by a Skiff Traveler, Who Loves Outdoors: Tells of Fish, Fur, Game and Other Things of Interest.* Columbus: A. R. Harding, 1913.

Unwin, Peter. *The Wolf's Head, Writing Lake Superior.* Toronto: Viking Canada/Penguin Group (Canada), 2003.

Wolff, Julius F. Jr. *Lake Superior Shipwrecks: Complete Reference to Maritime Accidents and Disasters.* Duluth, MN: Lake Superior Port Cities, 1990.

Wright, Larry and Patricia. *Great Lakes Lighthouses Encyclopedia.* Erin, ON: Boston Mills Press, 2006.